THE MEMORY OF TIME

Sarah Greenough
and Andrea Nelson
with
Sarah Kennel
Diane Waggoner
Leslie J. Ureña

National Gallery of Art
Washington

Thames & Hudson

THE MEMORY OF TIME

Contemporary Photographs at the National Gallery of Art

THE MEMORY OF TIME:
CONTEMPORARY PHOTOGRAPHS AT
THE NATIONAL GALLERY OF ART,
ACQUIRED WITH THE ALFRED H. MOSES
AND FERN M. SCHAD FUND

The exhibition is organized by the National Gallery of Art, Washington.

Exhibition Dates
May 3–September 13, 2015

10 9 8 7 6 5 4 3 2 1

Produced by the Publishing Office, National Gallery of Art, Washington
www.nga.gov

Judy Metro, editor in chief
Chris Vogel, deputy publisher and production manager

Designed by Wendy Schleicher
Edited by Caroline Weaver

Sara Sanders-Buell, permissions manager; John Long, assistant production manager; and Mariah Shay, production assistant

Typeset in Benton Sans. Printed on Satimatte Naturelle 170 gsm by Verona Libri, Italy

First published in hardcover in the United States of America in 2015 by Thames & Hudson Inc., 500 Fifth Avenue, New York, New York 10110
thamesandhudsonusa.com

First published in the United Kingdom in 2015 by Thames & Hudson Ltd, 181A High Holborn, London WC1V 7QX
www.thamesandhudson.com

Library of Congress
Control Number: 2015000096

British Library
Cataloguing-in-Publication Data
A catalogue record for this book is available from the British Library.

ISBN 978-0-500-54449-5

Note to the Reader
Dimensions are given in centimeters, with inches following, height preceding width, which precedes depth. Author names are indicated by initials at the end of each individual entry.

Details
pp. ii–iii: Matthew Brandt, *Salton Sea C1* (pl. 17); p. viii: Binh Danh, *Ghost of Tuol Sleng Genocide Museum #1* (pl. 29); p. x: Mikhael Subotzky and Patrick Waterhouse, *Televisions, Ponte City, Johannesburg* (pl. 53); p. 148: Idris Khan, *Houses of Parliament, London* (pl. 37)

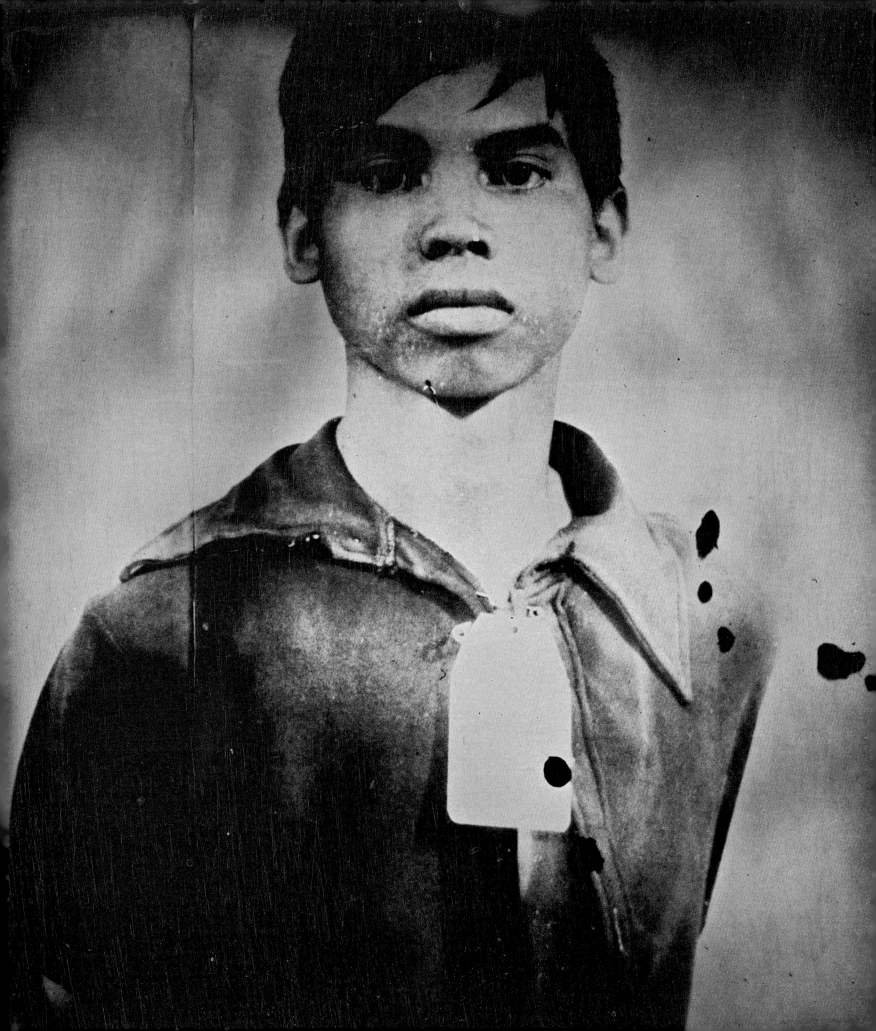

The Memory of Time: Contemporary Photographs at the National Gallery of Art, Acquired with the Alfred H. Moses and Fern M. Schad Fund presents work by artists who investigate the richness and complexity of photography's relationship to time, memory, and history. In the last two decades, as the ubiquity of digital photography has prompted profound changes in the medium of photography, and as we as a society have become more preoccupied with both time and memory, these issues have dominated the work of those photographers who seek not simply to reflect the world but to illuminate how photography constructs our understanding of it. From projects that explore early photographic processes and archives to ones that attempt to give visible form to the fluctuating and subjective experience of time itself, these artists have placed photography at the crux of a fascinating discussion about history, memory, and the perception of time and space.

The Memory of Time marks an important moment in the history of the Gallery's photography collection, which this year celebrates its twenty-fifth anniversary. This exhibition and its accompanying catalog are the Gallery's first to focus exclusively on trends in contemporary photography. We are delighted to present here work by twenty-six artists ranging in age from their thirties to their seventies and hailing from around the world: Canada, France, Germany, Great Britain, Netherlands, Japan, South Africa, Vietnam, and the United States. In seventy-six pieces their work beautifully demonstrates the fecundity and vitality of the medium today. We deeply thank these photographers—almost all of whom are new to the Gallery's collection—and their representatives for their collaboration in this exciting endeavor.

We are extremely grateful to Alfred H. Moses and Fern M. Schad for their remarkable generosity and vision in making it possible for us to acquire these works. With their keen interest in photography and their desire to support the museum at the highest levels, in 2007 they established an endowed acquisition fund for photographs—the first such fund for photography in the Gallery's history. Throughout the years this fund will ensure that we are able to acquire photographs of the greatest importance and highest quality to share with our international audience for generations to come. As photographs are added to the collection over time, the Alfred H. Moses and Fern M. Schad Fund will prove to be one of the most significant gifts bestowed upon the National Gallery of Art.

We also wish to extend our thanks to Peter T. Barbur, Gregory and Aline Gooding, and Dan and Jeanne Fauci, who augmented our purchase of several of Mark Ruwedel's photographs with the gift of five more works by him. Deep gratitude is also due to Sarah Greenough, senior curator of photographs, and Andrea Nelson, assistant curator of photographs, who conceived the exhibition and worked closely with Ms. Schad to select the works. The powerful presentation they have organized around these compelling works is a fitting tribute to the dynamism of our photography program. We thank them and their colleagues—Sarah Kennel, associate curator of photographs; Diane Waggoner, associate curator of photographs; and Leslie Ureña, curatorial research associate—for their insightful contributions to the accompanying catalog.

EARL A. POWELL III | National Gallery of Art

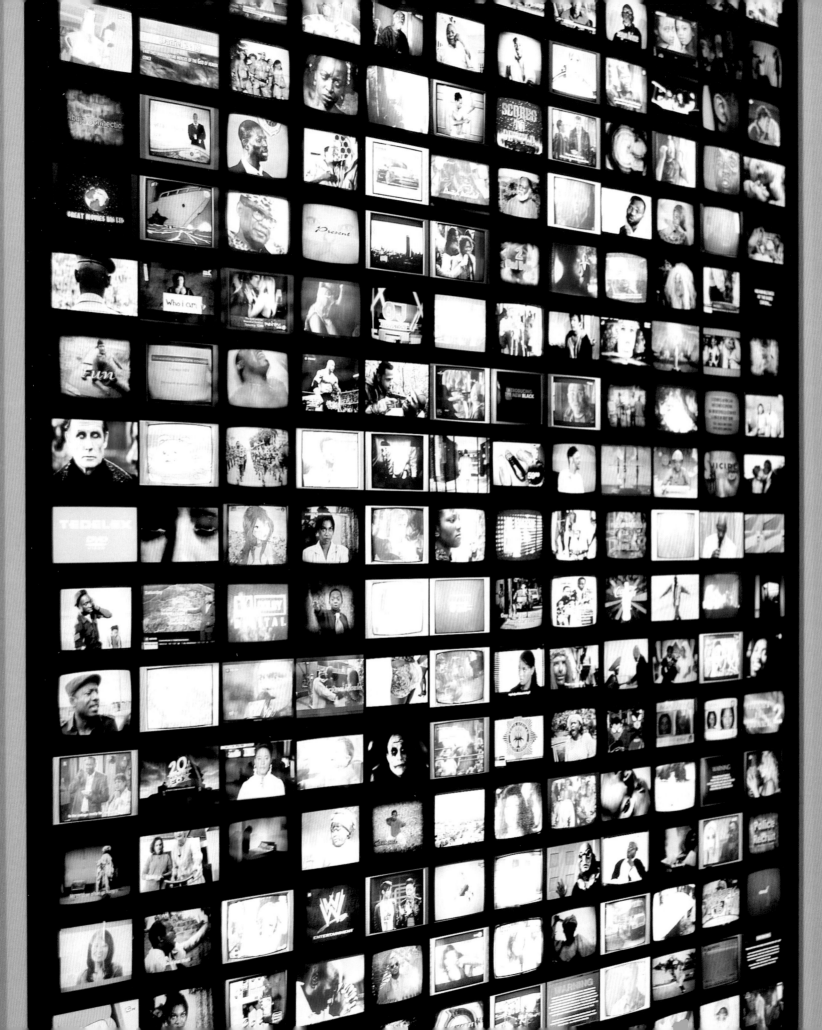

BETWEEN THE IDEA
AND THE REALITY
BETWEEN THE MOTION
AND THE ACT
FALLS THE SHADOW

T. S. ELIOT

In 1989 photography celebrated the 150th anniversary of its birth.[1] Fully enmeshed in all aspects of modern life, it was also comfortably ensconced in almost every major museum of art, science, history, and technology around the world. Numerous exhibitions, publications, conferences, and symposia marked the occasion, examining photography's history, as well as its profound impact on contemporary culture and thought.[2] Yet even as the celebrations were under way, photography itself was changing rapidly and utterly with the introduction of digital photography. Although digital technology has a long history, with roots in television, the postwar space race, and government spy agencies, in the early 1990s digital cameras burst into public consciousness as they and image-processing software suddenly became cheaper, easier, and far more widely available. Soon everyone seemed to have a camera that they used to document every aspect of their lives. Just as important, they shared these pictures not only with friends but also with strangers in radically new ways—online and through the burgeoning social media. In this new digital age, photography was suddenly everywhere.

Yet digital photography changed the medium profoundly not merely by its ubiquity or ease, but also by the way it fundamentally altered our understanding of the relationship of photography to truth. Despite our recognition that all photographs are subjective and contain a point of view, until the digital age we had

faith that a photograph was a picture of something that actually existed. Extolling its ability to provide an accurate witness to personal and public events, Louis-Jacques-Mandé Daguerre, one of the medium's inventors, even claimed that it was not a means of making pictures but "a chemical and physical process" that gave nature "the power to reproduce itself," while William Henry Fox Talbot, the father of all modern photography, asserted that it was a "process by which natural objects may be made to delineate themselves."[3] Although photographers have manipulated their pictures in a wide variety of ways since the medium's inception, this conception of photography as a tool capable of providing truthful evidence about the world persisted through the modernist age.[4] Photography enables us to "*see the world with entirely different eyes*," the Hungarian modernist artist and educator László Moholy-Nagy proclaimed in 1925; it fixes "the quintessence of movement," it arrests "fragments of the world," and it provides "an impartial approach, such as our eyes, tied as they are to the laws of association, do not give."[5] American modernists agreed: "The camera should be used for a recording of *life*, for rendering the very substance and quintessence of the *thing itself*, whether it be polished steel or palpitating flesh," Edward Weston insisted. It can "capture and record the essential truth of the subject," he continued, and show not just "how this person looks, but… what he is."[6] The invention of digital photography, however, forever shattered the medium's hold on truth, undermined its supposed objectivity, and decimated its evidentiary status, for now nothing in a photograph need be real; everything could be fabricated. If photography was no longer a faithful witness, what was it?

While some critics, theorists, and even photographers themselves suggested that the medium was dead, or at least changed so profoundly it was beyond recognition,[7] other artists in the last twenty-five years

have intensely scrutinized photography itself, examining what it is conceptually, ontologically, and physically. Two concepts have dominated their work: time and memory. These are not new concerns to photography; when the process was first announced to a startled world in 1839, artists, scientists, and the general public alike marveled at photography's unique and striking ability to capture a specific moment of time. Talbot was the first to celebrate this "magical" power: "The most transitory of things," he wrote, "a shadow, the proverbial emblem of all that is fleeting and momentary, may be fettered by the spells of our 'natural magic,' and may be fixed forever in the position which it seemed only destined for a single instant to occupy."[8] Time is also at the root of photography's association with truth. Early reviewers noted with awe that the ability to stop time enabled this new mode of representation to reveal facts about the world in a radically different way. "The minute truths of the many objects," one critic wrote, "the exquisite delicacy of the penciling, if we may be allowed the phrase, can…be discovered with a magnifying glass."[9] Yet Talbot and others also quickly recognized that photography did far more than just arrest time: with its capacity to save an image of something long gone, it preserved memory. Writing about this complex, dual nature of photography, a critic in *The Athenaeum* perceptively noted that Talbot's "fairy pictures" enabled us "to hand down to future ages" not just facts but "a picture of the sunshine of yesterday, or a memorial of the haze of today."[10] "It is not too much to say," another early proponent noted, "that no individual, not merely individual man, but no individual substance, nothing that is extraordinary in art, that is celebrated in architecture, that is calculated to excite the admiration of those who behold it, need now perish, but may be rendered immortal by the assistance of photography."[11]

Yet in the last few decades, as photography has shed its heavy mantle of truth, lessened its dependence on the external world, and abandoned the notion that it could ever make a faithful representation of reality, the concepts of time and memory have once again come to the fore. Roland Barthes's highly influential book, *Camera Lucida*, 1981, and especially his insistence that every photograph is a memorial (a recognition that "*this has been*") and embodies a premonition of death ("*he is going to die*") contributed substantially to this renewed interest in time and memory, as did his recognition that the meaning of a photograph was not stable but dependent as much on the spectator as the photographer or subject.[12] But other cultural factors also propelled the investigation of these concepts. As the millennium drew to a close and the world at large grappled with a plethora of new technological inventions and one economic, social, political, and environmental disaster after another, both the pace of change and a sense of anxiety dramatically escalated. In a culture where, as the theorist Edward Said noted, "nothing is seen for any length of time, there is no assurance of collective memory, and little carry-over from day to day. There is no background, but only a moving foreground. There is no accumulation of history." As history itself came to be seen as under attack, we began to conceive of it as consisting as much of memories as of facts, and informed as much by representations as by events.[13] Within this milieu, time and memory assumed profound importance for contemporary artists. Moreover, because of photography's peculiar ability to represent the past in the present, which is now frequently invoked as one of the medium's essential characteristics, and because of its capacity to provide a vivid trace of experience, otherwise only ephemeral and disconnected, photography has been viewed in recent years as an especially apt medium to address these issues.[14]

However, as many contemporary artists acknowledge, photography's relationship to time, the past, history, and memory is multifaceted and slippery. While most photographs seem to depict a singular moment of time, each image contains multiple layers, including the instant of exposure, the moment of viewing, and the lapse in between. And while most photographs seem to encapsulate a particular memory to their makers, or evoke a specific idea through labels and captions, when they are ripped from that original context, denuded of their descriptions, and viewed by others, they assume new, often multiple and unrelated meanings that can allow for a rereading and a rewriting of history. By recognizing and exploiting this tiered temporal and experiential complexity, contemporary artists have placed photography at the center of a discussion around the construction of history and memory, and around the perception of time and space. Divided into five sections—"Traces of History," "Time Exposed," "Memory and the Archive," "Framing Time and Place," and "Contemporary Ruins"—*The Memory of Time* examines work made from the early 1990s to the present recently acquired by the National Gallery of Art by artists who have explored these issues.

The first section, "Traces of History," presents works by photographers who share a fascination with history, including early photographic techniques. Since the late 1980s and early 1990s when the medium began to change from analog to digital, numerous artists, including Matthew Brandt, Chuck Close, Binh Danh, Adam Fuss, Myra Greene, David Maisel, Sally Mann, and Carrie Mae Weems have looked not forward but backward, reengaging with older, often nineteenth-century photographic materials, processes, and images.[15] Entranced by the lush tactility and powerful immediacy of earlier printing techniques, especially when compared with seemingly disembodied digital images, these photographers are, nevertheless, far from antiquarian revivalists. Seeking to merge form and content, they draw on our collective knowledge of visual and cultural history, and even our associations with antique printing techniques, as a way of employing the past to inform their present work. But they invert our expectations in order to make us question that very history itself. Like their nineteenth-century predecessors, these photographers frequently make daguerreotype, ambrotype, or tintype portraits, yet they do so with a far more self-conscious, critical scrutiny, often examining issues of identity and race. Chuck Close and Myra Greene, for instance, make daguerreotypes and ambrotypes that deliberately harken to older yet still persistent racial stereotypes that define character, intellect, and morality through physical features (pl. 1; pls. 5–11). While Greene chose to depict herself, in order to question whether her character resonates louder than the color of her skin, and to focus on photography's complicit role in racial classification and degradation, Close recorded his friend, the artist Kara Walker—well known for her work dealing with race, gender, sexuality, and violence—in a manner that alludes to her highly charged silhouettes, thus making us question how his photograph reverberates with the stereotypes she explores in her work (see fig. 1).[16] For her self-portraits, Sally Mann eagerly exploited the difficulties and vagaries of the ambrotype process, which is prone to bubbles and streaks, cracking and peeling, to confront the ravages of time on her body and spirit (pl. 4). However, unlike her nineteenth-century predecessors, she arranged her nine ambrotypes in a distinctly twentieth-century grid that collectively reveals a haunting, spectral image of the vulnerability of the human spirit.

When these artists turn to landscape or architecture, they often do so to examine not national character, as their nineteenth-century precursors did, but

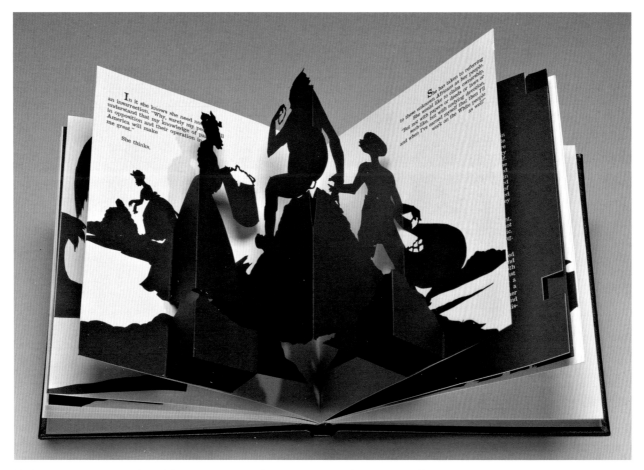

Fig. 1 Kara Walker, *Freedom, a Fable: A Curious Interpretation of the Wit of a Negress in Troubled Times*, 1997, bound volume of offset lithographs and five laser-cut, pop-up silhouettes on wove paper, National Gallery of Art, Washington, Dorothy and Herbert Vogel Collection

personal identity. Binh Danh, for instance, evoked the photographs of Carleton Watkins or Ansel Adams, but he used the mirrorlike surface of the daguerreotype, which merges together the image depicted and the reflection of the viewer, to examine the meaning and relationship of his subject, Yosemite National Park, to a nonwhite American such as himself (pls. 15, 16; see fig. 2). Matthew Brandt, using water from the Salton Sea to make a photograph of that same subject, recorded similar scenes as nineteenth-century western expedi-

tionary photographers, but unlike their sharply detailed albumen prints, his are soft-focused salted paper prints (pl. 17). Lacking the specificity of his pre-decessors' work, Brandt's pictures are not exuberant celebrations of the abundant richness and diversity of the American West, but poignant, more universalized meditations on the land itself. Subverting traditional associations of daguerreotypes, Adam Fuss played with scale (pl. 14). Nineteenth-century daguerreotypes, resplendent with minute, loving details, are usually

small, intimate, handheld. However, when enlarged to the size of Fuss' print of the Taj Mahal—23½ × 38 inches—they become something entirely different. Otherworldly, ethereal, and evocative, not literal and descriptive, Fuss' work, like the Taj Mahal itself, is a meditation on love and loss.

Art and social history have provided rich resources for other photographers, such as David Maisel and Carrie Mae Weems, enabling them to reflect on the nexus between past and present. Concerned with the "dual process of memory and excavation," David Maisel, for example, worked with x-rays of sculpture (pls. 12, 13; see fig. 3). By backlighting and printing them in color, he sought to make "the invisible visible," reanimating the two-dimensional x-rays, which themselves map the inner structure and outer skin of the three-dimensional works of art, in order to render the originals "acutely alive and renewed."[17] Others allude less specifically to their sources, allowing for more open-ended reflections. Carrie Mae Weems' two circular, sepia-toned photographs of African American girls reclining in a pastoral setting, wearing floral-print dresses and garlands in their hair, recall nineteenth-century formal portraits of middle-class leisure by such artists as Édouard Manet or Julia Margaret Cameron, as well as Renaissance depictions of the Madonna and child (pls. 2, 3). Yet, as the defiant gaze of the dominant figure in both photographs seems to acknowledge, such historical forms of privileged representation would have previously been unavailable to these young girls. The photographs' titles further amplify this revolutionary confrontation: *May Flowers* alludes both to spring revels around the maypole and the May Day celebrations of International Workers' Day, while *After Manet* suggests not only the inspiration of the work, but how Weems proposes to build on his artistic legacy and insert into this "historical narrative or tradition," as she said, "someone who was never there."[18]

The second section, "Time Exposed," examines those photographers whose work gives form to the literal passage of time, as well as to the fleeting evidence of historic and cultural change.[19] As the title "Time Exposed" indicates, the pictures by the photographers presented here, including Uta Barth, Linda Connor, Vera Lutter, Chris McCaw, and Hiroshi Sugimoto, are

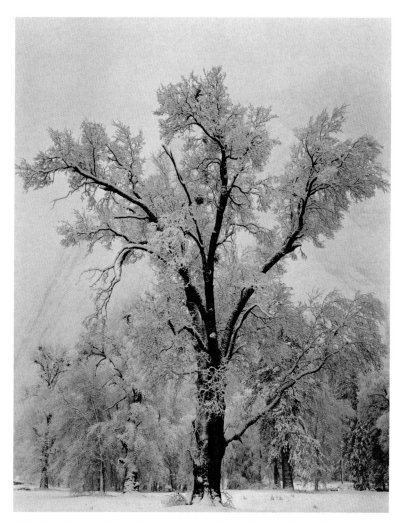

Fig. 2 Ansel Adams, *Oak Tree, Snowstorm, Yosemite National Park, California*, 1948, gelatin silver print, 1981. National Gallery of Art, Washington, Gift of Virginia B. Adams

expositions both *of* and *on* time. Working against the modernist fascination with speed, instantaneity, and the decisive moment, these artists explore slower rhythms of perception to delve more deeply into both their surroundings and the art of making photographs. Constructing conceptual frameworks that are often as elegantly simple as they are provocative, they deliberately plan their exposures, which frequently extend over long periods of time—several hours, or even days. Yet their intention is not to more thoroughly document a scene but to create new phenomenological experiences by compressing or expanding, layering or fracturing time. Recalling Barthes's remark that cameras "are clocks for seeing," these artists strive to heighten our perception of the passage of time, intensifying our awareness of our own vision and often creating pictures of things our eyes can never see.[20] Hiroshi Sugimoto, for example, set up his camera in darkened movie theaters and drive-ins and left the shutter open for the entire length of a film (pls. 21, 22). The slow accumulation of light illuminated the dim space, allowing us to see details that would not have been visible if we were sitting there, but the total exposure on the screen itself is so bright and overexposed that the movie itself is not discernible; the silver screen remains but the story it told is not to be found. Like Sugimoto, Vera Lutter uses the gradual accrual of light over many hours to make her photographs (pl. 23). Yet, using a camera obscura—the simplest of all cameras, nothing more than a box with pinhole— she exposes directly onto photographic paper, not negative film. The resulting tonally reversed pictures present a world turned inside out, as day becomes night, mass loses matter, and volume vacates space. Linda Connor explores a much more extended sense of time; her prints are made from glass-plate negatives that were taken over one hundred years ago and are pictures of light that emanated from the stars tens

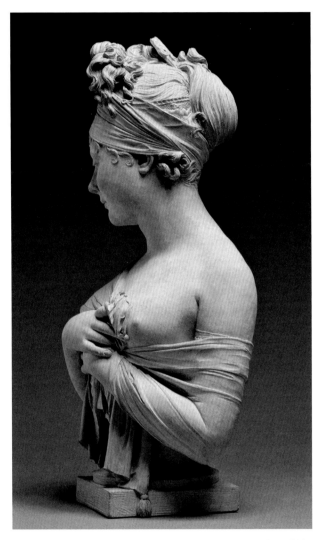

Fig. 3 Joseph Chinard, *Bust of Juliette Récamier (1777–1849)*, c. 1801–1802, terracotta, The J. Paul Getty Museum, Los Angeles

of thousands of years ago (pls. 25–28). Layering astronomical time on top of human time, Connor's work also shows how the negatives themselves aged, as the plates now are cracked and peeling.

Although these artists often note in their titles where and even when their pictures were made (Lutter's

Ca' del Duca Sforza, Venice II: January 13–14, 2008, Connor's *April 16, 1893*), because details are minimized and experience intensified through their long exposures, their art also has a timeless universality to it. Chris McCaw, for example, in his photographs made in San Francisco, the Galapagos, or the North Slope of Alaska, freely relinquished photography's claim to accuracy or specificity to exploit the volatile interaction of light, time, optics, and photographic chemistry (pls. 18–20). As his negatives turn positive from overexposure and the sun imprints its mark on the paper with such brute force that it slashes and burns the substrate, causing the edges of this wound to curl and turn an array of colors, the literal and descriptive give way to the monumental and the sublime, the ecstatic and the revelatory. In addition, because these works are created over time, they are also to a large degree performative, as the artists respond to their constantly changing environments. Far removed from the modernist photographer who surreptitiously shot a frame or two of 35 mm film and then melded back into the crowd, these artists, as McCaw notes, work in collaboration with their subjects and are joyous observers of their pictures' slow maturation.[21] Thus their art is often infused with a deeply reverential quality.

Yet these artists also wish to construct pictures that prompt us to think about the ontology of photography itself—not merely how it depicts the world, but what it is or can be as a means of making pictures, and how it makes us look at pictures. Sugimoto does this by creating what has been called an "abyss of riddles," allowing film to illuminate photography, but enabling photography to obliterate film.[22] Lutter does this by making visible a world we have never seen and could never experience. Uta Barth accomplishes this in a much quieter manner in the picture *...and to draw a bright white line with light (Untitled 11.5)* (pl. 24).

Striving to eliminate all narrative content and minimize the subject as much as possible, she selected the most anonymous and transparent of views— a window in her home—to gently harness the movement of light and illuminate the passage of time, revealing not *what* but *how* we see. By hanging the three photographs right next to one another, Barth surrounds viewers with this scene, directing us to move back and forth between them, thus making our act of looking temporally based and intensifying our perception of how we see. As time is revealed through light, the photographs become a phenomenological study of both how we perceive and study its passage.

Many contemporary photographers are also deeply fascinated with the idea of the archive, the subject of the third section of the exhibition, "Memory and the Archive." Whether created by governments, commercial enterprises, or private individuals, archives of "documents or records, both verbal and visual," as Charles Merewether has noted, provide "the foundation on which history is written," as well as a means of accumulating, accessing, and assessing that knowledge.[23] An interest in archives is not new: with the proliferation of mass media during the interwar years, dada artists, such as John Heartfield and others, mined institutional archives for their photomontages.[24] At the same time, Walter Benjamin wrote in *The Arcades Project* about the profound importance of "the afterlife of objects," noting the ability of collectors and others to take objects from the past into their own time and place, thereby shedding new light on what has been.[25] More recently, as artists and theorists have examined the complex role of the photograph within the archive and seen that it functions as both a document of and a commentary on an event, they have understood that archives themselves are not static entities out of which single monolithic histories

arise.[26] Instead, the artists in this section, including Sophie Calle, Deborah Luster, and Susan Meiselas, as well as Danh and Weems, have exploited archives as repositories of raw material that can be, as Benjamin asserted, reborn in the present, reexamined, and reordered to challenge existing narratives.[27] Focusing attention on people, events, and histories that have been marginalized or overlooked, both Weems in *Slow Fade to Black II* and Danh in *Ghost of Tuol Sleng Genocide Museum #1* act as archival artists, summoning images ingrained but buried in collective memory.[28] They excavate public archives—one created for commercial publicity, the other for a government's macabre documentation of prisoners prior to execution (pl. 33, pl. 29). Although our knowledge of recent political events and the titles of the photographs provide us with subtle but unsettling evidence of the fate of these people, Weems' and Danh's intention was not solely to present their subjects as inert icons of social and political injustice. Rather, through their selection and appropriation of heroic images—the performers at the height of their fame and accomplishment, the prisoner still in full possession of his dignity—they also ask us to study these people anew. Demonstrating the continued relevance of this material in our present day, they show that the archive can be a site of remembrance and rebirth.

Other contemporary photographers, acting as artists and archivists, have created and explored their own archives. In their elegiac work, both Ishiuchi Miyako and Deborah Luster discover traces of people who have died and might otherwise be lost or forgotten, and then photograph these things as a means of prioritizing, preserving, and perpetuating their memory (pls. 31, 32; pls. 35, 36). For her project, Ishiuchi collected intimate items—underwear, shoes, lipsticks—that still bore the imprint of her mother. Acting as both documents of and memorials to the past, Ishiuchi's

photographs are a means of structuring her memories and holding onto her mother in an almost physical way. Luster sought to give order and meaning to the past by photographing the sites where murders occurred in New Orleans, then printing her pictures in a circular format, as if she—and we—were looking through the sight of a gun. She paired these with pictures of "ledger books" that purport to depict police records of the violence, noting the name and age of the victim and the manner of his or her death. For Susan Meiselas, an artist deeply concerned with the ways in which the context surrounding an image affects our understanding of both it and history, the construction of archives and their use as a catalyst for remembrance is of central concern. In *The Life of an Image: "Molotov Man," 1979–2009*, she traced the many ways in which her celebrated photograph of a Sandinista rebel throwing a Molotov cocktail was appropriated and reused as an icon of the revolution by both pro- and anti-Sandinista forces, even by the Catholic Church, for over thirty years (pls. 34A–Q). Showing how the past continues to live in the present, she created an archival structure to demonstrate the object's multiple historic layers of evidence and information, including a variety of materials—35 mm slides, contact sheets, photographs, videos, magazines and clippings, even matchbooks—all necessary to trace the object's rich history and demonstrate its shifting cultural meanings.

Sophie Calle takes a quite different approach that blurs the lines between fact and fiction, private and collective experience, real and fabricated archives. Her work *Wait for Me* presents a photograph of a young child—herself?—standing alone on a boardwalk and pairs it with a text, written in the first person singular, describing the child's loneliness and sadness at being abandoned by her older playmates (pl. 30). It was first presented in Calle's 2010 book *True Stories*,

a continuation of a work she initially published in 1988 (and also referred to as *Les Autobiographies*) that includes short, presumably autobiographical texts and photographs describing episodes in her life—"The Love Letter," "The Husband," "Monique." By situating this work within that larger "autobiographical" archive, Calle not only plays with our willingness to accept the veracity of both photography and the written word, especially when linked together, but also suggests how much validity can be conferred on an idea or image by its placement within a larger archival context.

"Framing Time and Place," the fourth section of *The Memory of Time*, examines how photographs can make the past vividly present through the depiction of urban vistas and landscapes. Questioning how photographs construct our sense of history and memory, artists as diverse as Idris Khan, Andrew Moore, Mark Ruwedel, and Mikhael Subotzky and Patrick Waterhouse, explore sites where layers of time and history commingle, their evidence written in the physical nature and structures of the sites themselves. For his project *Westward the Course of Empire*, Mark Ruwedel, for example, recorded abandoned railroad lines in the American West in order to make an "inventory," as he has written, "of the landforms and ruins created…by the European occupation of the continent" (pls. 38–49).[29] Eschewing more fashionable color, he worked instead in black and white with a 4 × 5 inch view camera, which lend a stillness and gravitas to his pictures and link them with the more sober tradition of both nineteenth- and early twentieth-century documentary photography. Recording the cuts, grades, collapsed tunnels, and derelict trestles scattered throughout the West—which one nineteenth-century observer referred to as "an industrial Sahara"—Ruwedel reveals how time, nature, and humankind have relentlessly shaped the physical environment, constructing "a vast landscape of ruins, monuments

to the epic and relentless economic competition that characterized the 'opening of the West.'"[30]

As they wrestled with a medium whose evidentiary status is now in doubt, these artists also explore new strategies to infuse a sense of authority into their work. All have adopted a slow, methodical practice: the speed of the modernist reportage photographer, who quickly sought the decisive moment, has no part in their work. Instead, like Bernd and Hilla Becher, who systematically recorded German industrial architecture from 1959 through the early 2000s, they often exhaustively study and record their subjects, sometimes spending years and even decades doing so. Ruwedel, for instance, devoted more than a dozen years to his project; Mikhael Subotzky and Patrick Waterhouse spent three years on their examination of Ponte City, a fifty-four-story circular apartment building in a formerly whites-only section of Johannesburg, South Africa (pls. 52, 53). Using repetition to bolster truth, they, like the Bechers, also employ the same formal strategy in their pictures, and then display them either together in books or grids on the wall. Their collective groupings are not random arrangements of photographs of related subjects, but carefully ordered conceptual constructs. Ruwedel, for example, usually photographs the western landscape head-on with the object of his attention—grades or cuts—in the center of the composition. Working within a typological framework, he then composes both linear sequences and grids that amplify the engineering solutions that transformed the landscape.

Subotzky and Waterhouse push this idea even further in *Doors, Ponte City, Johannesburg* and *Televisions, Ponte City, Johannesburg*. Touted as the epitome of luxurious apartheid urban planning, Ponte City has a history as storied as the building is tall (fig. 4). It was completed in 1975—the year before the Soweto student uprising—then vacated in the early 1990s, as whites

fled to the supposedly safer suburbs, and invaded by gangs, prostitutes, and foreign nationals who moved into the rapidly decaying structure; it was bought by developers in 2007 who sought but failed to renovate it. Seeking to show "both the layers of history as well as individual fragments of interest," Subotzky and Waterhouse photographed every door, television set, and window in the apartment building, then arranged

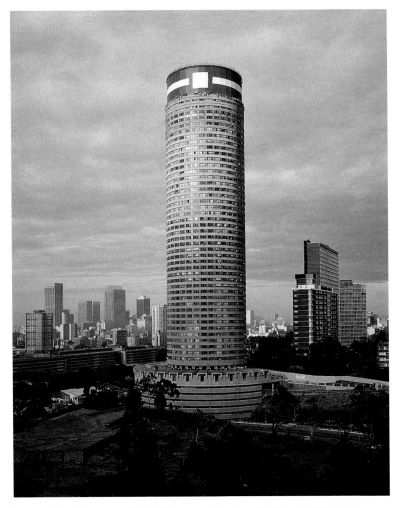

Fig. 4 Mikhael Subotzky and Patrick Waterhouse, *Blue Ponte / Red Ponte VI*, 2011, inkjet print on semi-matte paper. Courtesy Goodman Gallery

their pictures on light boxes nearly thirteen feet tall, according to the building's (not the artists') design: apartment by apartment, floor by floor.[31] The boxes themselves, although almost abstract in their patterning of colors and forms when seen from afar, are on closer examination abundantly rich in details. The doors, the entryway into each inhabitant's private life, are a dazzling display of reds and blues—their colors bespeaking the history of the renovation itself—but they are punctuated with pictures of people and, at the bottom, signs speaking of apartheid: *"European Ladies Dames"* and *"European Gents Here."* The television sets, the windows into the residents' imaginary lives, are a blazing patchwork of local soap operas, Congolese music videos, and Nollywood movies, as well as advertisements and news, and allude to the heritage of the building's multiethnic population, and also to their past and present lives and dreams. Like an archaeological excavation, the cascade of photographs—logical and methodical in its order, yet poignant and mesmerizing in its presentation—shows the building, as Subotzky and Waterhouse have asserted, as "a place of dust and dreams, befitting the land on which it sits."[32]

All of these artists also make pictures that are not only rich in history but replete with metaphors: Subotzky and Waterhouse's towering light boxes, like the building itself, allude to the history of urban decay in post-apartheid South Africa, while Ruwedel's photographs of abandoned and now overgrown railroad grades speak of the impact of technology on the landscape and nature's regenerative power. Andrew Moore's pictures *Palace Theater, Gary, Indiana* and *Model T Headquarters, Highland Park, Michigan* are metaphors for the decline of American cities and industry in the late twentieth century, but also, paradoxically, for their regeneration, albeit in a radically different form (pls. 50, 51). Like some of his documen-

tary predecessors from the 1930s who also sought to record a failed society, Moore used an 8 × 10 inch view camera for these pictures, adding the authority of exact, if horrific, detail; unlike most of them, however, he worked in color, not black and white.[33] Exploring "the busy intersections of history," he seeks to record not societies that have died but those in flux. While the buildings he photographs are beyond repair (a once opulent theater now an almost inconceivable hovel of strewn, collapsed chairs and crumbling walls; an office in the Ford Motor Company's Highland Park headquarters now sprouting an incongruous field of green moss and teeming with what appear to be miniature hedgerows), his pictures possess an undeniable beauty and point to a reawakening. By capturing the soft light of the city streaming in through holes in the walls, or the rich colors of its new carpet of moss, Moore imparts to his pictures a lushness verging on tactility, infusing them with the possibility of renewal and the hope, as the Detroit poet Philip Levine noted, that "the world doesn't quit."[34]

While Moore seeks to reveal how "multiple tangents of time overlap and mingle" in a place, Idris Khan in his *Houses of Parliament, London* strives to create an image not of an isolated fragment of time, but what he refers to as "stretched time" or "translucent moments of time"[35] (pl. 37). Like the others, he explores the power of repetition, but in a very different manner. In *Houses of Parliament, London* he digitally layered dozens of postcards and stock photographs of one of the city's most iconic and depicted views, one on top of another, editing out anything superfluous and selecting only "what really stands out in the photograph.[36] His aim was to capture an image not of the place itself, but rather, as he has said, of what has been "permanently imprinted on someone's mind, like a memory."[37] Although his photographs pay homage to London, he transforms them from purely documentary records of

what is visible at a specific time and place into reflections of what is remembered about the spirit of the city: its energy, cacophony, and abundance, its history and tradition. Khan noted that he sought to capture "the essence of the buildings." However, Khan's essence is not the truth of the confident modernist photographer, but instead the essence of memory of a questioning millennial, one whose vision has been formed by a profusion of images, each one only a trace, each one of no more importance or validity than the next, each one but raw material for a larger idea.[38]

The final section, "Contemporary Ruins," addresses the work of Moyra Davey, Witho Worms, Christian Marclay, Alison Rossiter, and Ruwedel, who critically examine ruins. As both remnants of and portals into the past, ruins can be provocative purveyors of nostalgia, yet they are also a concrete reminder of the passage of time and a powerful warning of the inevitability of change and death. While the study of ruins as a means to assess cultural history has a long tradition dating back hundreds of years and has animated artistic vision from Giovanni Battista Piranesi's architectural fantasies[39] to Ridley Scott's *Blade Runner*, the field has received renewed attention in the last two decades by contemporary photographers, many of whom focus on the decline of the built environment, especially the urban decay of postindustrial societies.[40] However, others, such as Ruwedel in his series *Dusk*, examine the degraded spaces of the suburban sprawl of Southern California's Antelope and Imperial Valleys (pls. 71–75). Constructing epic narratives out of small details, Ruwedel photographs modest houses that seem to have been either once inhabited and now abandoned, or never finished at all. Yet the evidence of humanity is everywhere present—in the trash-strewn landscape or broken windows, for example. These narrative fragments speak of the economic greed that fostered the development of houses on such

fragile ground, and of the human and environmental toll. Working in the high desert where the arid air has a particular quality of light that renders the edges of forms especially sharp, Ruwedel photographs at dusk, just as the objects "stand up and glow," as he says, further augmenting the mournful tone and the sense of decay and death.[41]

Witho Worms also looks at ruins in the contemporary landscape to speak not only about the industry that generated them and the lives affected, but also the process of reuse and regeneration (pls. 64–68). He photographs slag heaps, the visual remnants of the coal-mining industry that fueled the industrial revolution, bringing prosperity to a few and grueling labor, even death, to many more. A slag heap was the central figure of devastation in Richard Llewellyn's 1939 novel *How Green Was My Valley*, and many remain dangerous to this day; however, some have been reclaimed by nature, as Worms' photographs of tree-covered mounds demonstrate. Both dump and eco-monument to the industrial past, the slag heap's enigmatic nature is reflected in Worms' oddly ambiguous pictures. He describes their unnatural forms—some still in use are little more than mounds of shifting, dangerous mud, while others rise like man-made pyramids from the ground yet are incongruously covered with grass and trees. His process also speaks to the dual nature of these ruins as symbols of destruction and rejuvenation, for he grinds up coal from the potentially toxic sites where he photographs to make his dark, brooding, and strangely alluring prints.

Yet, as the other photographers in this section of the exhibition demonstrate, buildings and the landscape are not the only ruins that display the evidence of cultural and natural histories. Taking the ephemeral, the mutable, and the decaying as inspiration, Moyra Davey, Alison Rossiter, and Christian Marclay look to objects as telling markers of economic, environmental, or technological change and as a means to reflect on photography's connection to impermanence and deterioration. Davey, for example, examines the quotidian but no less poignant ruins that are present in our everyday lives, handled and worn by touch (pls. 54–63). Seeking to address what she has referred to as "the psychology of money," in 1990 she made detailed photographs of one hundred US pennies, focusing on President Abraham Lincoln's profile on the obverse.[42] Scarred, gouged, rusted, and covered with mold, Lincoln is not honored in her pictures but maligned: in one photograph his lips appear oddly swollen and red, while in another he seems to have been shot. Made during an economic downturn at the end of the Reagan era, the photographs show not only the fate of the lowly penny—a nuisance, something we throw away and overlook on the street—but also our casual disrespect for history. While Ruwedel reads the trash in the desert as part of a larger narrative of American history and culture, Davey meditates on the slippage of a great leader into the realm of detritus, just as she reflects on the interchange between individuals and the larger economic and governmental forces beyond their control.[43]

Reminding us that photographs, like ruins, are physical objects in perpetual transition with a past and history, Rossiter turns to the medium of photography itself (pls. 69, 70). Exploring the ephemeral nature of photographic paper, she makes her cameraless pictures by pouring or pooling photographic chemicals onto the paper. Through her earlier work in a photograph conservation lab, Rossiter realized that while each brand and batch of paper had inherently different qualities of color and texture, the history of the object itself—its age, storage conditions, and the impact of contaminants such as light, humidity, and

pollutants—was also embedded in it and could be made visible through development. As she documents the flaws of ruined paper, she also carefully notes its brand and expiration and processing dates, making us aware of the gap present in analog photographs between the manufacturing of the paper, its use, and our viewing. Like Worms, her work addresses both nostalgia and death ("This is photography as I learned it," she has stated, "but it is long gone"), but it also speaks to rejuvenation and rebirth, as she makes visible the latent life of these dead photographic papers.[44]

Like Rossiter and Worms, Marclay's *Allover (A Gospel Reunion)* resurrects the ruins of the past, repurposing them to make art for the present (pl. 76). Merging two outmoded technologies—the cyanotype print and audiocassettes—Marclay spread unspooled tapes onto photographic paper, creating a dazzlingly labyrinthine web of lines which he then exposed to light. Ruins and obsolescence, time and history are integral parts of this photograph: time is vividly and literally expressed through the tape itself, for the elapsed time of the song "A Gospel Reunion" is revealed through the physical length of tape itself. But the art of the past is also evoked, from the cameraless photograms of László Moholy-Nagy and the paintings of Jackson Pollock—especially his idea of the "allover" composition, his use of quotidian materials (paint sticks or basting syringes, for example), and his celebration of the automatic and intuitive[45]—to the American gospel tradition, with its joyful, looping rhythms and intense, passionate vocals that echo and augment one another. Yet, although *Allover (A Gospel Reunion)* alludes to cultural loss and technological obsolescence, it is hardly a lament to the past. Noting that "artists have always been attracted to detritus because by the time something reaches the dustbin, we have had enough interaction with it to finally reflect on it," Marclay unsentimentally argues that "the consumerism of one decade becomes the cheap alternative to the next decade's poor art students."[46]

Many scholars and artists say that photography is once again in the midst of a profound change, that with the advent of Google Glass, the ubiquity of smartphones and other devices equipped with cameras, and the popularity of Instagram, Snapchat, and other online mobile photo-sharing services, it is morphing from a process used to record and store memories and moments from the past into a direct form of communication.[47] It is true, when we see and experience something now, we immediately photograph it and send the picture to someone else. And when asked a question—"Where are you?" "What are you doing?"—we respond millions of times a day to people around the world, unimpeded by differences of time zone and language, not with words but a photograph to say: "I am here," "I am with this person," "I am eating, looking at, doing this." Yet, driven by economic forces and intimately responsive to the needs of society at large, photography has been changing throughout its entire history. A palimpsest of itself, it has always retained elements of its past while moving into its future. As *The Memory of Time* demonstrates, as photography settles into the twenty-first century and becomes the "new reality" that Barthes spoke about—"neither image, nor reality, a new being, really: a reality one can no longer touch"—and as it falls between the idea and reality of T. S. Eliot, it remains a rich and vital practice.[48]

1. Photography's gestation was lengthy, and its primary inventors—William Henry Fox Talbot, Louis Nicéphore Niépce, and Louis-Jacques-Mandé Daguerre—made key discoveries throughout the 1820s and 1830s. However, Talbot and Daguerre did not announce their processes until 1839.

2. The two major surveys of the history of photography were *The Art of Photography: 1839–1989*, organized by the Museum of Fine Arts, Houston, and the Royal Academy of Art, and shown at both those museums and at the Australian National Gallery, and *On the Art of Fixing a Shadow: One Hundred and Fifty Years of Photography*, organized by the National Gallery of Art and the Art Institute of Chicago, and shown there and at the Los Angeles County Museum of Art; both were accompanied by major publications. More focused exhibitions, also accompanied by publications, include *The Photography of Invention: American Pictures of the 1980s*, shown at the National Museum of American Art, and the book *Decade by Decade: Twentieth-Century American Photography from the Collection of the Center for Creative Photography* by James Enyeart. Other anniversaries were also celebrated that year: *Odyssey: The Art of Photography at National Geographic,* a publication and exhibition seen at the Corcoran Gallery of Art observing one hundred years of the *National Geographic* magazine, and *In Our Time: The World as Seen by Magnum Photographers,* a publication and exhibition at the International Center for Photography and the George Eastman House honoring more than forty years of Magnum photojournalism.

3. See Geoffrey Batchen, *Burning with Desire: The Conception of Photography* (Cambridge, MA, 1997), 66. Talbot's first published account of his process is *Some Account of the Art of Photogenic Drawing, or The Process by Which Natural Objects May Be Made to Delineate Themselves*; reprinted in Gail Buckland, *Fox Talbot and the Invention of Photography* (Boston, 1980), 42. Batchen in *Burning with Desire*, 68, points out that Talbot's title makes it clear that he saw his process both as a "mode of drawing and a system of representation in which no drawing takes place."

4. As Mia Fineman demonstrated in her exhibition and catalog *Faking It: Manipulated Photography before Photoshop* (The Metropolitan Museum of Art, New York, 2012), photography's claim to truth has been troubling from its birth. Inspired by a desire to correct perceived defects in the medium, enhance the pictorial qualities of their images, alter the truth, or rewrite history, photographers manipulated their pictures throughout the nineteenth and twentieth centuries.

5. László Moholy-Nagy, *Painting Photography, Film*, 1925; translated by Janet Seligman, reprinted (Cambridge, MA, 1973), 3, 7.

6. Edward Weston, *The Daybooks of Edward Weston, Volume 1, Mexico*, ed. Nancy Newhall (Rochester, NY, 1961), 55; Edward Weston, "Portrait Photography," 1942, reprinted in *Edward Weston on Photography*, ed. Peter Bunnell (Salt Lake City, 1983), 135.

7. Batchen begins his chapter "Epitaph" in *Burning with Desire*, 206, by quoting from Timothy Druckrey's catalog essay, "L'Amour Faux," in San Francisco Camerawork's 1988 exhibition *Digital Photography: Captured Images, Volatile Memory, New Montage*, in which he wrote that with the rise of digital photography "the very foundation and status of the [photographic] document is challenged….Whatever tenuous continuity ever existed between photography or digitized imagery and its message could be shattered, leaving the entire problematic concept of representation pulverized." See also Anne-Marie Willis, "Digitisation and the Living Death of Photography," in Philip Hayward, ed., *Culture, Technology & Creativity in the Late Twentieth Century* (London, 1990), 197–208. Others asserted that the rise of digital technology inaugurated the era of "post-photography"; see William J. Mitchell, *The Reconfigured Eye: Visual Truth in the Post-Photographic Era* (Cambridge, MA, 1994). The debate still continues: see Peter Plagens, "Is Photography Dead," *Newsweek*, December 1, 2007; for a summary of a conference at the San Francisco Museum of Modern Art on the subject "Is Photography Over?" see http://www.sfmoma.org/about/research_projects/research_projects_photography_over.

8. William Henry Fox Talbot, "Some Account of the Art of Photogenic Drawing," *London and Edinburgh Philosophical Magazine and Journal of Science* 14 (March 1839); reprinted in Vicki Goldberg, ed., *Photography in Print* (Albuquerque, 1981), 41.

9. *The Athenaeum* (February 2, 1839), as quoted in Buckland, 1980, 44.

10. *The Athenaeum* (February 22, 1845), as quoted in Buckland, 1980, 88.

11. Sir Frederick Pollock, 1855 address to the Photographic Society of London, as quoted by Mark Haworth-Booth, *Golden Age of British Photography* (Millerton, NY, 1984), 9.

12. Roland Barthes, *Camera Lucida: Reflections on Photography*, trans. Richard Howard (New York, 1981), 96.

13. Edward Said, as quoted by William Olander, "Fragments," in *The Art of Memory: The Loss of History* (The New Museum of Contemporary Art, 1985), 7.

14. In *Camera Lucida*, Barthes wrote: "in Photography I can never deny that *the thing has been there*. There is a superimposition here: of reality and of the past. And since this constraint exists only for Photography, we must consider it, by reduction, as the very essence, the *noeme* of Photography," 76–77. For an examination of the ways in which contemporary photography, video, and performance art are "haunted" by the past, see Jennifer Blessing and Nat Trotman, eds., *Haunted: Contemporary Photography/Video/Performance* (Guggenheim Museum, 2010).

15. For further discussion, see Lyle Rexer, *Photography's Antiquarian Avant-Garde: The New Wave in Old Processes* (New York, 2002).

16. See Lisa Saltzman, "Negative Images," in *Making Memory Matter* (Chicago, 2006), 193, for her assessment of the artist Betye Saar's critique of Walker's reiteration and perpetuation of stereotypes.

17. David Maisel, "Trace Elements and Core Samples," in *History's Shadow* (Portland, 2011), n.p.

18. Carrie Mae Weems as quoted by C. Carr, "More Than Meets the Eye: The Quiet Revolution of Carrie Mae Weems," *The Village Voice*, March 4, 2003, http://www.villagevoice.com/2003-03-04/art/more-than-meets-the-eye/full/. See also Kirsten Olds, "Recent Museum of Art Acquisition: Historically Resonant Portrait by Photographer Carrie Mae Weems," *Bulletin: The University of Michigan Museums of Art and Archaeology* 16 (2005), http://hdl.handle.net/2027/spo.0054307.0016.110.

19. The title, "Time Exposed," comes from Sugimoto; see Thomas Kellein, *Hiroshi Sugimoto: Time Exposed* (New York, 1995), 13.

20. Barthes, *Camera Lucida*, 15.

21. See Katherine Ware, "Heliomancy," in *Chris McCaw: Sunburn* (Richmond, 2012), 10; Chris McCaw, "Sunburn," http://www.chrismccaw.com/SUNBURN/SUNBURN.html.

22. Dr. Hans Belting, "The Theater of Illusion," *Hiroshi Sugimoto: Theaters* (New York, 2000), 8.

23. Charles Merewether, "Introduction: Art and the Archive," *Archive: Documents of Contemporary Art* (London and Cambridge, MA, 2006), 10.

24. Hal Foster, "An Archival Impulse," *October* 110 (Autumn 2004), 3.

25. Walter Benjamin, *The Arcades Project*, trans. Howard Eiland and Kevin McLaughlin, prepared on the basis of the German volume edited by Rolf Tiedemann (Cambridge, MA, and London, 1999), xiii and [N2, 3], 460.

26. Foster, "An Archival Impulse," 3–22; Benjamin H. D. Buchloh, "Gerhard Richter's *Atlas*: The Anomic Archive," *October* 88 (Spring 1999), 117–145; Michel Foucault, "The Historical a priori & the Archive," *The Archaeology of Knowledge*, trans. A.M. Sheridan Smith (London and New York, 2002).

27. See Okwui Enwezor, *Archive Fever: Uses of the Document in Contemporary Art* (International Center of Photography, 2008). See also Jae Emerling, *Photography: History and Theory* (London and New York, 2012), 121.

28. Foster, "An Archival Impulse," 4.

29. Mark Ruwedel, "Westward the Course of Empire," in *Westward the Course of Empire*, with an essay by Jock Reynolds (New Haven, 2008), n.p.

30. Jock Reynolds, "Time Will Tell," in *Westward the Course of Empire*, n.p., and Ruwedel, "Westward the Course of Empire," in *Westward the Course of Empire*, n.p.

31. Mikhael Subotzky Archive, "Ponte City, Windows, Televisions, Doors—Three Lightboxes," http://www.subotzkystudio.com/ponte-city-text-2/.

32. Mikhael Subotzky Archive, "Ponte City, Windows, Televisions, Doors—Three Lightboxes."

33. Some Farm Security Administration photographers did work in color. See Paul Hendrickson, *Bound for Glory: American in Color 1939–43* (New York, 2013).

34. Philip Levine, "Nobody's Detroit," in *Detroit Disassembled* (Akron Art Museum, 2010), 114.

35. Andrew Moore, "The Phoenix and the Pheasants," in *Detroit Disassembled*, 119; Idris Khan, as quoted by Kerri MacDonald, "Postcard from a New London," *Lens* (blog), *New York Times*, March 1, 2012, http://lens.blogs.nytimes.com/2012/03/01/postcard-from-london. See Khan, as quoted by Alfie Rosenmeyer, *Art World Magazine* (October/November 2007), 80.

36. Khan, as quoted in "Pretty as a Thousand Postcards," *New York Times Magazine*, March 1, 2012, http://www.nytimes.com/interactive/2012/03/01/magazine-idris-khan-london.html.

37. Khan, as quoted in "Pretty as a Thousand Postcards."

38. Khan, as quoted by MacDonald, "Postcard from a New London."

39. In her book *Pleasure of Ruins*, Rose Macaulay reflected on both the pleasurable and melancholic emotions that viewers have derived from looking at ruins, and questioned "what part is played by a morbid pleasure in decay, by righteous pleasure in retribution…by mystical pleasure in the destruction of all things mortal and the eternity of God…by egotistical satisfaction in surviving…[and] by masochistic joy in a common destruction" (New York, 1966), xv–xvi.

40. Often criticized for aestheticizing poverty, these photographers are also chastised for not addressing how urban blight affects people or commenting on the social and political forces that caused it. See John Patrick Leary, "Detroitism," *Guernica: A Magazine of Art and Politics*, January 15, 2011, https://www.guernicamag.com/features/leary_1_15_11/.

41. "National Gallery of Canada Artist Interview: Mark Ruwedel," YouTube video, 5:43, posted by "ngcmedia," January 3, 2013, https://www.youtube.com/watch?v=0bUHxGypnDg.

42. Jess T. Dugan, "A Conversation with Moyra Davey," *Big Red & Shiny* (1:79), http://www.bigredandshiny.com/cgi-bin/BRS.cgi?section=article&issue=79&article=INTERVIEW_WITH_MOYRA_2552759.

43. See Matthew Witkovsky, "Another History," *Artforum* 48, no. 7 (March 2010), 220.

44. As quoted by Robert Enright, "Paper Wait: The Darkroom Alchemy of Alison Rossiter," *Border Crossings* 30, no. 119 (September 2011), 74.

45. Noam M. Elcott, "Untimely Detritus: Christian Marclay's Cyanotypes," in Christian Marclay et al., *Cyanotypes: Christian Marclay* (Tampa, 2011), vii–x.

46. Christian Marclay, as quoted by Guy Tillim in Lyle Rexer's "Blue Tape: Christian Marclay's Old Masters," *DAMn*, no. 33 (May/June 2012), 104.

47. See, for example, Nick Bilton, "Disruptions: Social Media Images Form a New Language Online," *Bits* (blog), *New York Times*, June 30, 2013, http://bits.blogs.nytimes.com/2013/06/30/disruptions-social-media-images-form-a-new-language-online/?_r=0.

48. Barthes, *Camera Lucida*, 87; T. S. Eliot, "The Hollow Men," 1925, http://www.shmoop.com/hollow-men/poem-text.html.

PLATES

CHUCK CLOSE (American, born 1940)
1 *Kara*, 2007, daguerreotype

BLACKNESS BECAME A VERY
LOADED SUBJECT, A VERY
LOADED THING TO BE — ALL
ABOUT FORBIDDEN PASSIONS
AND DESIRES, AND ALL ABOUT
A HISTORY THAT'S STILL
LIVING, VERY PRESENT...

KARA WALKER[1]

An artist of immense invention and versatility, Chuck Close has a long and rich history with the medium of photography. He first began to use found photographs in 1965, only two years after he received his MFA from Yale University. Entranced with photography's capacity to relay incredible amounts of visual information, he quickly started to make his own photographs, employing them as models on which he based his photorealist portraits and nudes. In 1979 he began to explore the possibilities offered by the large-format 20 × 24 inch Polaroid camera and made a series of composite portraits consisting of many separate Polaroids, including his noteworthy *Self-Portrait/ Composite/Nine Parts*. These were not intended as studies for subsequent paintings but as works of art in their own right. "It was the first time," Close said, "that I considered myself a photographer."[2]

Close has been making daguerreotypes since 1997. Like so many others, he has been fascinated with their luminosity and intimacy, and with the magical way in which an image appears and disappears on the highly polished, mirrorlike surface. Looking at a daguerreotype requires viewers' active participation: they must move around to find the cor-

rect angle that makes the image observable, while negotiating between seeing the artwork and seeing themselves reflected in the photograph's surface. Although the practice of making daguerreotypes is intensely laborious and involves toxic chemicals, Close wanted to investigate it. After many failed attempts, he began working with a skilled daguerreotypist, Jerry Spagnoli, in 1999. The two radically reduced the long exposure times associated with daguerreotypes by using strobe lights; they also developed a system that, similar to the Polaroid process, allows them to see results in a matter of minutes.[3] This enables both Close and his subjects—usually family and friends—to engage in a dialogue about the work, one that often results in making adjustments to the final piece. Unlike their charming yet formal nineteenth-century precedents, Close's daguerreotypes are not mere novelties or historical artifacts, and according to the artist, they should not be interpreted as antiquarian revivals.[4] Instead, they are works involved in a critical discussion about the nature of photographic portraiture. Close does not make commissioned portraits, nor does he conform to the convention of the flattering portrait. Rather, he is almost obsessed with exploring the process of art-making, of trying "to collapse the idea of form and content into one perception."[5]

Kara stands apart from Close's other daguerreotype portraits. While he was immediately attracted to the high level of detail and precision achieved by the process, in his portrait of the artist Kara Walker (born 1969) he relied on bold minimal forms instead. Walker is backlit, allowing her profile and darkened hair to

stand out in sharp contrast to the glowing, iridescent background. Close eloquently evokes—and pays tribute to—Walker's own powerful cut-paper silhouettes, which have played a fundamental role in her art since 1993. For Walker, who like Close was first trained as a painter, the kitschy, middle-class art form of the silhouette provided an alternative medium to painting, with its upper-class connotations. The silhouette's simplified form first appeared cartoonish to Walker and recalled racial stereotypes, which are reductions of human beings to characterizations.[6] Yet this, coupled with their association with the eighteenth-century phenomenon of physiognomy (a pseudoscience that claimed a person's intelligence was inscribed on his facial features), made silhouettes an effective tool for Walker in her explorations of race and power relations. An extraordinary portrait, *Kara* demonstrates how both artists, Close and Walker, have reinvigorated older artistic processes as a means to provoke established histories. AN

1. Kara Walker, quoted in "Conversations with Contemporary Artists," Museum of Modern Art, New York, 1999, http://www.moma.org/interactives/projects/1999/conversations/kw_f.html.
2. "Chronology," in *Chuck Close: Daguerreotypes*, ed. Demetrio Paparoni (Milan, 2002), 208.
3. Typical exposure times are one and a half minutes, but it is almost impossible for a sitter to stay still for that amount of time. Neck and body braces were traditionally used to help immobilize sitters, as any small amount of movement could produce a blurred photograph.
4. "Interview," in *Chuck Close: Daguerreotypes*, 55.
5. Philip Glass, "I'm Just a Haystack," in *Chuck Close: Daguerreotypes*, 6.
6. Tommy Lott, "Kara Walker Speaks: A Public Conversation on Racism, Art, and Politics with Tommy Lott," *Black Renaissance* 3, no. 1 (Fall 2000): 69–91.

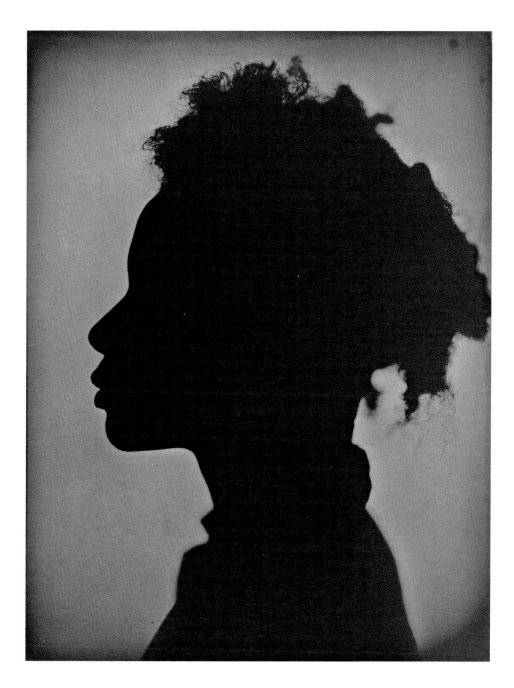

CARRIE MAE WEEMS (American, born 1953)

2 *After Manet,* 2002, chromogenic print | **3** *May Flowers,* 2002, chromogenic print

Drawing inspiration from her 1998 installation *Ritual and Revolution*, Carrie Mae Weems began a new project in 2002, which she titled *May Days Long Forgotten*. Where her previous installation boldly confronted the global history of humanity's perilous struggle for equality and justice, this new series embodied a slightly more encouraging tone, weaving together the promise of spring's renewal with the May Day celebrations of International Workers' Day—a time of labor protests and rallies that began in the late nineteenth century. By evoking revolutions of days past, Weems moves viewers not only to remember those efforts, but also to believe in their unending potential for future social change. The series includes a video and photographs, both color and black and white, of young African American girls wearing floral-print dresses and flowers in their hair. Whether reclining in a pastoral setting or dancing jubilantly around a maypole, the girls are striking, powerful subjects whom Weems employs in order to engage in a dialogue with history.

In the compelling prints *After Manet* (pl. 2) and *May Flowers* (pl. 3), Weems focuses specifically on the history of art. The tondo, or circular frame format, along with the truncated foreground space and tight focus on a figural group, harkens back to Renaissance paintings of the Madonna and child. The sepia tone of the prints and their subject matter recall both nineteenth-century paintings and photographs, such as those by the Pre-Raphaelites and Julia Margaret Cameron. Weems also subtly references Soviet propaganda, which featured children as symbols of a promising future, by

photographing young girls from working-class families she met near her home in Syracuse, New York.[1] Weems further intensifies these historical associations by glazing both of these works with convex glass, mimicking eighteenth-century mirrors as if to suggest that the photographs represent reflections of the world at large. Yet the color of the children's skin belies such a history. By focusing on African American girls, who were excluded as subjects of such formal works of art, Weems alludes to artistic precedents in order to question historical conventions. She explains, "I'm very aware of linking my figures to a historical narrative or tradition and reexamining that tradition by putting in someone who was never there."[2]

In *After Manet*, Weems makes direct reference not only to a celebrated artist but also to an important turning point in the history of European modern art. The French painter Édouard Manet shocked Salon-goers with his *Déjeuner sur l'herbe* (1863) by including a nude woman lunching amid a group of fully clothed men in contemporary dress. While Manet's composition pays tribute to the Renaissance painters Titian and Raphael, the work was received as a blatant challenge to the tradition of the pastoral landscape.[3] Manet's style and treatment of the canvas were just as controversial; his flattening of space, rough brushstrokes, and stark contrasts between light and dark areas gave testimony to his refusal to conform to convention.

Like Manet, Weems pays homage to art history's past, yet she also reinvents an outmoded artistic form: the allegorical portrait. In both photographs, the subjects

are arranged in various poses and possess arresting looks of self-assurance. The reclining girl in the forefront of *After Manet* purposely brings to mind the defiant posture and attitude of another of Manet's well-known subjects, Olympia. In his famous painting from 1863, Olympia's nude body is offered up to prospective admirers in the guise of the nineteenth-century odalisque; however, she brazenly returns the viewer's gaze, confronting the practice of voyeurism in the painting of female nudes.

In both of Weems' photographs, the act of looking back gives these young girls a sense of agency, and they are able to stake their claim as rightful subjects. For more than thirty years Weems has interrogated racial and gender stereotypes to explore issues that are significant for all people, such as political and social class struggles and unequal power relations. She creates art that ceaselessly scrutinizes the past in order to understand the constraints of the present. AN

1. Kathryn E. Delmez, ed., *Carrie Mae Weems: Three Decades of Photography and Video* (Frist Center for the Visual Arts, 2012), 196. Weems recalls that she had been looking for a young girl who reminded her of herself. See C. Carr, "More Than Meets the Eye: The Quiet Revolution of Carrie Mae Weems," *The Village Voice*, March 4, 2003, http://www.villagevoice.com/ 2003-03-04/art/more-than-meets-the-eye/2/.
2. Carr, "More Than Meets the Eye," http://www.villagevoice.com/2003-03-04/art/more-than-meets-the-eye/2/.
3. Manet was borrowing from the *Concert champêtre*, a painting by Titian that was attributed to Giorgione at the time, as well as Marcantonio Raimondi's engraving after Raphael's *Judgment of Paris*.
4. Carrie Mae Weems, *Ritual and Revolution* (Künstlerhaus Bethanien, Berlin, 1998), n.p.

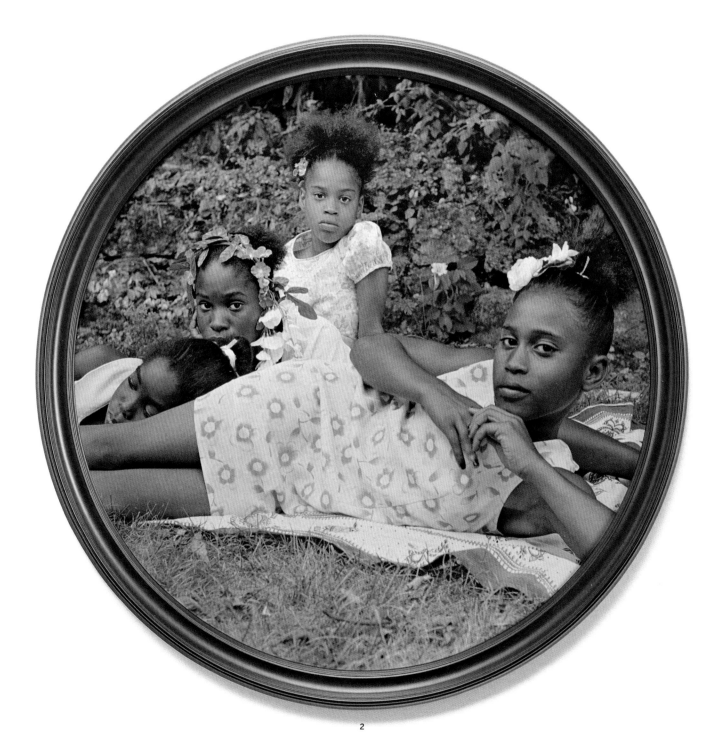

...I COULD SEE AGAIN
THE COMING OF SPRING'S HOPE
IN THE MAY FLOWERS
OF MAY DAYS
LONG FORGOTTEN.

CARRIE MAE WEEMS[4]

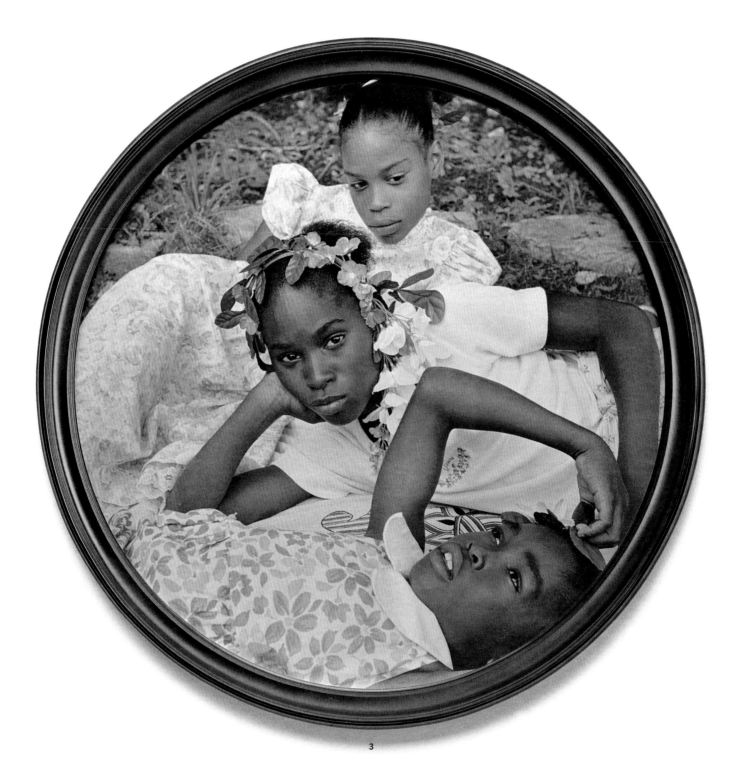

SALLY MANN (American, born 1951)
4 *Untitled (Self-Portraits), 2006–2012, nine ambrotypes*

For more than forty years, Sally Mann has made photographs that explore physical and psychic transformations wrought by nature, history, and time. Frequently using older photographic processes to elicit a wide range of striking visual effects, Mann's photographs press their insistent materiality into the service of metaphor, invoking themes such as the passage of time, the slipperiness of memory, and the dissolution of matter.

Mann's first book to garner significant attention, *Immediate Family* (1992), depicted her three children engaged in the typical pursuits of childhood and early adolescence at the family's summer camp in Lexington, Virginia. Sensually beautiful, yet infused with treacherous intimations of violence, sexuality, and distress, *Immediate Family* refuted the treacly stereotypes of childhood, offering instead an unsettling vision of its fragility and of the complexity of parental love. By the early 1990s, Mann turned her attention to photographing landscapes in the southern part of the United States as sites where personal, cultural, and national memory intersect. From the sultry, overgrown riverbanks of the Mississippi Delta to haunting, elliptical views of once-bloody Civil War battlefields, Mann's landscapes appear majestic, forlorn, and strangely static, as if time itself unspooled more slowly under her patient scrutiny.

The impression of time accreting in her photographs is due in no small part to Mann's deft manipulation of older photographic processes and equipment. While she has long used a traditional 8 × 10 inch view camera (and more recently has employed an even larger, more cumbersome one that can hold 13½ × 15 inch glass plates), she began making collodion negatives in the mid-1990s. This process, which was introduced in 1851 and widely used through the 1880s, entails pouring a viscous solution of collodion (gun cotton dissolved in ether and alcohol) on a sheet of glass, dipping the coated glass plate into a silver nitrate bath and then exposing it in the camera within several minutes. Enamored of the collodion negative's very fine grain and high level of detail, most nineteenth-century practitioners worked hard to control the vagaries of the process. By contrast, Mann deliberately cultivates its imperfections, allowing the chance formation of bubbles, streaks, swirls, light flares, pits, and gashes to serve as metaphors for evanescence, transformation, and decay. While she typically makes collodion negatives on clear glass and uses these to produce positive gelatin silver prints, she sometimes makes the negative on black glass, which results in a tonal reversal that causes the negative to appear as a positive image. This resulting photograph, a unique object, is called an ambrotype.

Throughout her career Mann has trained her camera on her family, but she did not photograph herself in any consistent way until 2006, when she suffered a grave horseback-riding accident. Determined to work but unable to move her heavy camera, she set it up in one position and repeatedly photographed her face, neck, and other parts of her body, using the ambrotype process. In the resulting series of self-portraits, Mann appears to confront her own physical and spiritual dissolution. In some of the plates, which range from a pink-tinged bronze to a murky black, her face is rendered as a ghostly, nearly abstract visage. In others, the light reflecting from her eyes alludes to an intensity of vision, even as the body fades away. The blurring and distortion of her features caused by her decision to photograph herself at close range, as well as by her choice of an antique, imperfect lens, conjure an otherworldly effect, as if we are witnessing the departure of the soul from the body. The physical surface of the plates themselves also conveys the experience of disintegration and loss, as the delicate layer of emulsion has flaked off in some places or been deliberately scratched away in others, leaving black scars and voids that function as analogues for the body's corrosion and death.

A haunting vision of an artist confronting her own aging, this masterful work recalls conventions of nineteenth-century spirit photography—but it must also be understood as Mann's contribution to a broader artistic tradition of carefully staged self-portraiture. Arranged in a grid that defies a single reading, *Untitled (Self-Portraits)* is ultimately less revelatory than chimerical, with each unique plate suggesting a fugitive emotion or state of embodiment, from meditative to almost demonic. Although the artist's physical presence is conjured by the work's ostentatious materiality—the drips, flakes, and pitted surfaces read like skin—Mann herself appears spectral, hovering in and out of focus, floating between matter and spirit as elusive as memory itself. SK

1. Quoted in the foreword to Camilla Brown, *Sally Mann: Family and the Land* (Photographers' Gallery, 2010), n.p.

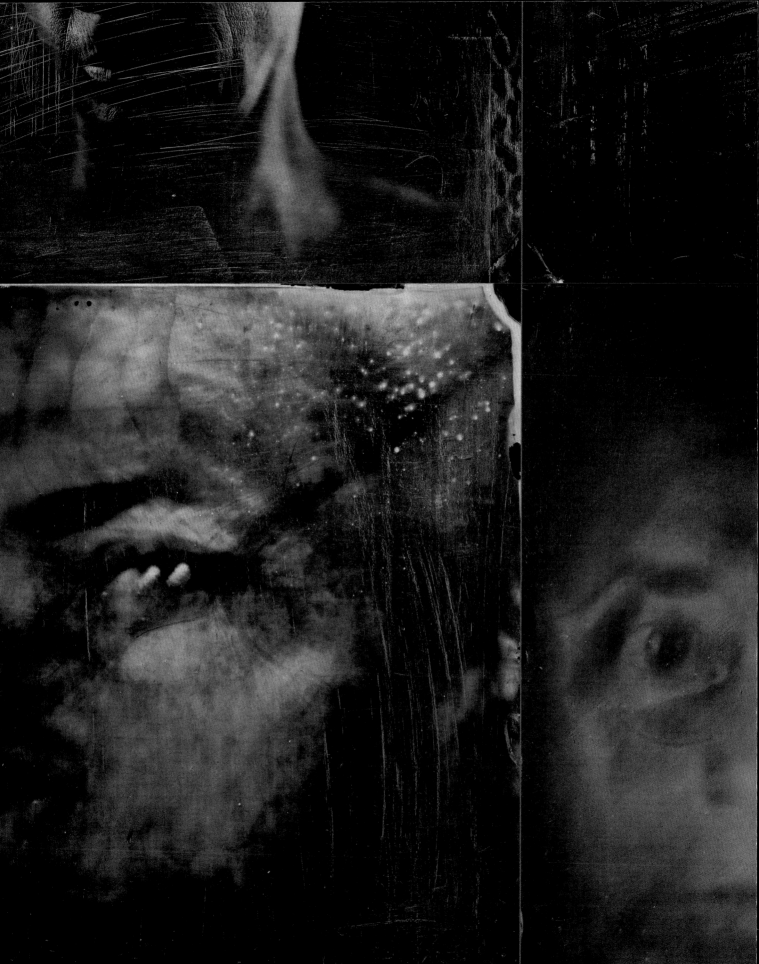

TIME, MEMORY, LOSS AND LOVE
ARE MY ARTISTIC CONCERNS,
BUT TIME, AMONG ALL OF THEM,
BECOMES THE DETERMINANT.

SALLY MANN[1]

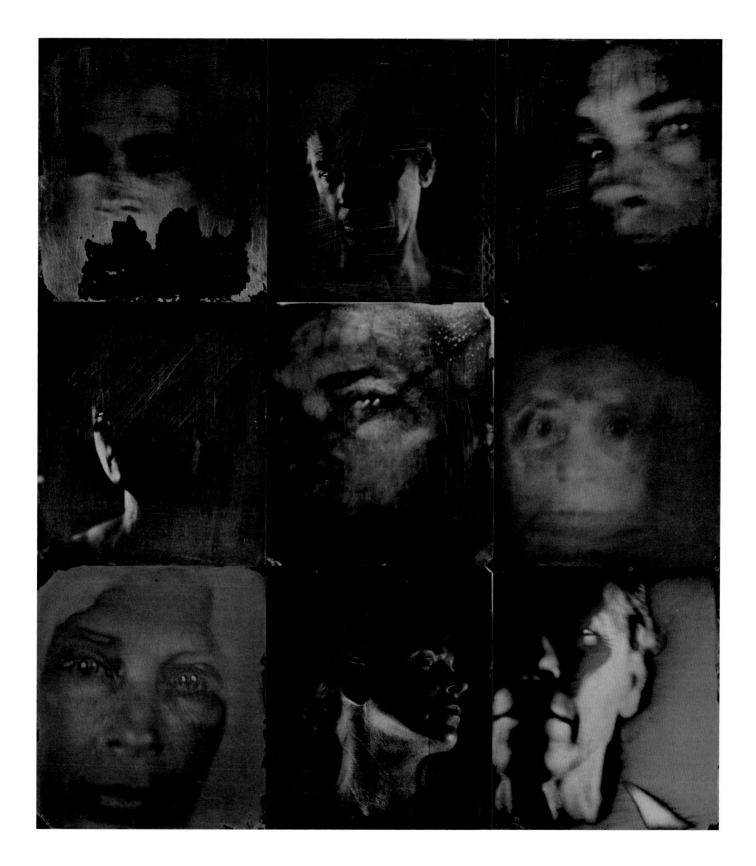

MYRA GREENE (American, born 1975)
5–11 *Character Recognition*, 2006–2007, seven ambrotypes

The convergence of two pivotal events led photographer Myra Greene to create her *Character Recognition* series in 2006. After making glass-plate self-portraits during a workshop on early photographic techniques, Greene surprised herself and her colleagues when she exclaimed that she thought she looked like a slave in her photographs.[1] This, coupled with her response to disturbing mass-media images of New Orleans' black residents after Hurricane Katrina, left Greene asking: "Does my character resonate louder than my skin tone, or am I nothing but black?"[2] Acutely aware of her own racial identity and how it is viewed in different environments, Greene decided to confront the history of photography, examining its role in teaching people how to see African Americans not as individuals but as racial types.

Greene's striking ambrotypes, each measuring roughly 3 × 4 inches, powerfully evoke the historical resonances surrounding early photographic technologies, particularly those implicated in the history of colonialism and slavery. From its inception, photography has been used both to proclaim individual identity and to discern social types. As a tool for ethnographic classification, photography helped create a typological record of racial physiognomy, which in turn was used to support the concept of phrenology, the belief that physical features signaled specific character traits such as intellect or morality. These pseudoscientific theories were used by governments and institutions to define racial types during the nineteenth and early twentieth centuries, often labeling African Americans as inferior and deviant.

Greene exaggerates this past practice of racial classification by creating tightly framed views of her own mouth, nose, ears, and eyes. Providing only fragmentary images of her face, she challenges the descriptive mode of documentary photography by denying the viewer's desire to fully observe the sitter's appearance. Greene is also able to control the way in which her body is photographed, capturing expressive gestures that assert her individual identity. In *Untitled [Ref. #75]* (pl. 11), her lips part as if she is about to speak, while in *Untitled [Ref. #72]* (pl. 8), she angrily bares her teeth. A more conventional profile view, a standard in anthropological documentation, can be seen in *Untitled [Ref. #56]* (pl. 7), yet it only clearly shows her nose and mouth. Pushing these boundaries even further, Greene creates such an extreme close-up in *Untitled [Ref. #60]* (pl. 6) that her face is almost completely abstracted. Traditional ambrotypes are one-of-a-kind direct positives made on transparent glass that must be viewed against a dark background material, but Greene develops her works directly onto black glass—a support that allows for the easier production of a positive image, but which also carries a metaphorical significance. Greene complicates this concept of blackness by manipulating the appearance of her skin tone through varying her exposure times and experimenting with the chemistry used to develop each plate.

Despite their fragility and diminutive size, these beautiful objects powerfully confront issues of racial inscription. *Character Recognition* questions the lasting effects of racism on contemporary society, examining the ways in which photography was utilized to classify race and codify the body. By drawing attention to this history, Greene also contests it, using photography to offer a new way of looking at race and allowing the body to "speak back."[3] AN

1. Shawn Michelle Smith, *Taking Another Look at Race: Myra Greene and Carla Williams* (Rochester, 2009), 5. Joseph Zealy's daguerreotypes of slaves made for Louis Agassiz helped to codify this representation of African Americans in photography.
2. Myra Greene, *Character Recognition*, self-published, 3. Also see David Gonzalez, "Some of Her Best Friends Are White," *Lens* (blog), *New York Times*, May 22, 2012, http://lens.blogs.nytimes.com/2012/05/22/some-of-her-best-friends-are-white.
3. Smith, 7. Greene also writes about the ambrotype process in *Character Recognition*: "While the process of wet plate codes the body in this work, the body is able to speak back," 3.
4. W. E. B. Du Bois, "Of Our Spiritual Strivings," in *The Souls of Black Folk* (Chicago, 1903), 9. In this work, Du Bois introduces two concepts that describe the quintessential black experience in America—the concepts of "the veil" and "double-consciousness."

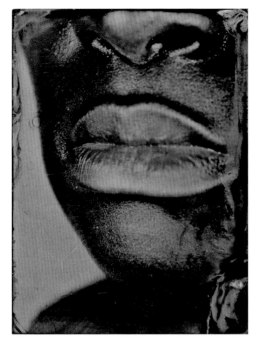

5

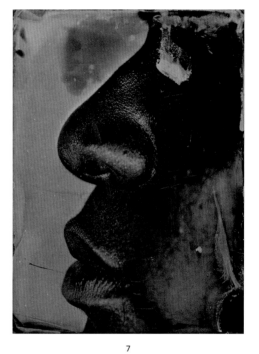

7

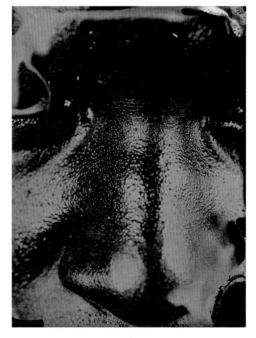

6

IT IS A PECULIAR SENSATION,
THIS DOUBLE-CONSCIOUSNESS,
THIS SENSE OF ALWAYS LOOKING AT ONE'S SELF
THROUGH THE EYES OF OTHERS,
OF MEASURING ONE'S SOUL BY
THE TAPE OF A WORLD THAT LOOKS ON
IN AMUSED CONTEMPT AND PITY.

W.E.B. DU BOIS[4]

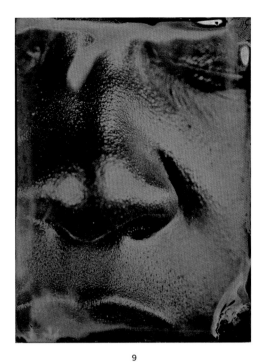

9

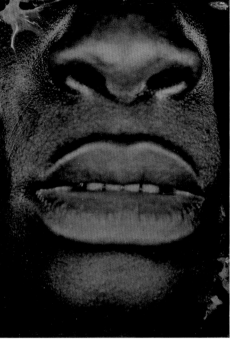

11

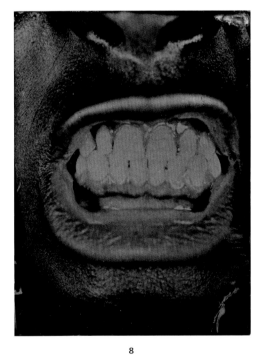

8

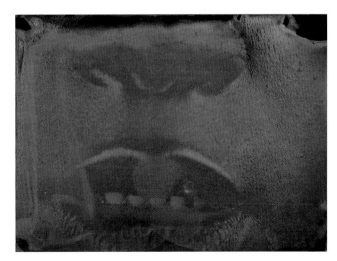

10

DAVID MAISEL (American, born 1961)
12 *History's Shadow GM16,* 2010, inkjet print | **13** *History's Shadow GM12,* 2010, inkjet print

For almost thirty years, David Maisel has been investigating the dual processes of memory and excavation by photographing landscapes transformed by environmental neglect. However, for his series *History's Shadow* he turned to a different subject: sculptures in museum collections, including that of the J. Paul Getty Museum in Los Angeles. Seeking to examine the vestiges of cultural history, Maisel does not depict the objects as they are displayed in the galleries; rather, he photographs x-rays of them housed in the archives of the conservation department. In his prints, the works of art appear as ghostly traces, revealing their inner workings and past treatment while simultaneously looking uncannily alive.

Maisel developed his project while a resident at the Getty Research Institute in 2007. He was intrigued by how images were used in art preservation and conservation and began to review the museum's x-rays of its permanent collection, finding some that "seemed to surpass the potency of the original objects of art."[1] Maisel equates his process to an archeological excavation, where the archives serve as his research site.[2] Combining the technology of the x-ray, discovered in 1895, with digital processes, he placed each piece of x-ray film on a light box, and using a long

exposure photographed it with color film. Maisel then scanned this new image to create a digital file, which he adjusted to bring out the latent colors in the film, emphasizing what he refers to as the x-rays' "spectral renderings" or "transmissions from the distant past, conveying messages across time."[3] His color choices also reference nineteenth-century photographic processes, such as cyanotypes and albumen prints.[4] In his final works, the sculptures emerge from an inky, dark background and have a more human cast: the male in *History's Shadow GM16* (pl. 12) gazes contemplatively at the viewer, his lips apparently pursed, while the female in *History's Shadow GM12* (pl. 13) seems to turn away demurely, both of her ears and an eyelid visible in the ghostlike form.

Maisel's intention was not to conduct a scientific investigation of each sculpture, yet his works reveal the intertwined histories of art and science. His fascination with x-rays opens to a wider audience what conservators and restorers have been able to see for decades: not only the sculptures' original construction but also their history as objects, how they have aged, suffered damage, and received consequent restoration. His photographs simultaneously capture both the internal structure and the

external details of the original sculptures, resulting in evocative images that "encompass both an inner and an outer world."[5] For instance, in *History's Shadow GM12,* we see both the hollow center of the terracotta bust of Juliette Récamier (c. 1801–1802) by the French sculptor Joseph Chinard (1756–1813) (fig. 3, page 6), and the fine details of the curls of her hair on the sculpture's surface. Through his layering of interior and exterior, Maisel's manipulation renders the sculptures as traces of the past that quietly communicate with the present, engaging us in a dialogue about our relationship to the cultures and societies that produced these original objects. AN/LJU

1. David Maisel, "Trace Elements and Core Samples," in *History's Shadow* (Portland, 2011), n.p.
2. Maisel, "Trace Elements and Core Samples," n.p. In addition to the Getty, Maisel has also photographed x-rays at the Asian Art Museum of San Francisco.
3. Maisel, "Trace Elements and Core Samples," n.p.
4. David Maisel, "The Heart of the Art," *New York Times,* October 2, 2011, SR9.
5. *History's Shadow,* http://davidmaisel.com/portfolio-item/historys-shadow/#1.
6. Maisel, "Trace Elements and Core Samples," n.p.

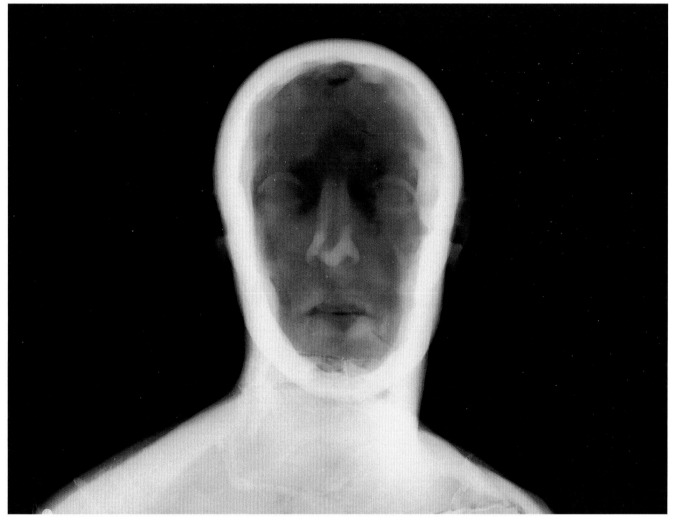

12

THEY MAKE THE INVISIBLE VISIBLE,
AND EXPRESS THROUGH PHOTOGRAPHIC MEANS
THE SHAPE-SHIFTING NATURE OF TIME ITSELF,
AND THE CONTINUOUS PRESENCE
OF THE PAST CONTAINED WITHIN US.

DAVID MAISEL[6]

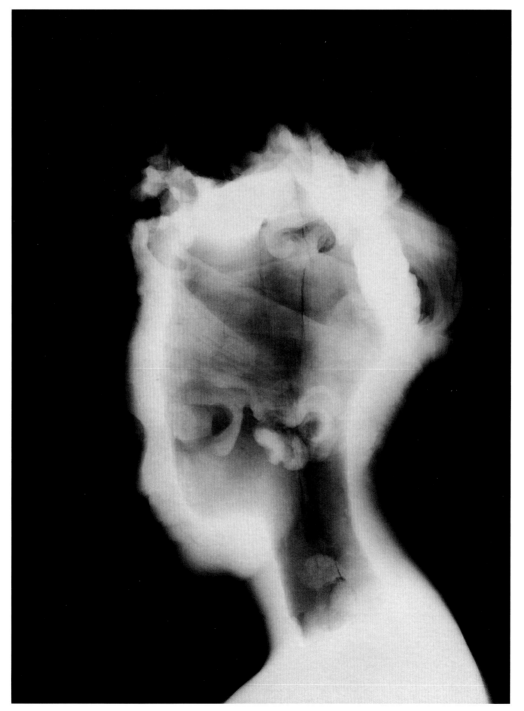

Throughout his career, Adam Fuss has explored essential mysteries of matter and emotion in his pristine, elegiac photographs. While his earliest work from the mid-1980s consisted of a group of darkly haunting pictures of sculpture taken with a pinhole camera, his subsequent projects have eschewed any kind of camera at all. Employing early photographic processes to make photograms—in which an object is placed directly on a light-sensitized surface—Fuss purposely divorces his practice from the strictures of traditional camera-based representation. His subjects are archetypal, ranging from babies placed on photo-sensitized paper, their shadowy shapes surrounded with dazzling color, to limpid flowers, water droplets, and snakes rippling through water. *For Allegra,* a continuation of the earlier *My Ghost* series (1995–2001), draws on the memento mori with crisply sensuous photograms of skulls, fragile butterflies, and christening gowns. These images play upon fundamental human feelings of love and loss, and underscore the role of objects in invoking memory and the passage of time. Fuss' pithy images conjure a separate world rich with the elemental resonances of growth and decay, birth and death, remembrance and mourning.

Fuss first began experimenting with the daguerreotype process in 1999 while working on *My Ghost,* later stating that "the marriage of photograph and mirror is a sort of reverberation I can't quite get my head around."[1] One of the first modes of photography, announced in 1839, daguerreotypes are made by sensitizing a highly polished silver-coated copper plate to light and then exposing it. Through his adept mastery, Fuss has produced some of the largest daguerreotypes ever made and created the first daguerreotype photograms, deftly controlling the medium's arresting visual effects to craft preternaturally radiant pictures.

Yet Fuss resists attention to the technical qualities of his work, seeing his art not as defined by a particular medium but rather, first and foremost, as emblematic imagery. In his photograms of swans, peacocks, and butterflies, the forms in the lustrous, mirrored surface of the daguerreotype plates appear to glow, wraithlike, from within, and float in a limitless expanse of incandescent blue. Though caused by overexposure—which in the nineteenth century would have been considered a defect—the color instead, to Fuss, expresses "a sadness, a sense of loss."[2] Piercing in their clarity, the objects are presented as icons, vibrating with raw, universal emotions.

The Taj Mahal daguerreotype is one of ten that Fuss has made using three 1864 waxed-paper negatives by John Murray, bringing together the daguerreotype with its nineteenth-century rival, the paper negative process, introduced simultaneously in 1839. In order to produce the final daguerreotype, Fuss scanned Murray's negatives and digitally manipulated them by filling in gaps to make a continuous view and then reversed the negative tones to yield a positive image. Uniquely within the *For Allegra* series, the photograph evokes a particular cultural past. The Taj Mahal was built by the seventeenth-century Mughal emperor Shah Jahan in Agra, India, as a memorial to his beloved wife, Mumtaz Mahal, after her death. For Fuss, the emotive impact of the famous architecture harnesses not only collective grief, but his own loss as well (a failed relationship has elliptically been identified as his impetus behind *For Allegra*).[3] By starting with Murray's nineteenth-century negatives of the building, Fuss channels the light of the past—an ephemeral passing of the light over the seventeenth-century monument recorded by Murray—and then reconfigures it into his own blue, melancholic picture in the present. The haunting interplay of ghostly light and deep shadow across the building invokes at once both specificity and timelessness, continuing Fuss' fertile, decades-long exploration of vital themes. His photograph is alchemical, layering light upon light, past upon present; shimmering, jewel-like, it conveys a sense of stretched, expansive time and deep emotional longing. DW

1. Trailer for the documentary *Artists & Alchemists,* YouTube video, 2:03, posted by "Market Street Productions," March 25, 2011, http://www.youtube.com/watch?v=QxpeNIN0iRA.
2. "Behind the Scenes with Adam Fuss," *Art on Paper* (September/October 2002), 69.
3. *Adam Fuss, "For Allegra,"* Baldwin Gallery, July 31–September 7, 2009, http://www.baldwingallery.com/archive/exhibitions/2009/0809_af-eg/.

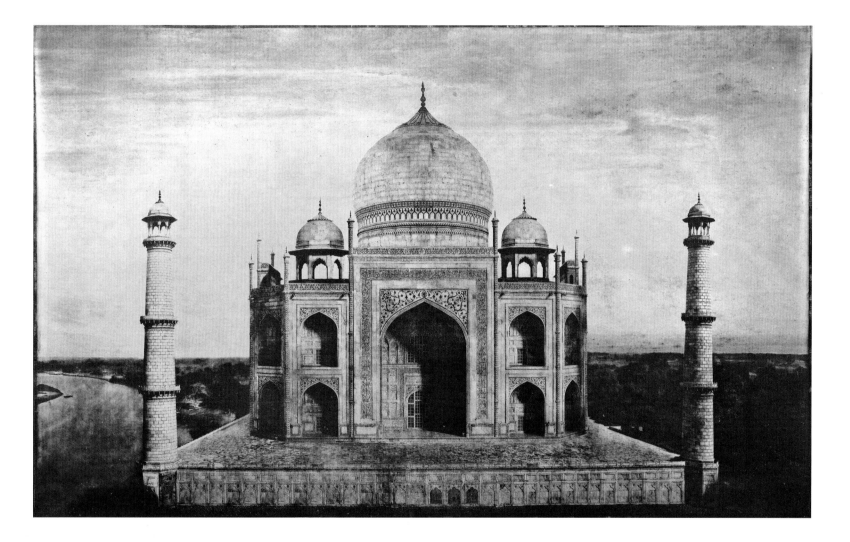

BINH DANH (American, born Vietnam 1977)

15 *Sugar Pine Tree, Yosemite, CA, April 2, 2012*, 2012, daguerreotype

16 *Lower Yosemite Falls, Yosemite, CA, October 13, 2011*, 2011, daguerreotype

For Vietnamese American photographer Binh Danh, Yosemite National Park in California offers a means to reflect on the intertwined relationship of photography, the American landscape, and his own identity. Emphasizing both the physicality of photography as well as its ephemeral nature, Danh is known for printing his pictures on unorthodox supports, including leaves and grass. For his views of Yosemite, he also experimented with an alternative process, but this time turned to one of photography's first techniques, the daguerreotype, invented in the 1830s. In works such as *Sugar Pine Tree, Yosemite, CA, April 2, 2012* (pl. 15) and *Lower Yosemite Falls, Yosemite, CA, October 13, 2011* (pl. 16), Danh utilizes the daguerreotype's mirrorlike surface to enable viewers to catch glimpses of themselves, and of those standing nearby, as they examine the details of Yosemite's famed towering trees and vertiginous falls. Keenly aware of how his own sense of self and belonging change depending on the landscape, Danh transforms the act of studying these pictures into a potentially communal experience, one that grants spectators—regardless of race, gender, creed, or nationality—the possibility of considering their own identity within this iconic scenery.[1]

Although raised in California, Danh never visited Yosemite National Park until he started working on this project. Having fled Vietnam at age two with his family, he lived in a refugee camp in Malaysia before moving to the United States. Because of this experience, Danh's parents never considered taking the family on trips into the wilderness. Instead he came to believe that the outdoors was a "white space" and not for someone who had to run "through the jungles at night to get onto a fishing boat and head into the South China Sea."[2] Nevertheless, as a child he was fascinated by photographs of the national parks and attributes the beginning of his interest in photography to a fifth-grade school camping trip, when his father gave him a camera.[3]

Though Danh approached Yosemite as an outsider, prints by Carleton Watkins (1829–1916), whose pictures helped to create the U.S. National Park system, and Ansel Adams (1902–1984), whose work was critical to the burgeoning environmental movement in the mid-twentieth century, significantly informed his understanding of the magnificence and importance of the site. By revealing nature's splendor through sublime landscape views that rarely included people

or signs of modernization, Watkins' and Adams' photographs helped convince the American public not only of Yosemite's extraordinary beauty, but also of a civic duty to protect and preserve nature. Danh does not attempt to replicate their pictures of the park; rather, his daguerreotypes are reminiscent of them. In his luminous works, Danh intertwines the history of the parks, as created through the imagery of these early photographers, with his own attempt to negotiate his identity and connection to the land. Through the selection of his views and in his printing method, Danh invites viewers to contemplate the national parks as places that offer a collective experience, one potentially powerful enough to unite a vast and multicultural nation.[4] LJU

1. Binh Danh, "Conversation between Binh Danh and Boreth Ly, August 2012," in *Binh Danh: Yosemite* (Haines Gallery, 2012), n.p.
2. Danh, "Conversation between Binh Danh and Boreth Ly," n.p.
3. Danh, "Conversation between Binh Danh and Boreth Ly," n.p
4. Danh, "Conversation between Binh Danh and Boreth Ly," n.p
5. Danh, "Conversation between Binh Danh and Boreth Ly," n.p.

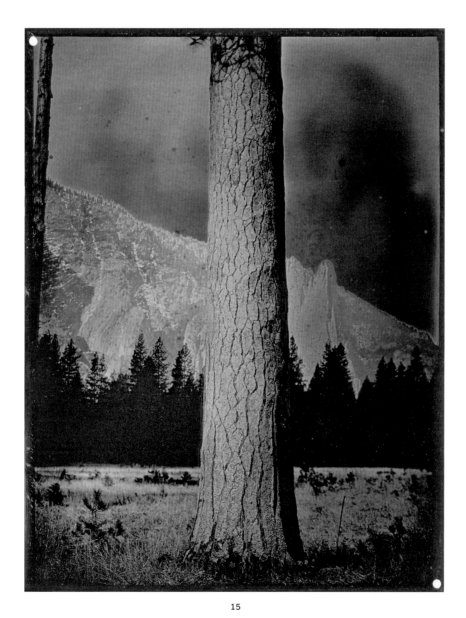

LANDSCAPE IS WHAT DEFINES ME.
WHEN I AM SOMEWHERE NEW OR UNFAMILIAR,
I AM CONSTANTLY IN DIALOGUE WITH
THE PAST, PRESENT, AND MY FUTURE SELF.
WHEN I AM THINKING ABOUT LANDSCAPE,
I AM THINKING ABOUT THOSE WHO
HAVE STOOD ON THIS LAND BEFORE ME.
WHOEVER THEY ARE, HOPEFULLY HISTORY
RECORDED THEIR MAKINGS ON THE LAND
FOR ME TO STUDY AND CONTEMPLATE.

BINH DANH[5]

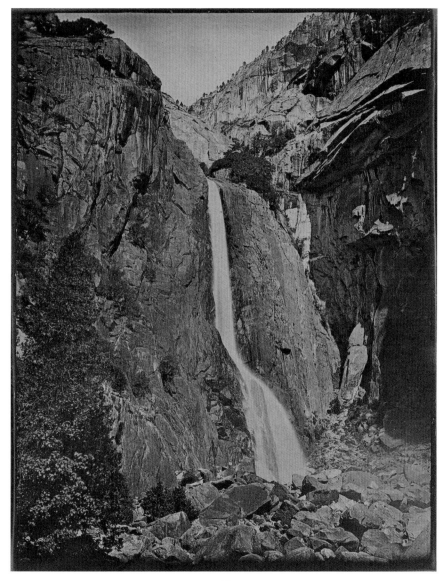

16

Matthew Brandt explores the early history of photography in an unconventional way by incorporating physical elements of what he photographs into the production of his prints. He has remarked, "It was a way to literally put the material index into the photographic index, to use the thing to represent the thing."[1] From images of trees printed both on paper and with ink made from the trees' own fallen branches to gum dichromate prints of honeybees made from an emulsion of dead bees, Brandt blurs the line between the photograph and what is photographed. His choice of subject matter often shares a degree of pathos, imbued with a particular sense of loss and impending change. For example, the trees mentioned above, which grew in Houston's George H. W. Bush Park, were photographed when the forty-third president left office—a time when Brandt felt ambivalent about the future. The honeybees, found dying along a beach, possibly from colony collapse disorder, signify looming environmental devastation.[2]

For *Salton Sea C1*, Brandt soaked the print in water from California's Salton Sea. Impurities in the water affected the overall tonality and texture of the piece, which can be seen in the mottled foreground and violet stains along the edges. Centered in the composition is an outcropping of branches with what looks to be a bird nest. The largest lake in the state, the Salton Sea sits below sea level and is located directly on the San Andreas Fault. Created by accident some 110 years ago when floodwaters from the Colorado River overwhelmed flimsy dikes, it is now an important ecological feature of Southern California, a stopping point for migrating birds that is also in imminent peril.

The son of a commercial photographer, Brandt grew up immersed in the technical capabilities and psychological dynamics of the medium, yet he left his hometown of Los Angeles for New York to study painting, earning a BFA from Cooper Union. Returning to Los Angeles for his graduate studies, he attended UCLA and focused instead on photography, working under the photographer James Welling. It was during this time that he began a serious study of the history of photographic techniques, starting with salted paper prints—one of the first positive prints processes announced by William Henry Fox Talbot in 1839. Made using ordinary writing paper coated with common table salt then sensitized with a solution of silver nitrate, the prints have a matte surface and a soft, atmospheric appearance. Their diffuse details and artistic effects stood in stark contrast to the highly detailed, glossier surfaces of both daguerreotypes and albumen prints, which were closely tied to commercial photography in the mid-nineteenth century.

Brandt, like several other photographers featured in this catalog, has been inspired by the history of landscape photography of the American West. While he sees his work as a type of "topographical mapping,"[3] his print of the Salton Sea does not speak of documentary evidence or of surveying the West for governmental and commercial entities—as was the impetus for most of the nineteenth-century western landscape photographers. Rather, by capturing a quiet detail of an expansive lake, Brandt creates a timeless, almost primordial scene.

From his *Waterbodies* series of salted paper prints of oceans, lakes, and rivers processed with water collected from the sources, *Salton Sea C1* is a one-of-a-kind print steeped in photography's past. Conceptual and insightful, Brandt cultivates a tension between pictorial depth and surface flatness through the convergence of subject and object. Exploring a more direct engagement with his environment and the material process of photography, he produces works with both physical and personal ties to the land and its history. AN

1. Doug Bierend, "Photos of Lakes Turn Psychedelic after Soaking in Their Waters," *Wired*, September 10, 2014, http://www.wired.com/2014/09/matthew-brandt-lakes-and-reservoirs/.
2. Lily Rothman, "'Lakes, Trees and Honeybees': Matthew Brandt at Yossi Milo Gallery," *Time LightBox* (blog), May 22, 2012, http://lightbox-time.com/2012/05/22/matthew-brandt/#1.
3. Mark K. Cunningham, "Surface Tension: Matthew Brandt's *Lakes and Reservoirs 2*," *Octopus: A Visual Studies Journal* 4 (Fall 2008): 145.

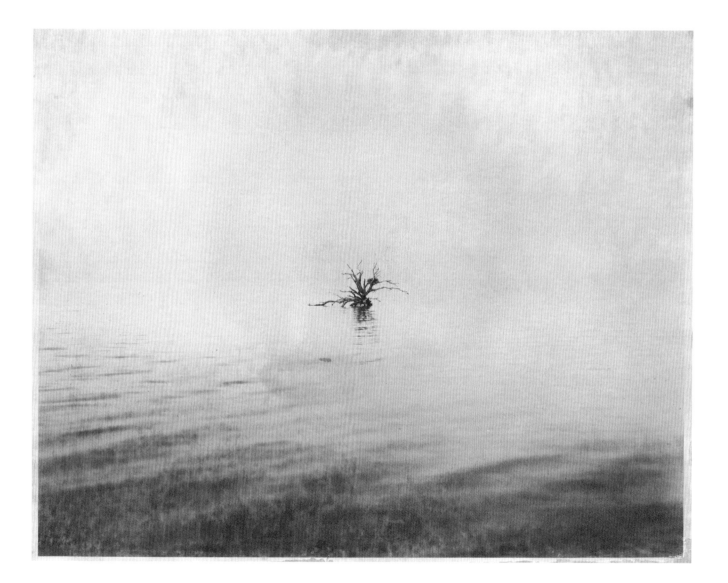

PLATES

CHRIS MCCAW (American, born 1971)

18 *Sunburned GSP #475 (San Francisco Bay)*, 2011, two gelatin silver paper negatives
19 *Sunburned GSP #492 (North Slope Alaska—24 Hours)*, 2011, thirteen gelatin silver paper negatives
20 *Sunburned GSP #541 (Galapagos)*, 2012, gelatin silver paper negative

The work of San Francisco–based photographer Chris McCaw strikingly visualizes the intrinsic elements of photography: light, time, and chemical reactions. For his ongoing series *Sunburn*, McCaw uses long exposures to trace the sun's movement across the sky, producing enigmatic works that reveal the passage of time. His distinctive approach began serendipitously, when in 2003 he forgot to close his camera lens after an exposure of the night sky. Believing that the morning sunlight had ruined his negative, he almost threw it away. Yet after further examination he learned that the heat generated by such a long, intense exposure not only burned the film but also overexposed it, inverting the image from a negative to a positive by a chemical process called solarization. Intrigued, McCaw investigated further and now constructs his own cameras, often fitting them with large, high-intensity lenses—normally used for aerial reconnaissance photography—and loads them with photographic paper rather than negative film.[1]

McCaw's pursuit of the sun's trajectory—especially rare solar events, such as eclipses and equinoxes—has led him on extraordinary journeys around the world. For the multipanel work *Sunburned GSP #492 (North Slope Alaska—24 Hours)* (pl. 19), he captured the natural phenomenon of the midnight sun—an event that occurs only during the summer solstice north of the Arctic Circle, when the sun is present in the sky for a full twenty-four hours. Turning his large-format banquet camera vertically, McCaw repositioned and reloaded it with 20 × 8 inch sheets of gelatin silver paper for each consecutive exposure, each lasting a little less than two hours. The undulating curve of the sun's path dominates the work, while the rugged landscape, barely visible along the bottom of the negatives, sets the context. Breaks in the line are due to sudden thunderstorms that caused McCaw to cover his camera for short periods of time. Steadfast in his commitment to the project, he made two trips to Alaska and several attempts to realize this work, as rain and snowstorms ruined his first exposures.[2]

To capture particular paths of the sun's movement, McCaw must photograph at certain times of the year and at specific geographic locations.[3] Trajectories like the one captured in *Sunburned GSP #475 (San Francisco Bay)* (pl. 18), when the sun appears to be moving along a forty-five-degree angle, are possible in northern California near the spring or fall equinoxes. In this work, the sun, with its fiery trail reflected in the glowing waters of the bay, resembles an asteroid falling to Earth. In *Sunburned GSP #541 (Galapagos)* (pl. 20), the apparent vertical fall of the sun is actually its rise from the horizon, captured because McCaw is near the equator during the summer.

In McCaw's work, the sun is both the subject and the means by which the image is made, revealing how photography is, at its most foundational level, "writing" with light. The burning of the gelatin layer of the paper, as seen in *Sunburned GSP #541 (Galapagos)*, leaves a slight orange tint, a metonymic reminder of the power of the sun. The photographs also have a strong material presence—they are sculptural, in fact, as the paper has curled and is singed, often completely burned through. McCaw's bold paper negatives are unique prints—an inspired use of analog photography during an age of digital production. The exquisite tonal reversal of these works casts them as otherworldly. Each lustrous print is layered with time; the time of exposure, but also the time of year in which the photographs are taken. McCaw has expressed how this project has "altered his sense of time."[4] For him, these photographs open up a new temporal connection to the world, shared by artist and viewer alike. AN

1. Expired gelatin silver papers, rather than contemporary papers, produce the tonal reversal that McCaw desires.
2. Chris McCaw, Katherine Ware, and Allie Haeusslein, *Chris McCaw: Sunburn* (Richmond, 2012), 86.
3. One should remember it is actually Earth that is moving, rather than the sun.
4. McCaw, Ware, and Haeusslein, *Chris McCaw: Sunburn*, 86.
5. McCaw, Ware, and Haeusslein, *Chris McCaw: Sunburn*, 86.

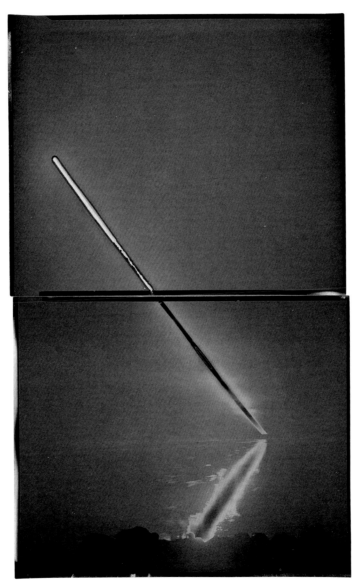

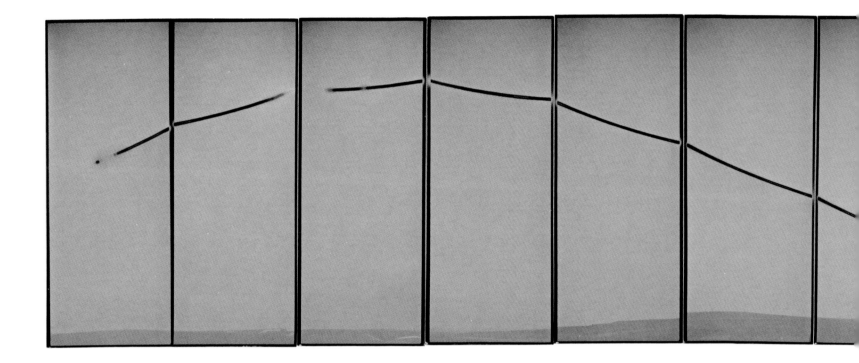

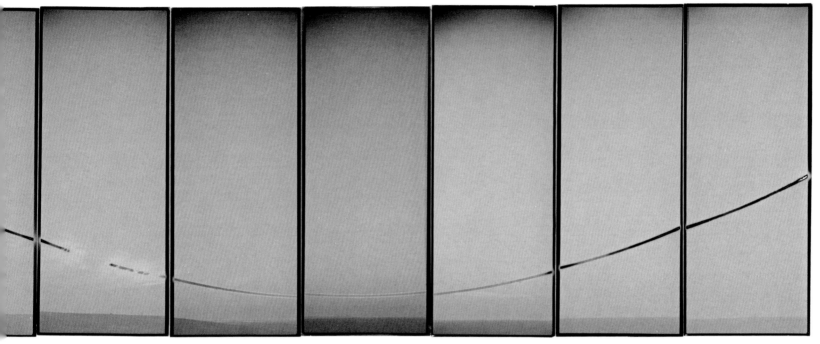

19

IN A WORLD OF CONSTANT CONNECTION
AND THEREFORE CONSTANT DISTRACTION,
THIS PROJECT HAS FORCED ME TO SLOW WAY DOWN…
I NOTICE THE WAY THE TIDES, AND HUMAN ACTIVITY,
EBB AND FLOW FROM SUNRISE TO SUNSET…
THIS PROJECT HAS ALTERED MY SENSE OF TIME.

CHRIS MCCAW[5]

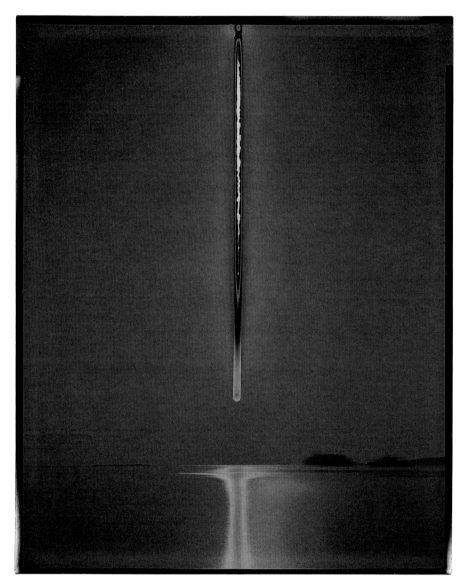

HIROSHI SUGIMOTO (Japanese, born 1948)

21 *Tri City Drive-In, San Bernardino*, 1993, gelatin silver print | **22** *101 Drive-In, Ventura*, 1993, gelatin silver print

For photographer Hiroshi Sugimoto, the camera is a powerful time machine that allows him to traverse history, creating evocative works that investigate the complex realm of memory. After leaving his native Japan in 1970, Sugimoto traveled westward, settling in Los Angeles to study art. Informed by the dominant practices of the era—minimalism and conceptual art—he turned to photography, developing a systematic approach to the medium. Featuring some of the few remaining vestiges of a bygone era, his strikingly surreal photographs of drive-in movie theaters explore not only the passage of time but also the cultural change that so often accompanies it. Part of his *Theaters* series (1975–2001), which includes interior views of opulent, historic movie palaces as well as more streamlined, modern ones, the group as a whole evokes a sense of loss and nostalgia, whether for the glamorous golden age of Hollywood cinema or the mythologized drive-in experience filled with fast food, cars, and romance.[1]

To create the luminous *Tri City Drive-In, San Bernardino* (pl. 21) and *101 Drive-In, Ventura* (pl. 22), Sugimoto centered his camera some distance from the front of the screen and then left its shutter open for the duration of the movie, closing it only after the credits finished rolling. This act, according to Sugimoto, "resolutely draws a line in time and determines what is to be seen."[2] Yet as each frame of the film flickers by, the shifting motion and light accumulate until the picture essentially dissolves itself, and all that remains is a glowing white form. Light becomes the primary narrative; the absorbing "blank" screen is open for the viewer's own projections, revealing that Sugimoto's seemingly straightforward depictions of these spaces are more nuanced and richly layered with meaning.

In *Tri-City Drive-In*, light from the projected movie illuminates a small playground in the fore, rendering an uncanny, dreamlike space. The swings, slides, and merry-go-round recall the heyday of drive-ins, when entire families were entertained. Now abandoned, the vacant scene feels peculiarly frozen in time and haunted by the past. While dominated by the screen's flat, static emptiness, the surrounding environs draw the viewer into the work, creating a formal tension between surface and depth, reality and abstraction. In *101 Drive-In, Ventura*, arching lines of light—possibly traces of stars or even airplanes moving across the night sky—introduce movement into the composition and materialize the passage of time. The blurred, backlit trees that flank the screen (also a result of the lengthy exposure) hint at a more vibrant world that lies just beyond the frame, one that includes suburban neighborhoods and public parks. This engaging play of spatial and temporal relationships reflects the nature of Sugimoto's process. By compressing thousands of sequential frames of a feature-length film into one still photograph, he radically alters accepted perceptions of time, exposing the present moment as a fusion of past experiences and memories. AN/LJU

1. Peter Hay Halpert, "The Blank Screens of Hiroshi Sugimoto," *Art Press*, no. 196 (November 1994): 52.
2. Hiroshi Sugimoto, "The Virtual Image," in *Theaters* (New York and London, 2000), 17.
3. Sugimoto, "The Virtual Image," 17.

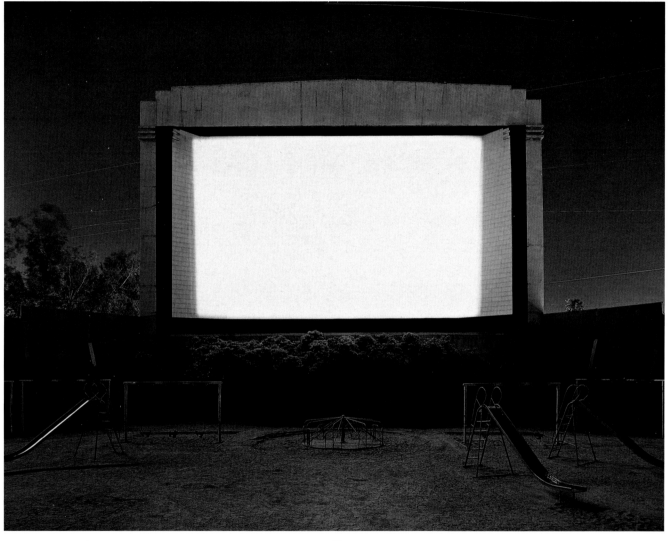

EACH PHOTOGRAPH...REPRESENTS A MOVIE —
A WHOLE MOVIE IN A PHOTOGRAPH.

HIROSHI SUGIMOTO[3]

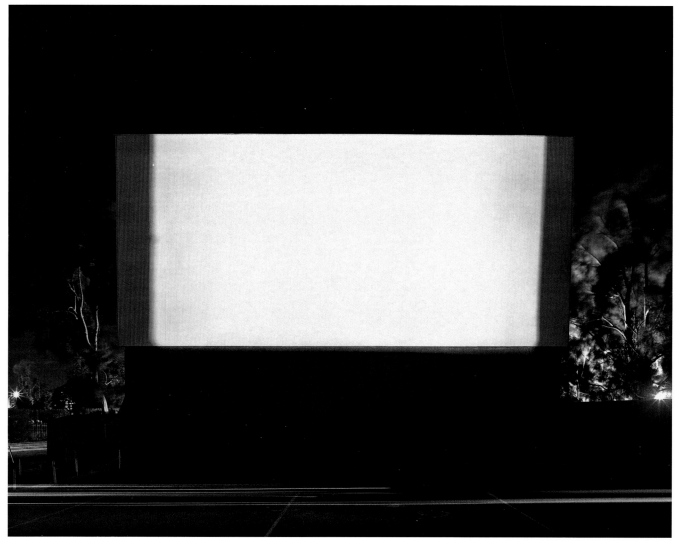

VERA LUTTER (German, born 1960)

23 *Ca' del Duca Sforza, Venice II: January 13–14, 2008,* 2008, three gelatin silver paper negatives

Using a seemingly rudimentary means of production, the pinhole camera, Vera Lutter has been making monumental photographs of cityscapes and commercial areas since the mid-1990s. Trained as a sculptor at the Academy of Fine Arts in Munich, Lutter moved to New York to pursue an MFA in photography in 1992. Her first apartment in the city was an illegal sublet on the twenty-seventh floor of a commercial building in the Garment District. Like so many newcomers to the city, she was overwhelmed by New York—by its light, sound, and energy. She was also amazed by the spectacle she could see from her windows, and by the way the outside world flooded her interior space. Steeped in conceptual art as a student, she decided that the room where she experienced this intensely visceral feeling should become, in her words, "the container to transform that very experience."[1] To do this, she turned her room into a giant camera obscura, darkening all of her windows and leaving only a small pinhole opening that projected an inverted image of the exterior world onto the opposite wall where she attached photographic paper.

Intrigued by the urban environment, industrial architecture, and modes of transportation, Lutter moved on to photograph more complex subjects, such as the Frankfurt Airport and the Battersea Power Station. Befitting her fascination with transportation, she often uses a shipping container as her camera obscura. As light slowly registers the forms onto her large sheets of paper, she often physically controls the process by covering areas that receive the most light.[2] The exposures themselves can last anywhere from a few hours to several days and weeks; one even lasted three months. Because of these long lengths of time, objects and people move during the exposures, making Lutter's final photographs as much about movement, time passing, and the creation of a sense of three-dimensional space as they are about the power of light to create images.

Lutter is equally intrigued with sites that have strong historic resonance. Venice, in particular, is a place she has returned to repeatedly since 2005. Still a top destination for global tourism, Venice has attracted artists and travelers for centuries. Yet in many ways, Lutter's photographs of the iconic city turn the tradition of representing Venice on its head, for they do not describe the glorious Venetian light nor do they, like *vedute* paintings, revel in the depiction of precise detail. Instead, with its ethereal and lugubrious tones, *Ca' del Duca Sforza, Venice II: January 13–14, 2008* describes a hauntingly mysterious place where otherworldly gondolas disappear into the misty waters of the Grand Canal.

Lutter determined very early on that she wanted each photograph to be about the experience of seeing; each one should be as direct and immediate as possible. Monumental in scale, the three-panel piece provides viewers with a life-size view of the canal.

Lutter's works are mesmerizing because they thwart our expectations. Each paper negative—which holds the original activity of light within its fibers—is a unique print bearing a reversal of tones, with the most intense light producing the deepest blacks. Lutter also registers the passage of time in her photographs, rather than freezing a single particular moment. The sense of duration that is inscribed in her works reveals change, even decay. In her desire "to make images that give evidence of the silent beauty that lies in the slow devastation of landscape,"[3] Lutter eerily reminds the viewer that Venice is a city that is slowly crumbling, even sinking. AN

[1]. Lutter recounts, "My intention was not to make a photograph as such but to make a conceptual piece that in its own way repeated and transformed what I had observed." See Peter Wollen, "Vera Lutter," *Bomb* 85 (Fall 2003): 48.
[2]. In order to alter the image as it is being made, Lutter creates light traps that allow her to enter the box and physically adjust the picture itself, masking areas that need less exposure.
[3]. Edith Newhall, "Turning Rooms into Cameras," *ARTnews* 9, no. 3 (March 2009): 104–105.

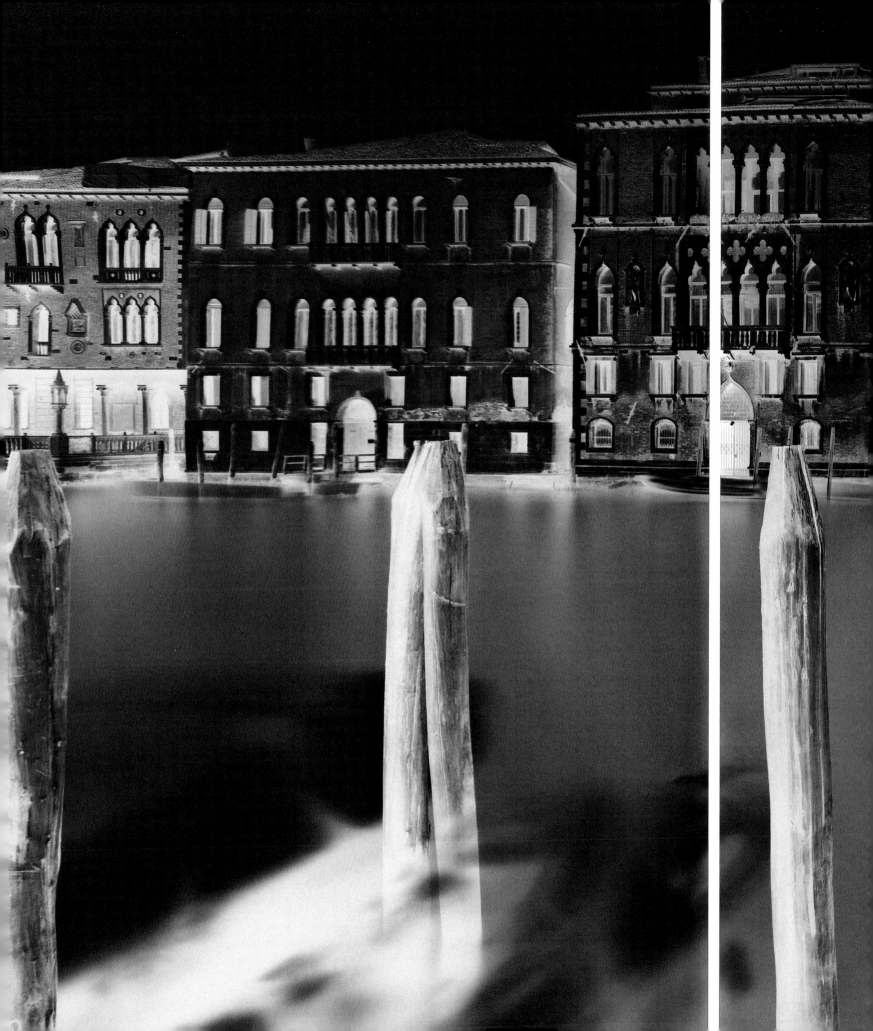

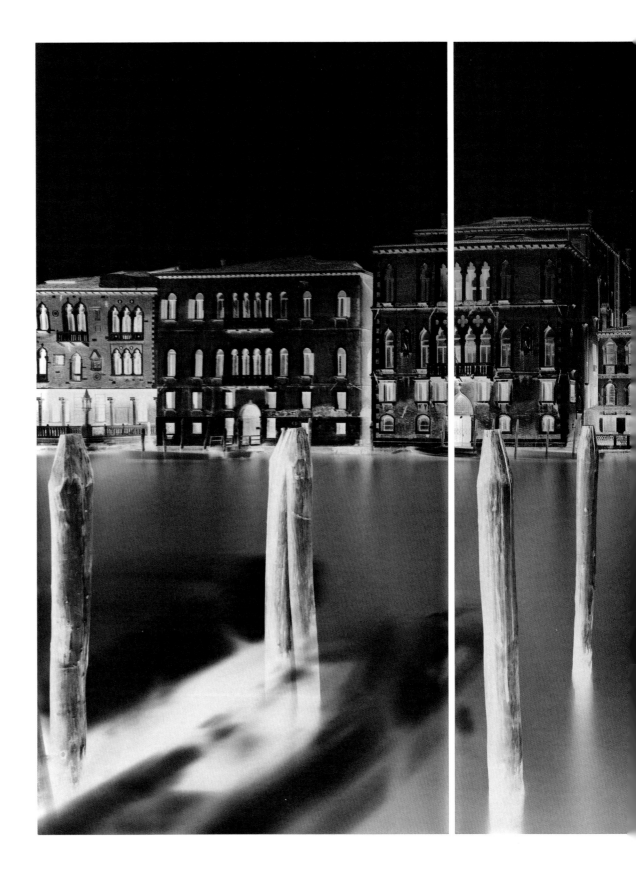

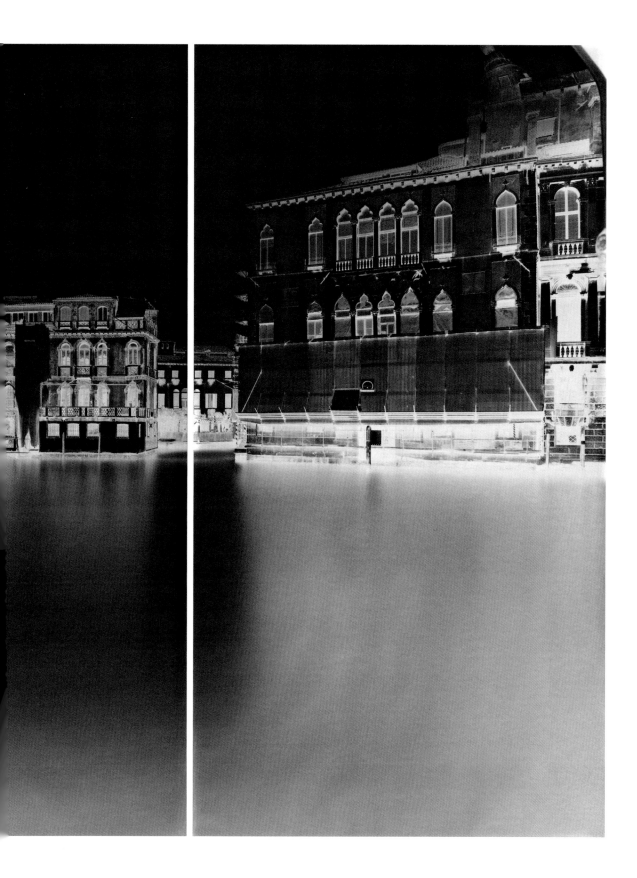

UTA BARTH (American, born Germany 1958)

24 *...and to draw a bright white line with light (Untitled 11.5),* 2011, three inkjet prints

AS THE VIEWER, ONE
STANDS SURROUNDED BY
TIME ARTICULATED IN LIGHT.

UTA BARTH[1]

To evoke a sense of time and place in her work, Uta Barth transforms the familiar into the unfamiliar, bringing attention to quotidian objects that may otherwise go unnoticed. The corner of a room, the section of a bookshelf, or shadows cast on the ground often appear in her photographs as a means to explore perception, without necessarily constituting the subject of her art. In her series *...and to draw a bright white line with light*, originally commissioned by the Art Institute of Chicago in 2011, Barth elevates the simple gesture of pulling back a curtain into a poetic act. Each panel of the section featured here shows a slightly different pattern of light as it traverses Barth's living room. This triptych, and the series as a whole, envisions time's passage through light's shifting shape, set into motion by the sun's path and the artist's gesture; the two are united and shown in the photograph as one still moment.

This subtle yet richly textured work reveals a delicate interplay between the curtains and the light. The title of the series itself, *...and to draw a bright white line with light*, is crucial to understanding the piece's conceptual framework. The light shimmering across the three panels delineates the form of the curtains, while the presence of the diaphanous cloth renders the otherwise ephemeral light substantial. Once captured and made tangible, the light becomes akin to ink, paint, or graphite—a medium Barth uses to inscribe a line as she pulls her curtain. With this action, Barth "in effect *draws* the light," as the critic Paul Soto notes.[2] Her play on words also recalls William Henry Fox Talbot's remark that his photographs, which he named photogenic drawings, were the result of "the mere action of Light" as it interacts with sensitized paper.[3]

By working with sunlight, Barth continues her engagement with perceptions of time, which she explored in the earlier series *...and of time.* and *Sundial*. The photographs from *...and of time.* depict light as it moves about her home at different points of the day—whether across her sofa or along the floor—revealing how it strikingly transforms the space.[4] In *Sundial* she recorded her domestic environment as the light cast onto the wall changed at dusk, but here she altered the viewer's perception by presenting both negative and positive images of her compositions. With *...and to draw a bright white line with light* each photograph is arranged so as to denote the passage of time as sunset approaches, from left to right.[5] By moving the curtain to manipulate a line of light, Barth creates a visualization of time in what she deems a "long performance."[6] Her intervention accentuates the interdependence of time and light, making a claim for the materiality of both. LJU

1. Uta Barth in Paul Soto, "Literal Photography: Q+A with Uta Barth," *Art in America*, October 18, 2011, http://www.artinamericamagazine.com/news-features/interviews/uta-barth/.
2. Paul Soto, "Light, Difference, and the Inevitable Passage of Time," in *Uta Barth. "to draw with light"* (Annandale, NY, 2012), 83.
3. William Henry Fox Talbot, "Introductory Remarks," in *The Pencil of Nature* (London, 1844), 1.
4. Russell Ferguson, "Wider than the Sky," in *Uta Barth: The Long Now* (New York, 2010), 19.
5. Soto, "Light, Difference, and the Inevitable Passage of Time," 83.
6. Up until this point, Barth notes, "it has been important for me not to manipulate the scene." However, in the case of this series, "It is clear that this new work could only be made by my intervention." See Barth in Soto, "Literal Photography: Q+A with Uta Barth."

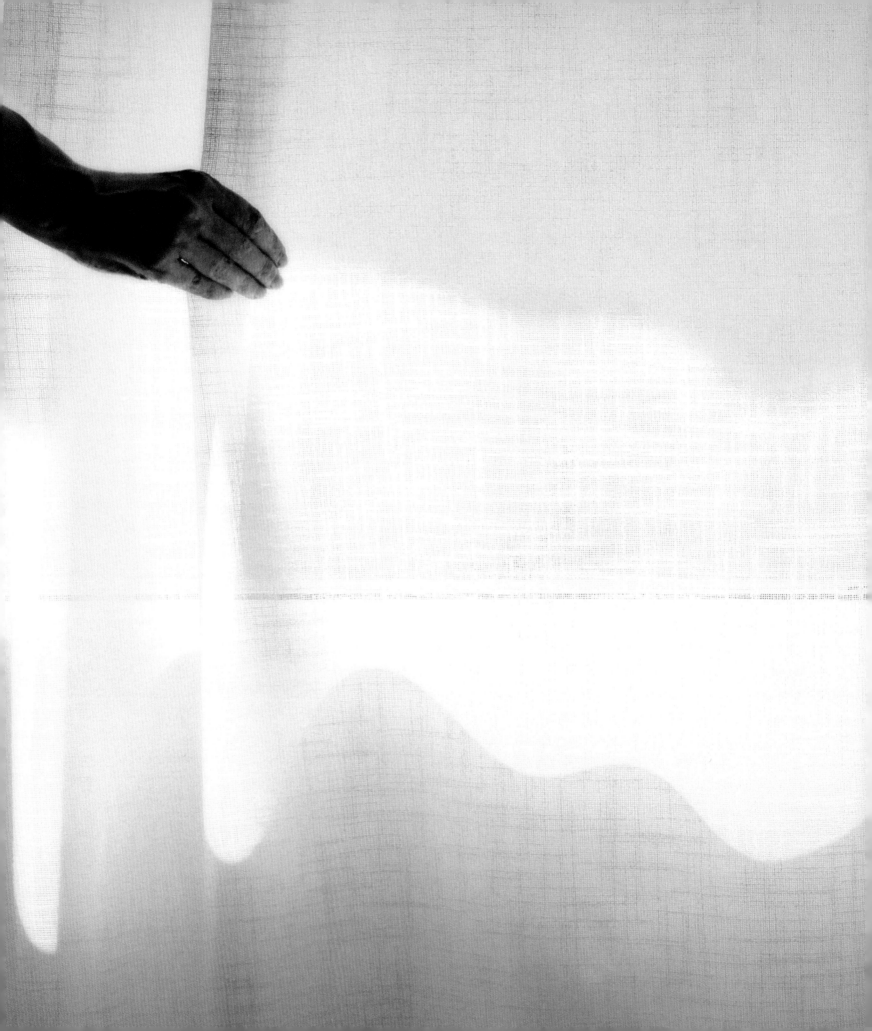

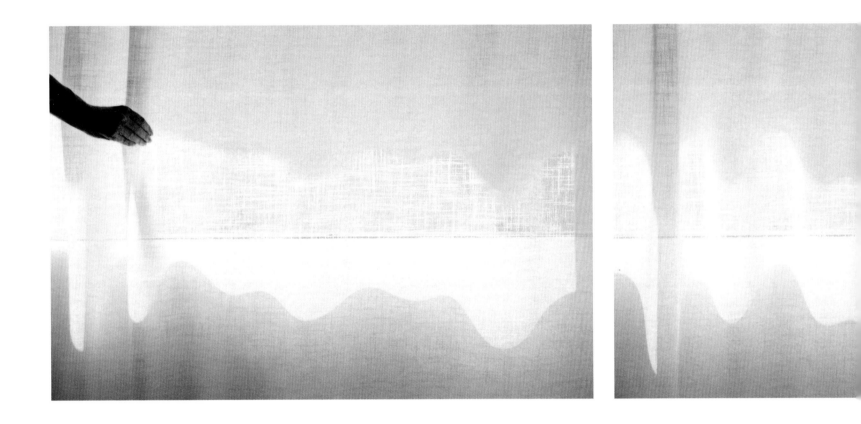

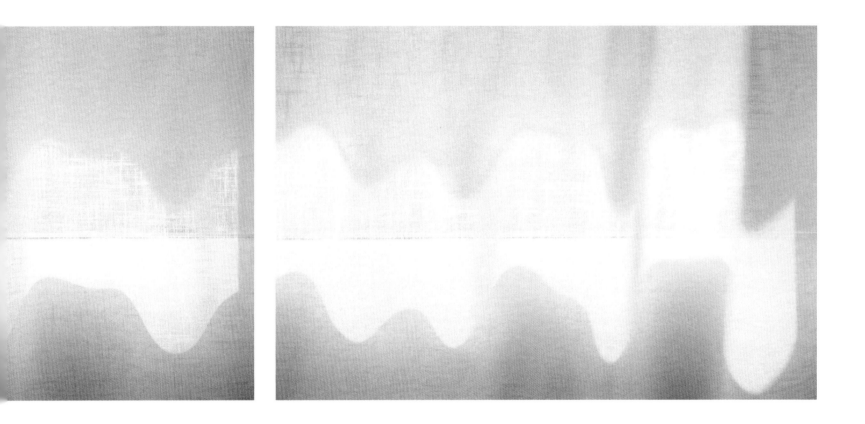

LINDA CONNOR (American, born 1944)
25 *July 23, 1903*, 2002, gelatin silver print | **26** *September 3, 1895*, 2002, gelatin silver print
27 *April 16, 1893*, 1997, gelatin silver print | **28** *August 10, 1955*, 1996, gelatin silver print

Beginning in the mid-1990s, Linda Connor made a series of photographs using glass-plate negatives culled from the extensive archives of the Lick Observatory in California.[1] Opened in 1888, the Lick Observatory was quickly known worldwide for its state-of-the-art equipment and ideal location atop Mount Hamilton near San Jose. Its first director, Edward Holden, promoted photography as the "servant of astronomy" and hired a number of professional photographers, including E. E. Barnard.[2] Connor's project, a study and reprinting of selected negatives made by these astrophotographers, creates a thought-provoking dialogue between science and art, and cosmological time and human history.

For her selections from the Lick archive, Connor set the negatives directly onto photographic paper and exposed them using the natural light just outside the observatory. She then developed and gold-toned the final prints in her studio, giving the night skies a rich, violet-tinged, sepia color. Yet the negatives functioned as more than just source material for Connor. Her process accentuated their physicality and fragility, purposely emphasizing the glass plates' edges and cracks. This is especially evident in works made from broken plates. Before printing, Connor carefully reassembled the broken negative shards in a wood frame to hold them in place.[3] The cracks allowed light to seep through during the exposure, creating weblike

patterns that resemble the lines of a constellation map. Connor's emphasis on the material qualities of the negative and her concern for the beauty of the resulting prints distinguish her project from the original use of the negatives as records, which were usually reproduced in scientific publications.[4] Connor transforms these documents into rich explorations of the multiple dimensions of time and the mysterious, abstract grandeur of space.

These four photographs reveal a fascinating study of the passage of time: the time for light to travel across the galaxy, the time for light to expose the original negatives, and the lapse between the original negatives and Connor's prints. *July 23, 1903* (pl. 25) is a view of a comet first spotted on June 21, 1903, by the French astronomer Alphonse Louis Nicolas Borrelly. As the comet moved closer to Earth, its appearance became brighter, revealing more of its "brushy" tail, as seen in the over two-hour-long exposure taken more than a month after its discovery.[5] The comet's vertical movement, imprinted on the negative as streaking lines of light, contrasts strikingly to a spinning field of stars. In *September 3, 1895* (pl. 26), a recording of a lunar eclipse originally made by Barnard, Connor includes her predecessor's notation of the nine-minute exposure written directly onto the glass-plate negative. The time it took to create the original negatives reminds us that a long

exposure time was not always an obstacle, but could instead serve as a useful tool in the registration of celestial events too distant or too slow to ever be captured by the human eye. Working at the end of the twentieth century, Connor creatively translates the delicate traces of eclipses, comets, and star fields—first captured on the original negatives many years ago—with light emitted from another star: the sun. AN/SK

1. The Lick Observatory's collection of glass plate negatives is estimated at 150,000. The dates of Connor's titles are the original dates on which the negatives were exposed.
2. William L. Fox, "In Fields of Light," in *Odyssey: The Photographs of Linda Connor* (San Francisco, 2008), n.p. The still active Lick Observatory, which was built between 1876 and 1887 and financed by the San Francisco millionaire James M. Lick, originally held a telescope "more powerful than any yet made." See 1874 deed, quoted in Edward S. Holden, *Hand-Book of the Lick Observatory of the University of California* (San Francisco, 1888), 24.
3. Weston Naef, "Drawing with Light," in *Starstruck: The Fine Art of Astrophotography*, ed. Anthony Shostak (Bates College Museum of Art, 2012), 32.
4. Alex Soojung-Kim Pang, "'Stars Should Henceforth Register Themselves': Astrophotography at the Early Lick Observatory," *The British Journal for the History of Science* 30, no. 2 (June 1997): 177–202.
5. R. G. Aitken, "Comet c 1903 (Borrelly)," *Publications of the Astronomical Society of the Pacific* 15, no. 91 (August 10, 1903): 203; R. J. Wallace, "Photographs of Comet c 1903 (Borrelly)," *Publications of the Astronomical Society of the Pacific* 15, no. 92 (October 10, 1903): 213.

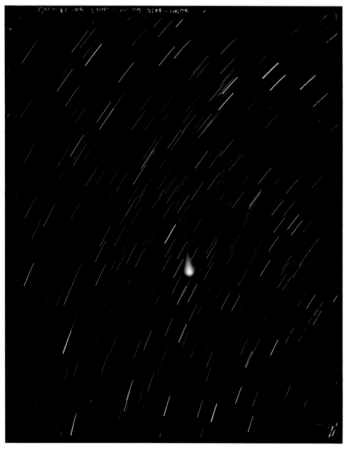

25

26

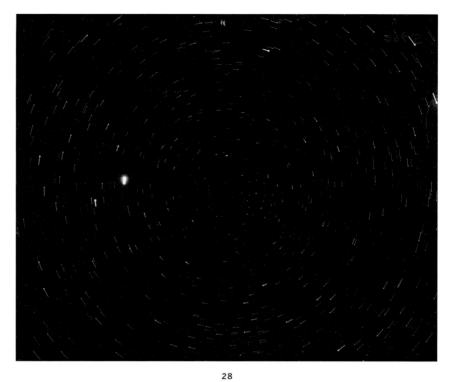

28

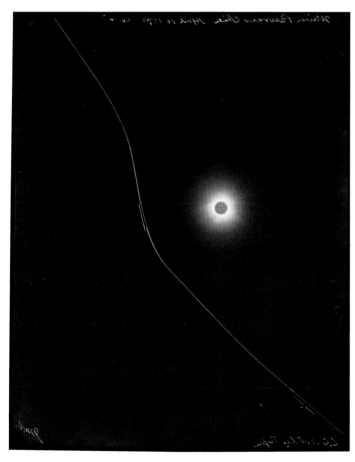

27

PLATES

This photograph, which could at first glance be mistaken for a nineteenth-century studio portrait, is in fact a contemporary commentary on the genocide perpetrated by the Khmer Rouge in Cambodia during the 1970s. Upon examination, we see that the rectangular object at the young man's throat, which resembles a necktie, is actually a tag; his erect posture, while not unusual for nineteenth-century portraits, is suspiciously rigid. However, the work's title—*Ghost of Tuol Sleng Genocide Museum #1*—reveals the true story behind it, obviating any belief that it was produced in a typical studio environment. In fact, the young man's upright stance is not due to formality: his posture is stiff because his hands are tied behind his back; he is a prisoner, not a free man willingly posing for a portrait. In 2008, Danh rephotographed this picture and others of Cambodians facing incarceration, torture, and execution at S-21, the high school turned notorious prison, now the Tuol Sleng Genocide Museum in Phnom Penh. By examining Tuol Sleng's archives, Danh, who was born in Vietnam but grew up in the United States, sought to address Southeast Asia's collective memory and to elegize the deeply disturbing history of the Cambodian genocide.

When Danh traveled to both Tuol Sleng and Choeung Ek, the site of the Killing Fields, he was struck by the detailed documentation made by the Khmer Rouge of their Cambodian and Vietnamese victims, including passport-sized photographs and negatives of at least seven thousand prisoners held at S-21.[1] As with many of those the Khmer Rouge photographed, the sitter in *Ghost of Tuol Sleng Genocide Museum #1* remains nameless, but his anonymity did not deter Danh's commemorative act. Rather than make a gelatin silver print—a relatively quick and easy method, similar to the assembly-line prints made by the Khmer Rouge—Danh printed this work as a daguerreotype, a far more elaborate and time-consuming process invented in the 1830s by the Frenchman Louis-Jacques-Mandé Daguerre (1787–1851), which produces a one-of-a-kind object. In this way, Danh acknowledged the prisoner's humanity and individuality, which the Khmer Rouge sought to eradicate through its genocidal acts. But Danh did far more than that. By using the distinctly nineteenth-century process, whose French origin is embedded in its very name, Danh alludes to both Vietnam's and Cambodia's colonial past and suggests, as Max Weintraub notes, "that the goal of this project is not just the restoration of individual identities but of collective identity as well."[2] Moreover, this haunting work is part of the larger series *In the Eclipse of Angkor*, which brings together Danh's photographs from Tuol Sleng and Choeung Ek with daguerreotypes he made of Angkor Wat.[3] As that title indicates, all of these photographs must be understood both as existing in the shadow of the now faded glory of the twelfth-century temple—built at the height of the Khmer Empire (ninth to fifteenth century)—and as an attempt to reclaim a sense of cultural identity in light of the region's gruesome recent past.

By extracting his young subject's image from the archive and demonstrating photography's ability to memorialize an individual, Danh has subverted the Khmer Rouge's original documentary project of meticulously recording the dehumanization of their prisoners; his work has furthered recent efforts in Cambodia and abroad to honor the victims of the genocide. However, his photograph is also evidence of the prisoner's impending death: the Khmer Rouge usually took these portraits shortly before executing their victims.[4] *Ghost of Tuol Sleng*, therefore, is a solemn reminder of the 1.7 million people who perished at the hands of the regime—and of photography's role as witness. LJU

1. For his photographs, Danh rephotographed the prints on display at Tuol Sleng, which are themselves enlargements of the Khmer Rouge's documentation. See Rachel Hughes, "The Abject Artifacts of Memory: Photographs from Cambodia's Genocide," *Media, Society and Culture* 25, no. 1 (January 2003): 23–44. Also see Boreth Ly, "Devastated Vision(s): The Khmer Rouge Scopic Regime in Cambodia," *Art Journal* 61, no. 2 (Spring 2003): 73.
2. Max Weintraub, "Mirrors with Memories: The Photographs of Binh Danh," *Art21 Magazine*, December 7, 2010, http://blog.art21.org/2010/12/07/on-view-now-mirrors-with-memories-the-photographs-of-binh-danh/.
3. Danh also printed some of the photographs from the series on leaves. See Robert Schulz, Amy G. Moorefield, and Joanna Ruth Epstein, *In the Eclipse of Angkor* (The Eleanor D. Wilson Museum, 2009).
4. Charles Merewether, "Archival Malpractice and Counterstrategies," Vimeo video, 33:44, posted by "ARGOS centre for art and media," November 13, 2010, http://expo.argosarts.org/videos.jsp?video=51, 2:17. The victims already knew their fate by the time they were photographed.

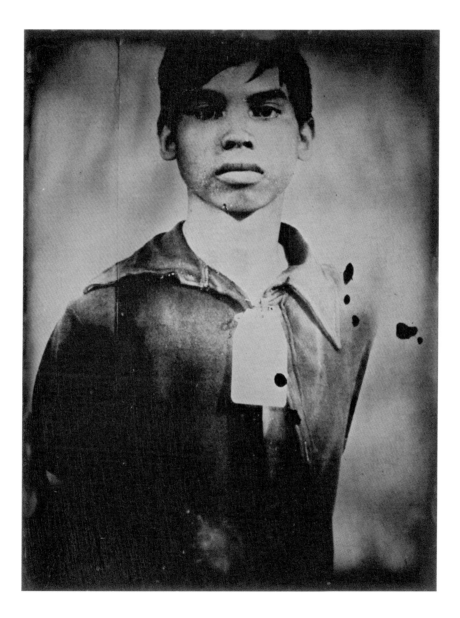

SOPHIE CALLE (French, born 1953)

30 *Autobiographies (Wait for Me)*, 2010, inkjet print and text panel

IN MY WORK IT IS THE TEXT THAT HAS COUNTED MOST. AND YET, THE IMAGE WAS THE BEGINNING OF EVERYTHING.

SOPHIE CALLE[1]

Sophie Calle creatively blurs the line between private and collective experience by operating outside the accepted definitions of visual art. In 1979, after traveling around the world for seven years, Calle returned to Paris. Feeling isolated and alone, she embarked upon a series of projects intended to reacquaint herself with the city and its inhabitants. These provocative performances, which included following and photographing strangers as she walked through the city, opened the door to her first major work of art, *The Sleepers* (1979), where she asked friends and strangers to sleep in her bed for eight-hour shifts over the course of one week. Her observations of the participants, which took the form of both photographs and written notes, were used to produce the final piece.

For the series *True Stories*, begun in 1988 and often referred to as *Les Autobiographies*, Calle examines personal memories from various phases of her life, from her childhood and adolescence in Paris to her husband and their tumultuous relationship. Each "Autobiography" is akin to a chapter in her life story and takes the form of a text paired with a large photograph. Adopting the style of a report, she writes in the first-person singular, present tense. Yet these reports are often testimonies that focus on thoughts, habits, memories, desires—not just "facts." Calle couples these accounts with deliberately constructed or found photographs that entangle the viewer in a web of questionable documentary evidence. Together, they further open the door to challenge the nature of all truths.[2]

More than any other series, *True Stories* reveals how Sophie Calle weaves her life and work together to create intriguing narratives. *Wait for Me* inhabits a peculiar space between fact and fiction, between her life as lived and imagined, by combining an image of a young child, possibly Calle herself, with a text panel that tells the common story of children intentionally abandoning a younger playmate. The endearing snapshot of a young girl dressed in a fancy white dress, bonnet, and sandals could easily be interpreted as a memento of a pleasant family outing. Her precocious look enchants the viewer, which makes reading the distressing text all the more poignant.

Calle purposely thwarts our expectations of the truthfulness of photography, whether she stages a photograph or incorporates a found one, and this uncertainty is precisely what makes her works so compelling. In *Wait for Me*, the power of photography to preserve memory comes under scrutiny. Claiming that "all these objects represent memories: I have such a bad memory,"[3] Calle casts doubt on the ability of any photograph to securely hold a singular truth or a specific individual's memory. Rather, she suggests that photographs can unleash a wave of fleeting memories particular to each viewer. Calle has revealed that she is a savvy investigator of behavior, both her own and that of strangers, often adopting multiple identities as author, performer, and character in the process. For all of her projects, she constructs a set of rules or invents a game that frames her action or interaction with a participant. This social exchange formulates the central narrative of the work, which is at once personal and intimate yet purports to be documentary. AN

1. Sophie Calle, *True Stories: Hasselblad Award 2010* (Göttingen, 2010), 13.
2. Nehama Guralnik, "Sophie Calle: True Stories," in *Sophie Calle: True Stories* (Tel Aviv Museum of Art, 1996), 218.
3. Claudia Barbieri, "Sophie Calle: Tapes, Diaries, and Burial Plots," *New York Times*, June 12, 2012, http://www.nytimes.com/2012/06/13arts/13iht-rartcalle13.html.

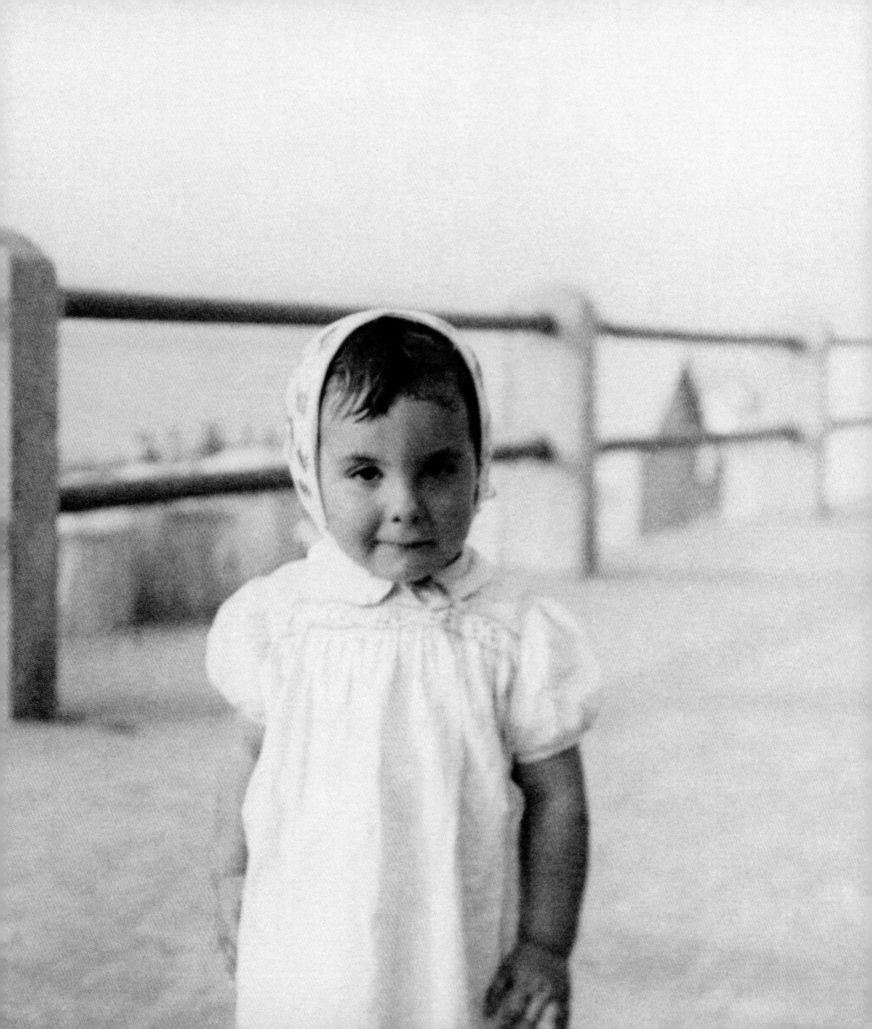

I was two. It happened on a beach — Deauville, I think. My mother had entrusted me to a group of children. I was the youngest and they had to get rid of me: that was their game. They huddled together, whispering, then burst out laughing and scattered when I tried to come near. And I ran after them, shouting: "Wait for me! Wait for me!" I can still remember.

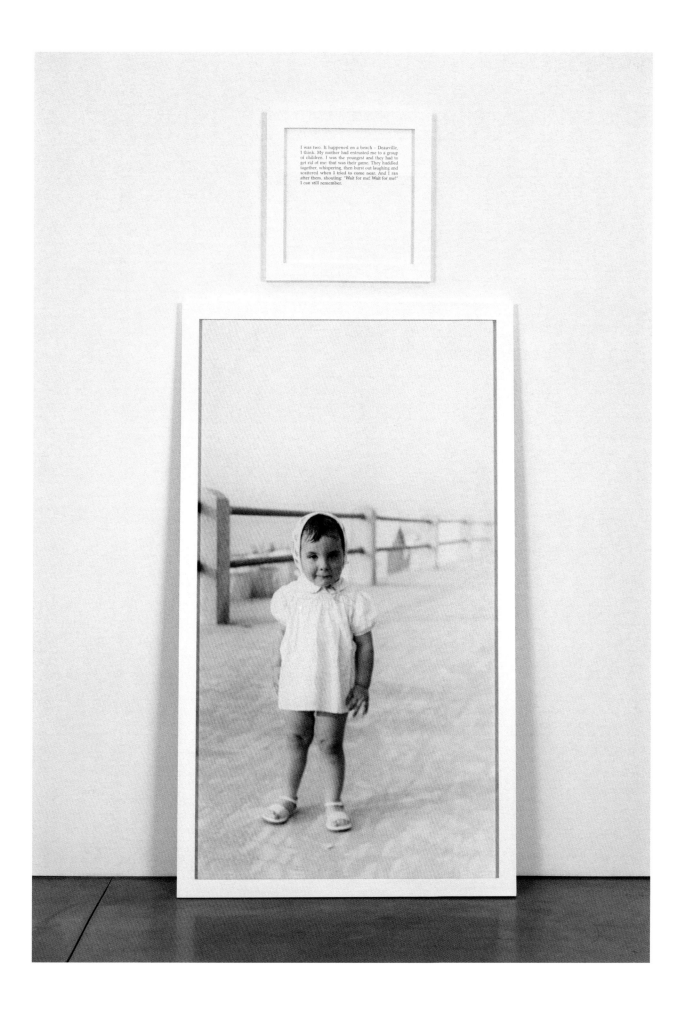

I was two. It happened on a beach – Deauville,
I think. My mother had entrusted me to a group
of children. I was the youngest and they had to
get rid of me: that was their game. They huddled
together, whispering, then burst out laughing and
scattered when I tried to come near. And I ran
after them, shouting: "Wait for me! Wait for me!"
I can still remember.

ISHIUCHI MIYAKO (Japanese, born 1947)
31 *Mother's #24,* 2001, gelatin silver print | **32** *Mother's #49,* 2002, gelatin silver print

Born just after the end of World War II, Ishiuchi Miyako is part of a generation of photographers who confronted the trauma of postwar Japan and the birth of a new era. Using her camera to "ascertain [her] origins," as she has said, Ishiuchi in her first major body of work focused on her hometown of Yokosuka, revealing it to be a place of alienation and conflict between its traditional Japanese culture and its American naval bases.[1] Yet she also saw Yokosuka as a city of wounds, whose traces she found strangely beautiful. Noting that she frequently depicts places where "time is stored and compressed, including the lost moments and articles from the past," Ishiuchi has stated that she is drawn to taking pictures of wounds "because they are so much like a photograph....They are visible events, recorded in the past. Both the scars and the photographs are the manifestation of sorrow for the many things which cannot be retrieved and for love of life as a remembered present."[2]

For her series *Mother's* (2000–2005) Ishiuchi recorded both the possessions and scarred body of her mother, a strong-willed woman who worked as a truck driver during the war. Although they had not been close, Ishiuchi began to photograph her mother toward the end of her life and became immersed in the project after her sudden death in 2000, distraught that she no longer had the ability to reconcile with her. As Ishiuchi wrestled with her conflicted memories, she brought one item after another—lipsticks, shoes, undergarments—"out into the light," examining her mother's private life through intimate belongings that had once touched her body.[3] Many still bore her imprint—lipsticks and shoes, for instance, were worn down with use. For other articles, such as slips and girdles, Ishiuchi taped them onto the sliding glass doors leading to her garden, allowing the sunlight to suffuse the garments, impregnating them with form. The lace-edged black slip of *Mother's #49* (pl. 32), for example, wrinkled yet delicate, hangs as if set aside at the end of the day; its tag (at left) and calligraphic seams render the garment's sheerness all the more apparent and touching. Despite the absence of a body, the undergarment of *Mother's #24* (pl. 31) gives the impression of still being wrapped around someone's legs, while the light shining through it poignantly emphasizes its emptiness. Otherwise unseen and private, these intimate items, Ishiuchi believes, are akin to "pieces of her [mother's] skin" and surrogates for the woman herself.[4]

By collecting the objects together into an archive, Ishiuchi was able to identify those qualities that quietly spoke about her mother's character—her resilience and thriftiness, her elegance and style. The photographs she made of these items publicly reveal not only the very private act of sifting through a deceased parent's belongings, but also the experiences of mourning and commemoration. Ishiuchi has said that, paradoxically, once she exhibited these pictures and saw others' raw emotional responses to them, she was able to move on from her own grief: "I saw so many women in the exhibition hall crying at my photographs. That's when I realized [my mother] wasn't mine anymore. She belonged to everyone."[5] S G

1. Ishiuchi Miyako, "TateShots: Miyako Ishiuchi," YouTube video, 3:57, posted by "Tate," October 14, 2013, https://www.youtube.com/watch?v=qopziSZ-z2A.
2. Ishiuchi, "TateShots: Miyako Ishiuchi," and Ishiuchi quoted in "Miyako Ishiuchi," *SepiaEye*, http://sepiaeye.com/miyako-ishiuchi.
3. Ishiuchi Miyako, *Mother's*, trans. Ito Haruna (Tokyo, 2002), n.p.
4. Ishiuchi Miyako, quoted in Kasahara Michiko, "Ishiuchi Miyako: Traces of the Future," in Kasahara Michiko and Sandra Phillips *Ishiuchi Miyako: Mother's 2000–2005: Traces of the Future* (Tokyo, 2005), 123.
5. Ishiuchi Miyako, quoted in Linda Hoaglund, "Behind Things Left Behind: Ishiuchi Miyako," http://lhoaglund.com/behind-things-left-behind-ishiuchi-miyako/.
6. Ishiuchi, *Mother's*, n.p.

WHAT I HAVE NOW ARE THE ONLY THINGS
THAT MY MOTHER LEFT BEHIND FOR ME.
I BRING THEM OUT INTO THE LIGHT ONE BY ONE,
TO [IMPRESS] THEIR IMAGE ONTO [A] PHOTOGRAPH,
AS A FAREWELL TO HER.

ISHIUCHI MIYAKO[6]

CARRIE MAE WEEMS (American, born 1953)
33 *Slow Fade to Black II,* 2010, seventeen inkjet prints

In *Slow Fade to Black II,* Carrie Mae Weems investigates photography's powerful role in both preserving and creating memory. Weems' purposely blurred, haunting images of African American female performers pose important questions about how one is remembered or forgotten by history. In a play on the cinematic fade—the transition of an image to a blank screen—Weems suspends publicity stills of once highly recognizable entertainers, including Josephine Baker, Nina Simone, and Ella Fitzgerald, somewhere between fading in and fading out. Weems has intensified the tonality of the prints with highly saturated colors that recall classic Hollywood films made in Technicolor, a reference to the fact that many of these photographs originally date from the 1930s to the 1960s. By selecting mass-media images that have defined memorable moments in these women's careers, Weems points out how photography effectively creates celebrity. However, through her manipulations, Weems also uses these photographs to call attention to both the women's physical absence and society's fading memories of them. It seems they have all but vanished from our collective imagination. Some viewers may think they recognize a figure

from her features, gestures, or costume; others may question their memory, or are even left dumbfounded as they simply do not recognize the woman.

With a background in street theater and dance, Weems has long been interested in the stage as a place for public expressions of a positive black persona.[1] In *Slow Fade to Black II* she honors a group of significant African American women who helped shape American cultural identity during the first half of the twentieth century. Powerful images—Marian Anderson singing "My Country 'Tis of Thee" before a bank of microphones at the Lincoln Memorial, for example—are striking reminders of the history of segregation in the United States,[2] while the emotive expressions of Dinah Washington and Mahalia Jackson are more subtle indicators of the fundamental role black women played in the history of American music and social activism.

In her archive of photographs, whose subjects appear to be "dissolving before our eyes," Weems provides us with a visual experience of forgetting.[3] The poignant series focuses our attention not only on the challenges these women faced to remain relevant in a culture that often marginalized them,

but also on the fleeting nature of fame in general. Rather than constructing stereotypes, these spectacular yet silent photographs are helping to restore these performers' presence in contemporary society. Saddened that she rarely hears mention of these women and that few are included in mainstream history books, Weems hopes that this series will inspire a new generation to learn more about them, to search out recordings of their musical performances, and to hear their voices.[4] AN

1. Kathryn E. Delmez, ed., *Carrie Mae Weems: Three Decades of Photography and Video* (Frist Center for the Visual Arts, 2012), 242.
2. Anderson had been scheduled to sing at Constitution Hall in Washington, DC, but the managing organization—the Daughters of the American Revolution (DAR)—denied her the right to perform because of her race. Upon learning this, First Lady Eleanor Roosevelt resigned from the DAR in protest and helped arrange an alternate performance at the Lincoln Memorial. On Easter Sunday in 1939, Anderson gave a free concert attended by more than 75,000 people.
3. Weems quoted in Maurice Berger, "Black Performers, Fading from Frame, and Memory," *Lens* (blog), *New York Times,* January 22, 2014, http://lens.blogs.nytimes.com/2014/01/22/black-performers-fading-from-frame-and-memory.
4. Berger, "Black Performers, Fading from Frame, and Memory."

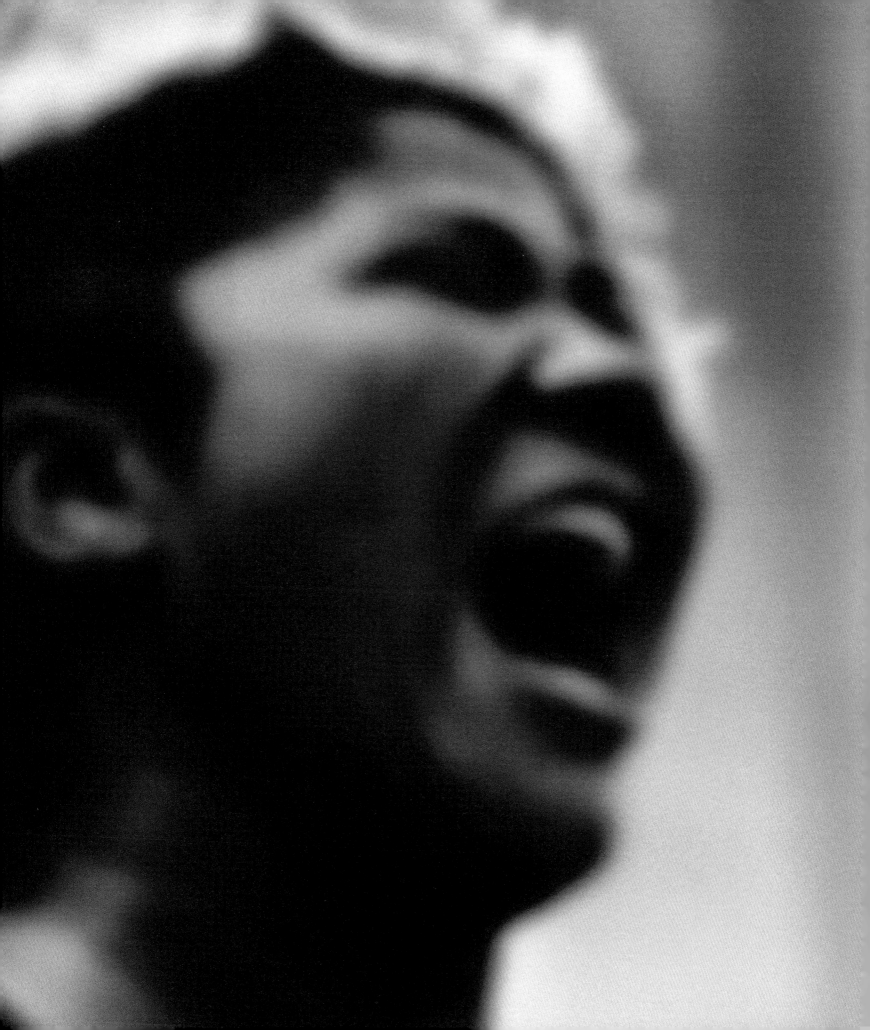

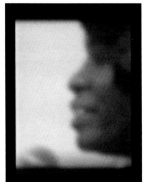
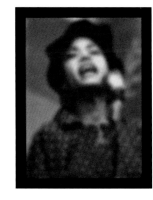

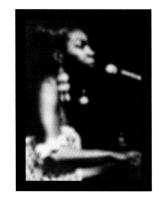

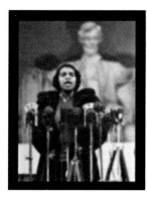

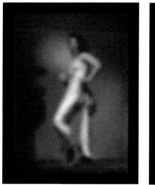
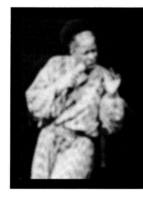
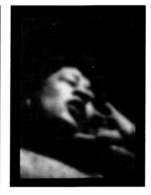

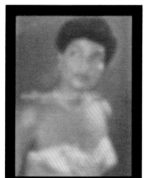

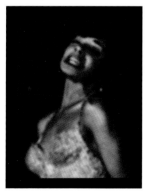

SUSAN MEISELAS (American, born 1948)
34 *The Life of an Image: "Molotov Man," 1979–2009*, 2014, mixed-media installation

MANY OF MY IMAGES...HAD A PUBLIC LIFE, BUT ONE THAT WAS DISPERSED. I WANTED TO GATHER THEM BACK, MAKE SENSE OF THEM AND GIVE THEM COHERENCE—AS WELL AS PERMANENCE.

SUSAN MEISELAS[1]

Susan Meiselas has devoted much of her career to recording civil and political unrest around the world, including in Nicaragua where she spent several weeks between 1978 and 1979 photographing the Sandinista revolution against the Somoza dictatorship.[2] On July 16, 1979, she photographed Pablo Jesús Aráuz, clad in a beret, green shirt, and jeans, with a rosary dangling from his neck, standing before a tank with a cannon pointed at him. In his bandaged left hand he holds a rifle; in his right, a Molotov cocktail, which he hurls at the National Guard Headquarters in Estelí, Nicaragua, one of the last bastions of the regime. Since that day, Meiselas' image of "Molotov Man" has taken on a life of its own, having been claimed as a symbol of the insurrection by conflicting parties including the Sandinistas (or FSLN, Frente Sandinista de Liberación Nacional), the Catholic Church, and the Contra (an assortment of anti-FSLN groups). In *The Life of an Image: "Molotov Man," 1979–2009* Meiselas examines the history of this photograph, aggregating its different iterations into an archive.

Arranged in a loosely chronological order, the work begins with color transparencies, a black-and-white contact sheet, and photographic enlargements of Aráuz lighting the Molotov cocktail, as well as the iconic image that came to be known as Molotov Man (pls. 34A–D). Meiselas next "re-encountered" Molotov Man in 1980 on a matchbox cover that marked the first anniversary of the rebellion (pl. 34F).[3] That same year, the Nicaraguan Catholic Church published his image on the cover of a magazine commemorating the assassination of one of its priests by Somoza's forces (pl. 34G). The photograph was also reproduced in Europe, including in a pro-Sandinista article from about 1981 in a leftist Swedish publication, chronicling misleading information in the press about the effects of the revolution (pl. 34E).[4] In 1983 the Contras used the silhouette on fundraising newsletters directed at Americans, focusing on the Sandinistas' communist leanings and their violation of human rights (pl. 34I).

In the final section, Meiselas presents her own engagement with the image throughout the last thirty years. She photographed it stenciled onto walls across the city of Estelí (pl. 34L) and also utilized by the FSLN to represent courage (pl. 34M). She recorded the 2007 sculpture erected in Estelí dedicated to the fallen and living heroes of the revolution, which was loosely based on Aráuz's likeness but bare-chested and holding an FSLN flag rather than a rifle (pl. 34P). For the revolt's thirtieth anniversary, and in a nod to Molotov Man's Marxist lineage, Meiselas photographed his image printed on T-shirts, alongside Che Guevara's (pl. 34Q). However, Meiselas also noted how Molotov Man has been erased as political parties have shifted: a mural in Masaya where he

had joined other FSLN legends was painted over around the time of the 1990 elections when the Sandinistas lost control of the government (pls. 34J–K).

Additionally, in the documentary film *Pictures from a Revolution* (1991) Meiselas interviewed Aráuz, who expressed surprise that the picture of him had circulated worldwide, making him an icon (pl. 34N). For the twenty-fifth anniversary of the revolt, Meiselas returned to Nicaragua in 2004 to install enlargements of her photographs where she had originally taken them. The accompanying documentary film, *Reframing History* (2004), includes a scene of children approaching, touching, and quizzically examining the enlargement of Molotov Man placed on a cinderblock wall (pl. 34O).

The Life of an Image draws together different moments in the history of Molotov Man's likeness, allowing viewers to come to terms not only with the tumult that Meiselas initially documented, but also with the ways in which a photograph's circulation in multiple venues and throughout time shifts its meaning along the way. LJU

1. Susan Meiselas, "An Interview with Susan Meiselas," in *Susan Meiselas: In History*, ed. Kristen Lubben (International Center of Photography, 2008), 116.
2. The Somoza family had been in power since 1936. In 1961 the Sandinista National Liberation Front (Frente Sandinista de Liberación Nacional, or FSLN) was founded in opposition to the Somoza dictatorship as a leftist coalition.
3. See Joy Garnett and Susan Meiselas, "On the Rights of the Molotov Man: Appropriation and the Art of Context," *Harper's Magazine* 314, no. 1881 (February 2007): 57.
4. Thanks to Taru Spiegel and Amber Paranick at the Library of Congress for their assistance with the translation.

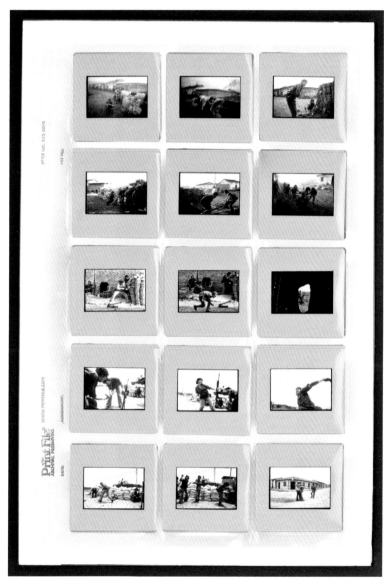

34A Series of transparencies from the final assault on the National Guard Headquarters, Estelí, Nicaragua, July 16, 1979

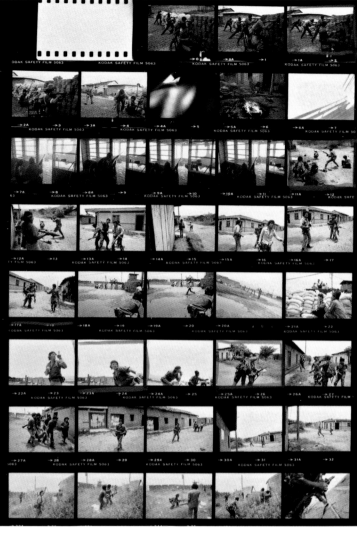

34B Final assault on the National Guard Headquarters, Estelí, Nicaragua, July 16, 1979

34C The moment before, Estelí, Nicaragua, July 16, 1979

34D "Molotov Man" at the walls of the National Guard Headquarters, Estelí, Nicaragua, July 16, 1979

NU BÖRJAR LÖGNERNA OM

NICARAGUA

Vad har egentligen hänt i Nicaragua under de två som gått sen revolutionens seger?

—Fasaden börjar spricka, svarade Fritjof Haglund i TV-Aktuellt den 19 juli.

—Fernissan börjar flagna, förtydligade Expressen den 29 juli. Aha, men hur då?

—Indianerna på östkusten flyr i tiotusental, förklarade Fritjof Haglund.

—Förtrycket inne i landet har tilltagit markant, sammanfattade Expressen.

Aj fan!

—Tidningen La Prensa har stängts och chefen för kommissionen för mänskliga rättigheter har fängslats påpekade Dagens Nyheter redan den 21 februari.

—Det finns totalitära tendenser, konstaterade Fritjof Haglund.

—Oppositionen mot sandiniströrelsen växer sig allt starkare, sa DN den 7 juni och preciserade:

—Nu har också kyrkan gått till attack.

Det låter verkligen inte bra men , säg, varför flyr indianerna? Varför stängdes La Prensa? Varför fängslades ordföranden för kommissionen för mänskliga rättigheterna? Vad är det för slags opposition som finns?

Jag letade i de stora tidningarnas klipparkiv efter svar. Och när jag ändå letade så tänkte jag att det kunde vara kul att ta reda på vad som hänt med jordreformen, med alfabetiseringskampanjen, med det nya sjukvårds- och undervisningssystemet, och så där i allmänhet hur

Hemmagjorda molotovcocktails.

... med livvakter.

34E Tear sheet from Swedish magazine, c. 1981

CRISTIANOS REVOLUCIONARIOS
II

FOLLETOS POPULARES
GASPAR GARCIA LAVIANA

No.4

34G Catholic church publication, Nicaragua, 1980

34F First anniversary matchboxes of the FSLN
triumph over Somoza, Nicaragua, July 1980

34H Sandinista poster to raise a popular militia, Nicaragua, 1982

Communist Aggression In Nicaragua

Facts America Should Know

● **Who Are the Sandinistas?**

For 42 years, up until 1979, right-wing dictator Anastasio Somoza ruled Nicaragua. Somoza was vehemently anti-communist, and wanted free enterprise to flourish in his country, but his government was corrupt. Many people, both rich and poor, wanted to get Somoza out of power, and many of them had valid grievances.

In 1962, the Sandinista National Liberation Front (FSLN) was founded by a self-professed communist, Carlos Fonseca Amador. Author of *A Nicaraguan in Moscow*, which was an apology for the Soviet system, Amador began to develop close ties with Fidel Castro. His goal was to model a revolution in Nicaragua after the pattern of events that took place in Cuba.

In 1978, the leaders of the Sandinista regime met with Fidel Castro and worked out the final plans for their takeover. They would seek to align themselves with many non-Marxist sectors of society, and present themselves as if they were seeking democracy. The common people of Nicaragua believed them. When Somoza was overthrown in 1979, the new Sandinista government came into power, and the event was heralded as a "victory for democracy."

● **Were All the Revolutionaries Communists?**

There were many people who wanted to see Somoza overthrown. Many of these people were involved in planning the revolution, and they conceded to allow the radical Sandinistas to help them. But when it finally happened, it was too late to stop the Sandinistas from gaining full control. Hundreds of these other revolutionaries fled the country. Others stayed for awhile, hoping that they could somehow bring about the democracy they had hoped for. But the Sandinistas eventually began to bring criminal charges against anyone who did not favor their party.

● **How Are the Sandinistas Suppressing Freedom?**

A billboard advertising the Sandinista Defense Committee indicates what has happened to individual freedom in Nicaragua since the revolution. It reads, "Thousands of Eyes Are Watching You Twenty-four Hours a Day."

These Defense Committees, modeled after Cuba's Revolutionary Defense Committees, are headquartered on every block in every town and are supposed to monitor the activities and attitudes of every person who lives in the neighborhood. There are said to be 8,500 Sandinista Defense Committees throughout the country. These Defense Committees do more than spy on the people. They also control the rationing cards, which must be presented in order to buy items like rice and sugar in government stores.

The Sandinistas, despite all their promises of free elections, freedom of expression, and a non-aligned foreign policy, have made Nicaragua into a police state that is in complete harmony with the goals of the Soviet Union. Ninety percent of all means of communication have been confiscated, and the remaining means are heavily censored. Independent journalists are physically harassed, their radio stations are ransacked, and they often receive death threats.

Non-Sandinista political parties are denied access to the media and are barred by law from political campaigning. Most leaders of opposing political parties have fled the country.

34I Flyer soliciting funds for Contra revolution, United States, 1983

34J Mural featuring Nicaraguan folk legends including "Molotov Man," Masaya, Nicaragua, 1986

34K Wall previously painted with "Molotov Man," blackened before election campaign, Masaya, Nicaragua, 1991

34L Wall stencil based on "Molotov Man," Estelí, Nicaragua, 1982

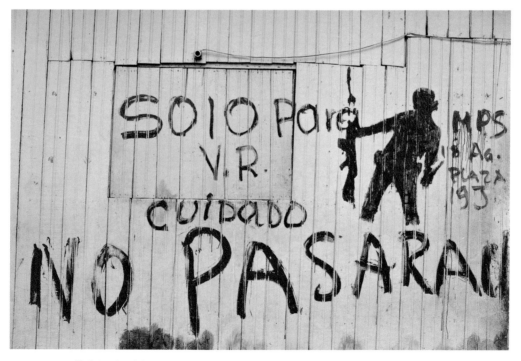

34M Wall stencil mobilizing popular militia to fight against the Contra, based on "Molotov Man," and reads, "They will not pass," Estelí, Nicaragua, 1982

34N Interview with "Molotov Man," Pablo Jesús Aráuz, in Somoto, Nicaragua, March 25, 1990, outtake from the film *Pictures from a Revolution* by Susan Meiselas, Alfred Guzzetti, and Richard P. Rogers

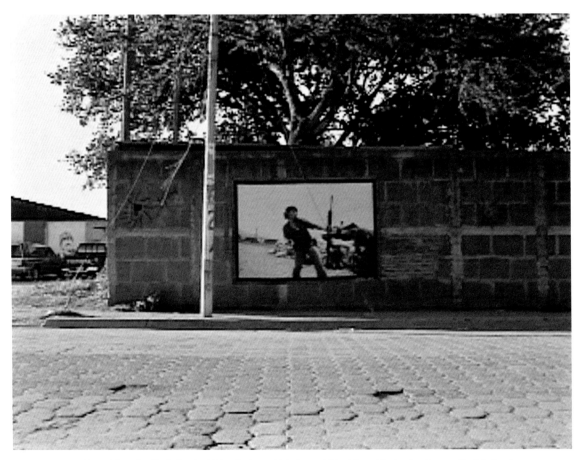

34O Excerpt from the film *Reframing History* by Susan Meiselas and Alfred Guzzetti, showing the mural installation for the twenty-fifth anniversary of the overthrow of Somoza by the FSLN, Estelí, Nicaragua, July 2004

34P Monument to Pablo Jesús Aráuz, known as "Molotov Man," Estelí, Nicaragua, July 2009

34Q T-shirts sold at the thirtieth anniversary celebration in the Plaza of the Revolution, Managua, Nicaragua, July 2009

DEBORAH LUSTER (American, born 1951)
35 *Tooth for an Eye: A Chorography of Violence in Orleans Parish #06-16,* 2008–2011, ledger panel and gelatin silver print
36 *Tooth for an Eye: A Chorography of Violence in Orleans Parish #06-22,* 2008–2011, ledger panel and gelatin silver print

Acting as a witness, Deborah Luster photographs sites within New Orleans where murders have taken place, creating striking memorials to the lives of a largely disregarded population. She captures these anonymous, often eerily empty spaces with her camera sometimes long after the deaths have occurred. Her project *Tooth for an Eye: A Chorography of Violence in Orleans Parish* is not only a recording of the physical locations where violence transpired, it is also a personal archive that explores, in her words, "the empty, dizzying space at the core of violence."[1] Unlike geography, which surveys large tracts of land, chorography is mapping on a small scale, one that attempts to understand the local experience. Luster's chorography, a detailed study of New Orleans' violence, brings viewers to parts of the city not usually depicted in art and easily overlooked.

The series is composed of black-and-white photographs and oversize "ledger books" that contain corresponding records akin to police reports. Luster's photographs are circular in format, reminiscent of the earliest Kodak snapshots but on a much larger scale. This format emphasizes a purposeful type of looking, as through a microscope or binoculars. Yet the circular photographs are also unsettling; like peepholes or views from a gun scope, they make viewers conscious of the act of looking while forcefully disrupting the normal rectangular format of the camera view. To

achieve this effect, Luster used an 8 × 10 inch Deardorff camera equipped with a lens that captures a perfect circle of vision with very little fall off. Her slow film and ninety-second exposures result in some blur, whether it is wind moving trees or cars driving past.

Luster is intrigued by the relationship between image and text, and her quotidian images quickly turn ominous when read in relation to their written records. Designing her own template, she uses a black stamp to denote the headings—"Location," "Date(s)," "Name(s)," and "Notes." Each record is filled out by hand and given a number created by Luster specifically for the project. This "disarchive" number reveals that her archive, as factual and documentary as it appears, is still a subjective one. *Tooth for an Eye* is the second half of Luster's earlier project *One Big Self: Prisoners of Louisiana,* where she took formal portraits of convicts in the Louisiana penal system as a response to her own mother's homicide in 1988.[2] Her title, *Tooth for an Eye,* is an alteration of the Old Testament verse "an eye for an eye, a tooth for a tooth."[3] By altering the original scripture, which calls for a punishment that equals the crime (Exodus 21:24), Luster draws attention to the issues surrounding the violence of New Orleans and to systems of retaliation and retribution in the United States.

Luster's photograph for *#06-22* (pl. 36) depicts the corner of Edinburgh and Eagle Streets, the site of Big Time

Tips Bar and Lounge where several murders occurred in 2002 and 2009. Doubling the interplay between image and text, the print includes a wall with the words "No Loitering" handwritten in white paint, while "R. I. P. Ralph" has been spray-painted on the sidewalk along with a small heart shape. Although difficult to discern, there is also a Crime Stoppers sign in the window behind the safety bars. *#06-16* (pl. 35) records a site located in the neighborhood of St. Roch, which was also a scene of several homicides from 1993 to 2009. The view from a columned porch speaks to the romantic ideal of the "Old South," but a quick look across the street reveals a stretch of severely run-down homes. Shunning nostalgia, Luster's project possesses an acute awareness of loss and desolation as she attempts to represent individuals who, now absent, have been largely forgotten by society. AN

1. Deborah Luster, "Project Statement," in *Tooth for an Eye: A Chorography of Violence in Orleans Parish* (Santa Fe, 2011), n.p. New Orleans' high homicide rate, nearly eight times the national average, makes it one of the most violent cities in the world.
2. Luster, "Project Statement." Luster was partly inspired by author Julia Reed's comment that living in New Orleans is "not unlike living in the Old Testament."
3. Davia Nelson and Nikki Silva, "Tooth for an Eye: A Gallery Walk with Photographer Deborah Luster, Jack Shainman Gallery, New York," February 1, 2011, www.kitchensisters.org/girlstories/tooth_for_an_eye/.

Location

.2400 North Villere Street St. Roch . . .

Date(s)

January 10, 1993 June 13, 2009 1 a.m.
.January 18, 1993. . . November 17, 2008

Name(s)

. .Germaine White (20) . . .Leroy Harris. .(19.).

. .Brother Emerson (17) Kendrick Thomas (22)

Notes. All gunshot.

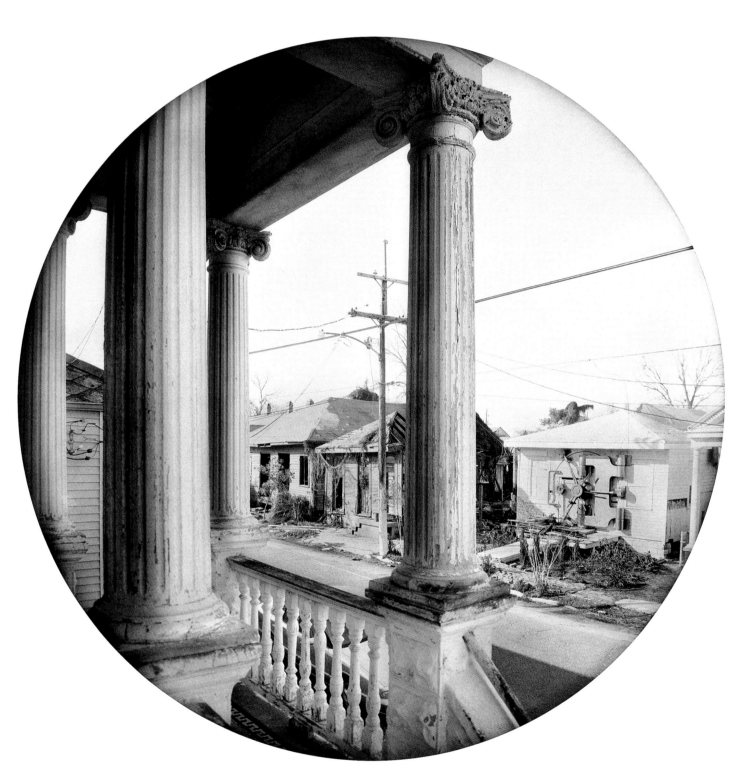

35

Tooth for an Eye

disarchive# 06-22

Location

8801 Edinburg at Eagle - Big Time Lips Bar and Lounge

Date(s)

November 30, 2002 9 p.m. July 31, 2009

Name(s)

Jeffery McLeod (24) unidentified man

Elvery White (27)

Notes: Gunshot - at bar. Gunshot - on sidewalk.

PLATES

Traces of History

Time Exposed

Memory and the Archive

Framing Time and Place

Contemporary Ruins

IDRIS KHAN (British, born 1978)
37 *Houses of Parliament, London,* 2012, digital silver bromide print

I TRY TO CAPTURE THE
ESSENCE OF THE BUILDING—
SOMETHING THAT'S BEEN
PERMANENTLY IMPRINTED
IN SOMEONE'S MIND,
LIKE A MEMORY.

IDRIS KHAN[1]

London-based artist Idris Khan densely layers texts and images that he appropriates from a wide array of sources to create new compositions investigating memory, creativity, and experience. Whether photographing and superimposing every page of the score of Franz Joseph Haydn's master oratorio *The Creation* or condensing every spherical gas tank photographed by Bernd and Hilla Becher into a single print, Khan makes photographic palimpsests that explore the medium's capacity to aid memory and reveal what he has described as the "essence" of the subject. In *Houses of Parliament, London,* Khan digitally combined dozens of postcards and stock photographs of the well-known landmark, many of which he had collected from tourist shops around the city, rendering the iconic site simul-taneously recognizable and unfamiliar. In first distilling and then layering these competing images produced for mass consumption into a single, almost other-worldly composition, Khan explores not only how places are perceived and defined through the reproduction and circulation of photographic imagery, but also, more importantly, how this process effectively creates memories of them.

Part of a series commissioned by the *New York Times Magazine* in antici-pation of the 2012 Summer Olympics in London, *Houses of Parliament, London* commemorates the city by invoking its complexity, diversity, and constant change. Although Khan's source images are static and clichéd, his photograph transforms them into a vibrating, shim-mering mass resembling an expressive charcoal sketch whose energetic trac-ings have rendered solid architecture intangible. Big Ben, for example, seems to move across the photograph, its clock appearing in multiple places at once and displaying various times of day. Its apexes, and those of the other Westminster Palace towers, resemble peaks on a frequency chart running along the top of the photograph. Meanwhile, along the bottom, Westminster Bridge's zig-zagging arches weave subtle traces that suggest the ghostly passage of boats along the Thames, endowing the image with what Khan has described as "the feeling of stretched time."[2]

Khan constructed his composite photograph with discerning selection, deliberately choosing images with slightly different viewpoints. Additionally, rather than utilize each source in its entirety, Khan culled only their distinc-tive parts, further denaturing any single, coherent view. In a process of intricate layering, Khan amassed an overflowing abundance of extracted segments— however blurred and fragmented they may be—as a means to convey the elu-siveness, imprecision, and changeability of the memory of a place over time. Compressing the passage of time and history, Khan's picture of the Houses of Parliament conjures instead a multi-plicity of memories of the site, indepen-dent of whether one has actually been there or not. AN/LJU

1. Idris Khan in Kerri MacDonald, "Postcard from a New London," *Lens* (blog), *New York Times,* March 1, 2012, http://lens.blogs.nytimes.com/2012/03/01/postcard-from-london/.
2. "Pretty as a Thousand Postcards." *New York Times Magazine,* March 1, 2012, http://www.nytimes.com/interactive/2012/03/01/magazine/idris-khan-london.html.

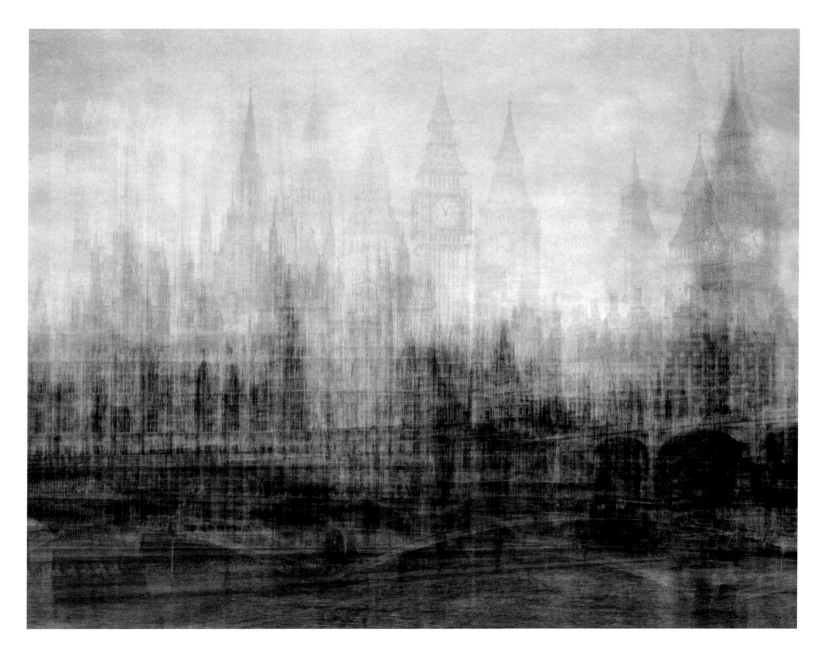

MARK RUWEDEL (American, born 1954)
38–49 *Westward the Course of Empire*, 1994–2007, twelve gelatin silver prints

Mark Ruwedel has photographed the topography of the American West for nearly three decades, often focusing on nature's reclamation of the land over time. For his series *Westward the Course of Empire* (1994–2007), Ruwedel surveyed the once mighty network of railroads that was forged across the western United States and Canada during the second half of the nineteenth century.[1] With many lines now defunct, these grades, cuts, bridges, and tunnels have been transformed through time into sites where the relationship between nature and civilization has come full circle. A fourteen-year project, *Westward* began in Utah when Ruwedel came across an abandoned railroad line by accident and took a photograph of it. The resulting print inspired him to search out other lines, trekking hundreds of miles and taking more than five hundred pictures in the process.

A keen student of nineteenth-century landscape photography, Ruwedel studied the extraordinary work of A. J. Russell, William Henry Jackson, Timothy O'Sullivan, and Carleton Watkins, among others. These practitioners recorded the land and natural resources of the American West for the United States government as well as for private commercial entities, including railroad and logging companies. Their photographic surveys compellingly documented both public and private ambitions for the land, helping to mine its resources, expand tourism, and build the nation. Yet Ruwedel did not rephotograph the same magnificent vistas captured by these photographers; rather, he subverted such grandiose interpretations of the landscape. No longer emblems of industrial

power, the traces of railroad track and bridge pilings are obsolete remnants of the past embedded in the landscape. Revealing how history, particularly the legacy of Manifest Destiny, is visibly written into the land, Ruwedel labeled individual works using the names of locations and railroad lines used during the nineteenth century. Evoking a bygone era when the railroad was the vehicle for territorial conquest and expansion, each title—such as *Oregon California and Eastern*, *Mohave and Milltown*, and *Nevada Short Line* (pls. 44, 47, 48)—is handwritten by the artist on the mount, another nod to historic expedition survey albums.

With his aspirational series title, Ruwedel makes direct reference to Thomas Cole's famous painting cycle *The Course of Empire* (1833–1836). In five grand history paintings, Cole charts the rise of classical civilization from a primitive state to the epitome of empire, and then its ultimate fall into ruination. His canvases reveal the human impact on the landscape through a progression of epochs or states—savage, pastoral, empire, destruction, and desolation— yet in Ruwedel's photographs we see only the last state, desolation. Instead of constructing a cyclical narrative, Ruwedel organizes his photographs in grids that are reminiscent of the typologies constructed by the German photographers Bernd and Hilla Becher, who in their images of historic and often condemned industrial structures were seeking to reclaim aspects of their country's troubled past. Ruwedel also notes that the monumental land art projects from the 1970s by artists such as Robert Smithson and Michael Heizer, helped

him to conceptualize his photographic projects as a type of "earthwork."[2]

In *Westward the Course of Empire* Ruwedel focuses on specific components of the railroad, from the grades and bridges to the cuts made in the rugged landscape that allowed the tracks to pass. The twelve photographs presented here focus on railroad lines that cross open plains. Some of the most subtle works from the series, they reveal tracks that are barely visible under mounds of dirt and vegetation. In some prints, only ghostly traces of lines are left, worn and marked into the landscape, while in others, weathered pieces of wood resembling railroad ties or even trestles are scattered about as if washed up by some past flood. Yet, in this subtlety is a very powerful comment on the fate of history as we see its artifacts disappearing before our eyes. Ruwedel understands the landscape as active and changing and sees the railroad as a dynamic link between technology and the land. Like pieces of forensic evidence that speak of human history in relation to the natural world, Ruwedel's prints question how photographs construct our sense of history and our memory of place as they record the effects of time on the land. AN

1. The United States Congress passed the Pacific Railway Act in 1862, which authorized the construction of a transcontinental railroad. The first such line was completed on May 10, 1869, and by 1900, four additional transcontinental railroads connected the eastern states with the Pacific Coast.
2. Mark Ruwedel, "The Land as Historical Archive," *American Art* 10, no. 1 (Spring 1996): 36–37.
3. Ruwedel, "The Land as Historical Archive," 36–37.

38

39

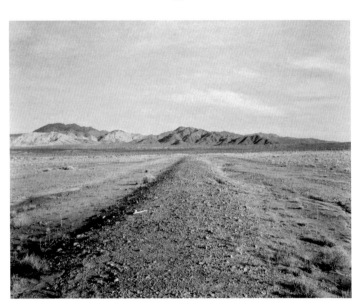

40

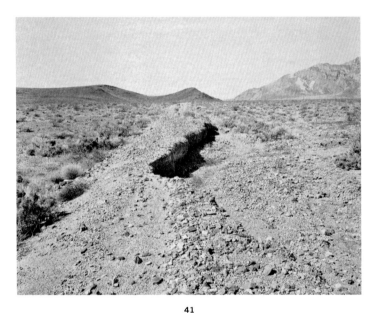

41

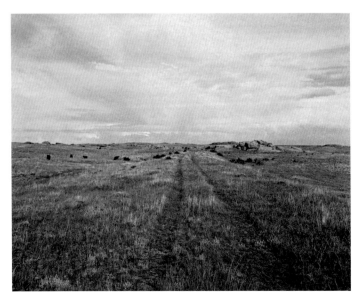

42

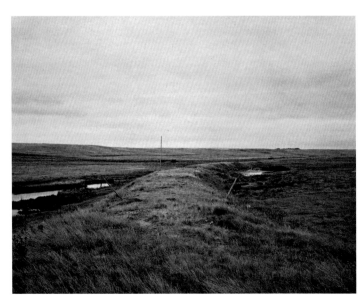

43

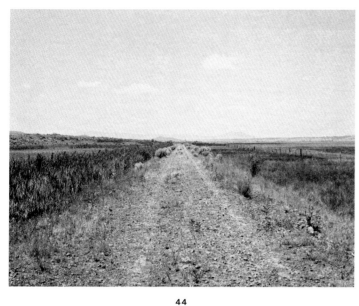

44

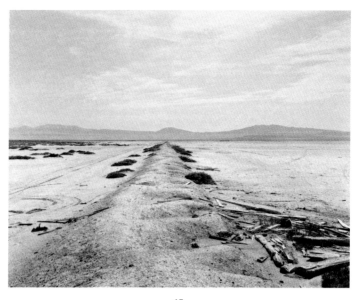

45

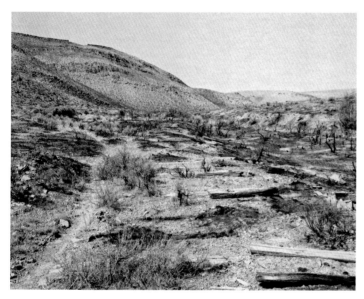

46

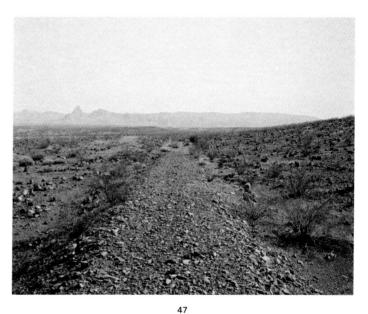
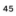

47

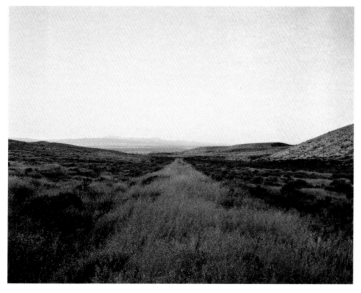

48

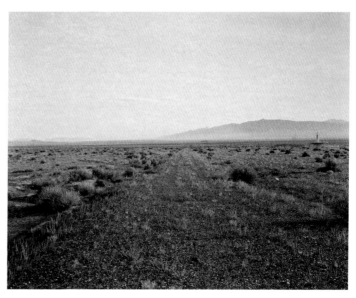

49

AS A LANDSCAPE PHOTOGRAPHER,
I HAVE COME TO THINK OF THE LAND
AS BEING AN ENORMOUS HISTORICAL ARCHIVE.
I AM INTERESTED IN REVEALING THE NARRATIVES
CONTAINED WITHIN THE LANDSCAPE,
ESPECIALLY THOSE PLACES
WHERE THE LAND REVEALS ITSELF
AS BEING BOTH AN AGENT OF CHANGE
AND THE FIELD OF HUMAN ENDEAVOR.

MARK RUWEDEL[3]

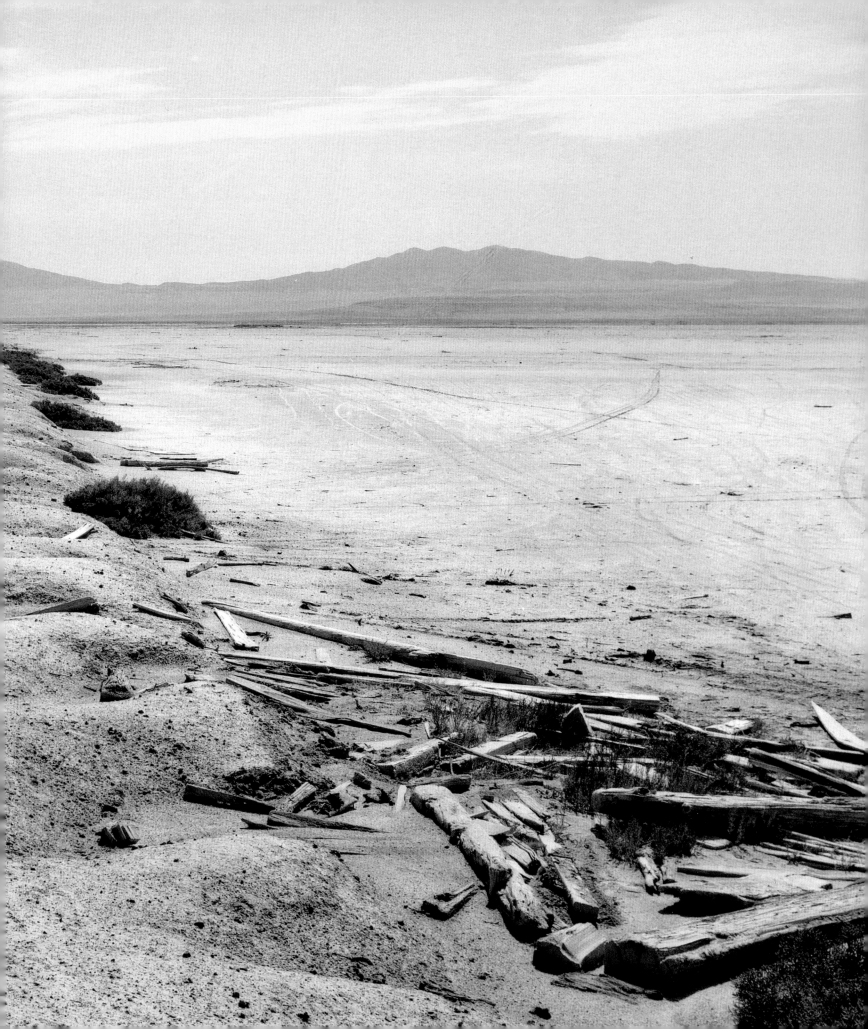

ANDREW MOORE (American, born 1957)

50 *Palace Theater, Gary, Indiana*, 2008, inkjet print

51 *Model T Headquarters, Highland Park, Michigan*, 2009, inkjet print

For the past two decades, Andrew Moore has photographed locations where, as he puts it, "multiple tangents of time overlap and tangle."[1] From forlorn monuments to Soviet rule and decrepit traces of a once glamorous Havana to the spoliated remains of Detroit's industrial quarters, the subjects of Moore's photographs are places that have undergone accelerated cycles of growth and decay, transfigured less by the slow march of time than by sudden catastrophe or cataclysmic change.

Moore, the son of an architect, first studied photography with Emmet Gowin at Princeton. Sensitive to the built environment and fascinated with what he described as "the process of becoming and changing."[2] Moore began to photograph lower Manhattan in 1981 and then spent the next three decades traveling across the globe, using an 8 × 10 view camera to photograph the afterlife of buildings in places that have undergone dramatic change due to political, economic, or social events.

Palace Theater, Gary, Indiana (pl. 50) documents the wreckage of an art deco jewel in what was once a bustling American steel town. Built in 1925 to house vaudeville acts before turning into a movie theater, the Palace was shut down in the early 1970s, a victim of the city's economic downturn, rising crime, and urban blight.

Expansive and elegiac, Moore's photograph hinges upon the poignant contrast between the visible traces of the theater's original function as an ornate space that offered fantasy, pleasure, and entertainment, and its current state of dilapidation. Surrounded by a scattered sea of overturned seats and pipes violently wrenched from crumbling walls, a painted front curtain depicts a sun-kissed, vaguely Mediterranean scene, its harmonious calm a striking contrast with the dramatic ruins that surround it. Framed by the stage's proscenium arch, the curtain functions as a trenchant metaphor for all that has been lost: prosperity, glamor, and the wholeness of a classical order in which architecture serves as a pivot of civic life. The curtain also alludes to the painterly qualities of Moore's photography, which in its saturated color, scale, and subject matter recalls the work of nineteenth-century painters who specialized in sublime landscapes, including Joseph Mallord William Turner, Thomas Cole, and Frederic Edwin Church, among others.

The depiction of ruins and the melancholy pleasures they provide enjoys an even longer history in Western painting and literature. But in Moore's photographs, ruination serves more explicitly as an allegory of modernity's failure. In 2008, Moore began to explore the many abandoned buildings across the city of Detroit and its surrounding areas. Once a shining beacon of American industry and productivity—and the nation's fourth-largest city—by that time Detroit had experienced decades of ever-worsening economic disaster, with tens of thousands of derelict buildings bearing mute witness to the carnage. Moore's photographs reveal less about what has been destroyed, however, than they do about the surreal transformation the city has undergone since, as nature has reclaimed its hold over culture, in a process that Moore has described as "reruralization." In *Model T Headquarters, Highland Park, Michigan* (pl. 51), for example, a velvety layer of emerald green moss has consumed and replaced the original wool carpet in what served as an executive suite in the Ford Company's Highland Park plant during the 1910s and 1920s. Transformed into a warehouse after the Ford operations moved to the River Rouge plant in nearby Dearborn in the late 1920s, the plant was abandoned in the mid-1970s. A powerful metaphor for the fate of Detroit's most famous industry, *Model T Headquarters, Highland Park, Michigan*, offers a startling image of time's forward trajectory reversed: we are witnessing devolution in action.

The movie palace and the executive suite each hold a special place in the fantasy of American life as glamorous, modern, and powerful. In depicting these icons as ruins, Moore goes beyond documenting disaster or invoking our collective nostalgia. Though their aesthetic power lulls us into an awed contemplation of what has been lost, Moore's photographs also acknowledge the contingency of the present and perhaps even quietly challenge the legitimacy of the modern political and social order by picturing an unplanned, anarchic alternative that emerges, phoenixlike, from the ashes. SK

1. Andrew Moore, "The Phoenix and the Pheasants," in Andrew Moore and Philip Levine, *Detroit Disassembled* (Akron Art Museum, 2010), 119.
2. Mike Rubin, "Capturing the Idling of the Motor City," *New York Times*, August 18, 2011, http://www.nytimes.com/2011/08/21/arts/design/andrew-moores-photographic-take-on-detroit-decay.html.
3. Rose Macaulay, *Pleasure of Ruins* (New York, 1966), xvi.

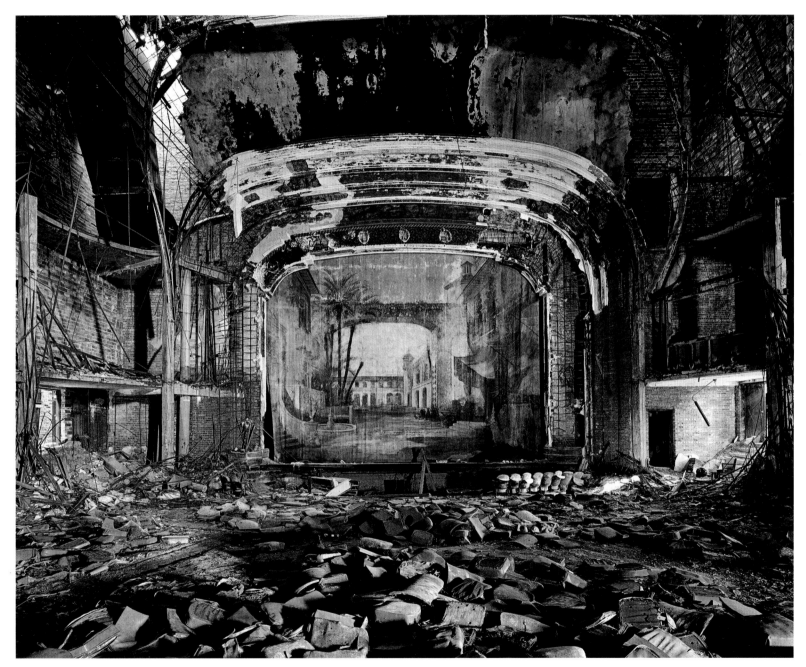

NO CIRCUMSTANCE SO FORCIBLY
MARKS THE DESOLATION OF A SPOT
ONCE INHABITED AS THE PREVALENCE
OF NATURE OVER IT.

ROSE MACAULAY[3]

MIKHAEL SUBOTZKY (South African, born 1981) AND PATRICK WATERHOUSE (British, born 1981)

52 *Doors, Ponte City, Johannesburg,* 2008–2010, light box with color transparency

53 *Televisions, Ponte City, Johannesburg,* 2008–2010, light box with color transparency

Ponte City, a spectacular fifty-four-floor cylindrical skyscraper, was designed as a luxury residential building in a segregated area of Johannesburg, South Africa. Completed in 1975, the building was marketed by developers as white-only, with forty-two floors of apartments and the remaining twelve stories for storage, parking, servants' quarters, and a shopping center.[1] Due to its location, Ponte City was largely unaffected by the 1976 Soweto student uprising.[2] But as South Africa's economy faltered and the end of apartheid changed the country's socioeconomic dynamics, the 1990s saw a white exodus toward the suburbs.[3] The areas surrounding Ponte City slowly emptied out; gangs and drug dealers moved in, and the building became an often contradictory emblem of both urban decay and revitalization in post-apartheid South Africa.

Photographer Mikhael Subotzky and artist Patrick Waterhouse recorded Ponte City at a transitional point in the building's history. In 2007, it was purchased by a developer, who emptied half of it in order to begin renovations; by 2008, after these efforts collapsed, it reverted to the previous owners, who started yet another overhaul. Subotzky and Waterhouse spent much of the time between 2008 and 2010 documenting the site, walking the hallways of the partly inhabited and ransacked structure, where they encountered individuals whom they asked to photograph. Returning with the

prints, they were granted even more access, witnessing the residents' lives and even joining some of them to watch television for hours.[4]

After making thousands of photographs, the artists selected approximately six hundred, which they then divided among three light boxes: one each of doors, windows, and television sets. Following the building's design, they arranged the pictures apartment by apartment, floor by floor, and made the light boxes almost thirteen feet high, suggesting Ponte's soaring presence as it glows over the urban landscape. Ponte City's conflicted racial and socioeconomic history—intertwined with that of the city of Johannesburg itself—unfolds as viewers look from unit to unit, examining the varied doors (some open, some closed), encountering different inhabitants, and occasionally sneaking glimpses of their television screens. On the light box composed of images of televisions, some of the screens glamorize sex and violence, solidifying the perception of Ponte City as a lawless place; others, of children's cartoons and advertisements for soft drinks and shoes, reveal it to be a building where, as the artists note, "young people and families went about their lives calmly."[5]

After opening to much excitement, Ponte City's eventual fate has followed the vicissitudes of South African history from segregation to a more inclusive society, albeit one that retains the vestiges

of the racism that originally defined it. Subotzky and Waterhouse's evocative layering of Ponte City's many and frequently simultaneous phases of construction, decay, and renovation questions the sometimes sensationalized assumptions about the building.[6] Their examination travels up and down its stairwells, peering into apartments, depicting individual lives being lived, presenting a more candid view of the complexity and multiplicity of the place. LJU

1. *South African Jewish Times,* "Ponte-Nucleus Is the Tallest Building in the Southern Hemisphere" (Rosh Hashanah 5736–August 1975): 110, reproduced in Mikhael Subotzky and Patrick Waterhouse, "I. Newsreel," in *Ponte City,* ed. Ivan Vladislavić (Göttingen, 2014), n.p.

2. The series of protests against language regulations in schools culminated on June 16, 1976, in violent clashes between demonstrators and the police. See Michael T. Kaufman, "Witnesses Tell What They Saw When Riots Came to Soweto," *New York Times,* June 28, 1976.

3. Jean Dykstra, "Mikhael Subotzky and Patrick Waterhouse," in Joanna Lehan, Kristen Lubben, Christopher Phillips, and Carol Squiers, *A Different Kind of Order: The ICP Triennial* (New York, 2013), 176.

4. The pair continued their work at Ponte City until 2013, producing additional photographs, installations, and a publication based on the project. See Subotzky and Waterhouse, in *Ponte City,* ed. Vladislavić.

5. Mikhael Subotzky and Patrick Waterhouse, "Ponte City," http://www.subotzkystudio.com/ponte-city-text/.

6. Subotzky and Waterhouse, "Ponte City."

7. Subotzky and Waterhouse, "Ponte City."

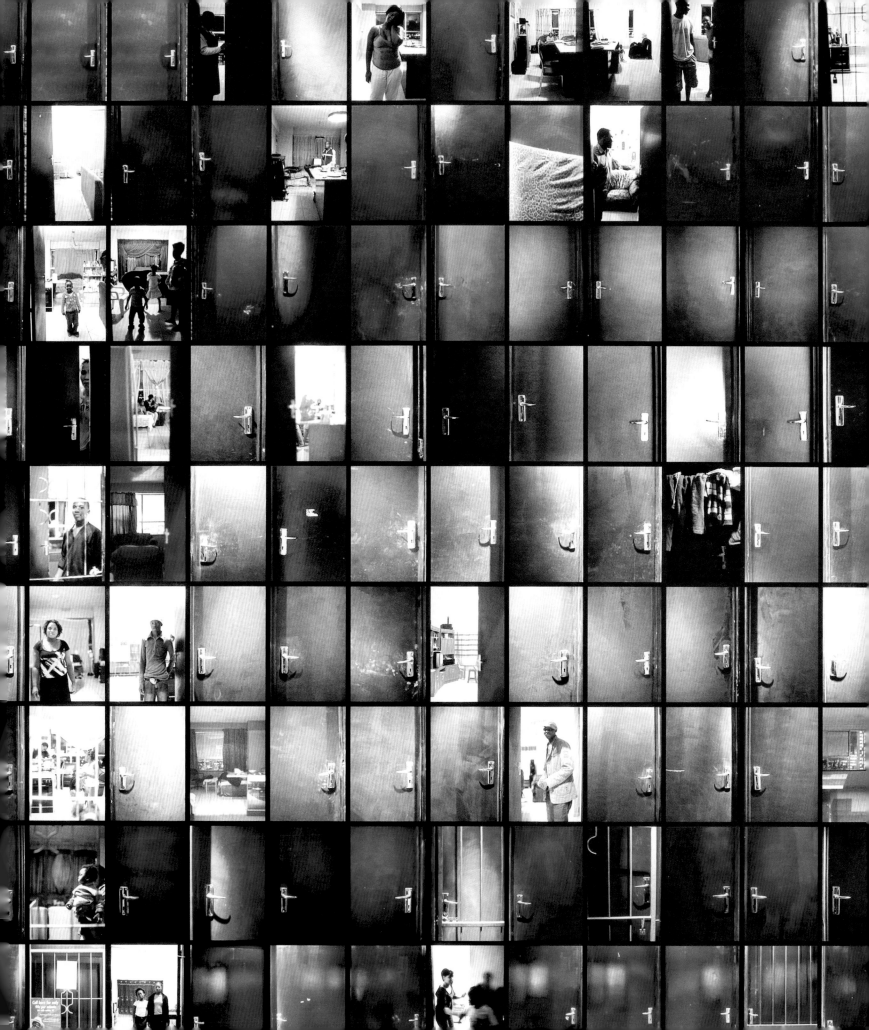

PONTE HAS ALWAYS BEEN
A PLACE OF MYTH, ILLUSION
AND ASPIRATION. THIS IS
WHAT WE SEEK TO EVOKE.

MIKHAEL SUBOTZKY AND
PATRICK WATERHOUSE[7]

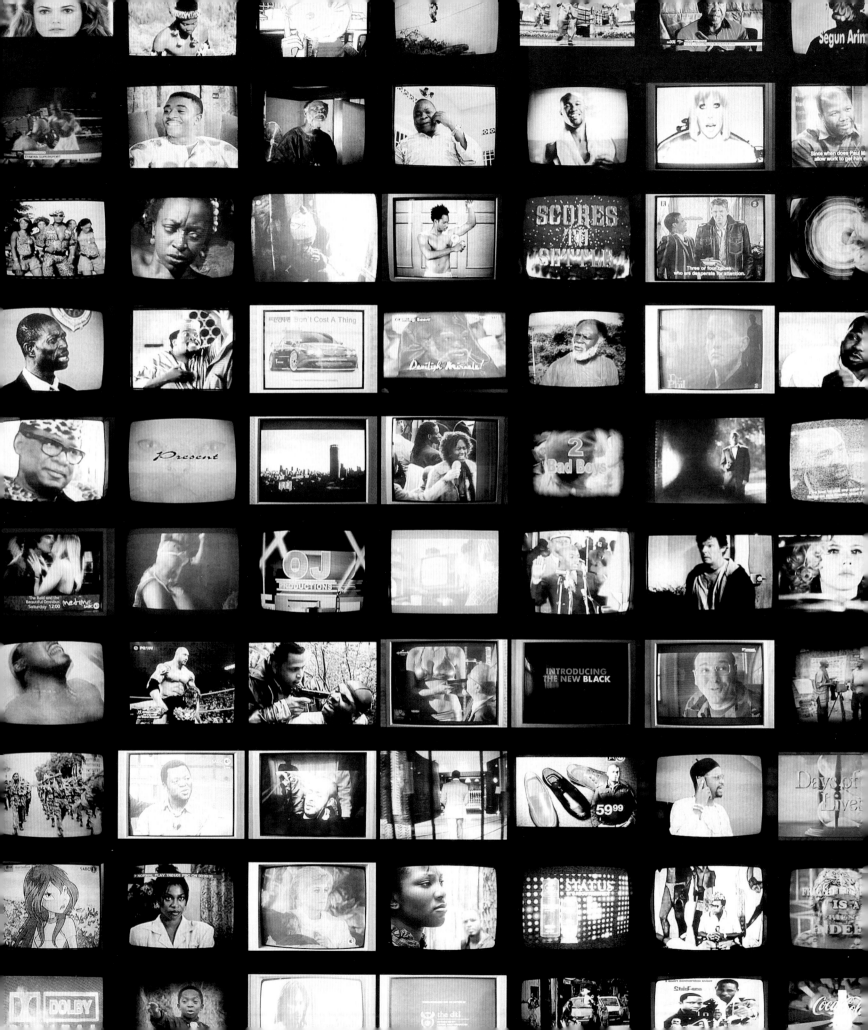

PLATES

Traces of History
Time Exposed
Memory and the Archive
Framing Time and Place
Contemporary Ruins

MOYRA DAVEY (Canadian, born 1958)
54–63 *Copperheads,* 1990, ten chromogenic prints

I AM INTERESTED IN WHAT
CLOSE LOOKING REVEALS
ABOUT THE WORLD.

MOYRA DAVEY[1]

Photographer, filmmaker, and writer Moyra Davey explores the psychological effects of time through the often banal objects of everyday life. Looking to the interior of her own studio, Davey studies dust, old diaries, a pile of newspapers, record albums, and five years' worth of empty liquor bottles as forgotten artifacts, finding within them all a quiet beauty and a surprising sense of melancholy. After earning degrees at Concordia University in Montreal and at the University of California, San Diego, Davey participated in the Whitney Independent Study Program in New York. It was around this time, not too long after the stock market crash of 1987, that she started photographing money and conceived the idea for the series *Copperheads.* Davey later recalled, "I had identified 'money' as a central issue in my life and wanted to make work that investigated the psychology of money."[2] Consisting of one hundred photographs featuring the faces of US pennies the artist found randomly on the city street, in her own coin purse, or purchased from dealers at flea markets, the work is often installed as a grid, with each print roughly 10 × 8 inches. These close-up, almost microscopic views of the abraded and eroded surfaces of pennies were not only a timely commentary on a troubled economy, but also a powerful rumination on the passage of time.

A second iteration of the series, featured here and printed in 2010–2011, is composed of larger photographs organized in smaller sequences, often just in rows. The larger print size, 24 × 20 inches, amplifies the physical marks of wear on each penny, particularly as it affects the engraved profile of Abraham Lincoln. Here, as seen in *Copperhead #22* (pl. 61) and *Copperhead #40* (pl. 59), the surface seems like a skin susceptible to scratches and wounds. In *Copperhead #36* (pl. 58) a silvery gouge on Lincoln's forehead looks like a bullet hole, and in *Copperhead #77* (pl. 55) his lips and mouth are worn away—a more subtle yet equally disturbing image of a voice being silenced. Lincoln's likeness automatically directs our attention to the time of the American Civil War. Pennies are known as "copperheads" in part because when they were first struck, they were made purely of copper. However, "copperhead" was also a derogatory nickname for the Northern Peace Democrats who opposed Lincoln and any involvement in the Civil War. The name came about in reference to the poisonous copperhead snake, as the Northern Peace Democrats were seen as treasonous, betraying the nation in their attacks on the war effort.[3] In Davey's series, the unsettling contrast between the most devalued piece of currency and one of the most elevated figures in American history creates shocking memorial portraits that evoke a deep sense of loss.

Davey's practice is based on intimacy and accident; her concern with the material traces of time and ruination

results in a process that is deceptively modest but actively engages with complex themes. Her almost obsessive attention to detail reveals a keen sensitivity to that which is often overlooked—the mundane and outmoded. As an archive of ghostly silhouettes and a typology of portraits, *Copperheads* recalls photography's early history.[4] Yet rather than providing a recognizable visage, Davey's series of pennies is more abstract in its various stages of disintegration. Similar to Lincoln's vanishing likeness, pennies and physical photographs are becoming obsolete. Once objects of mass circulation, handled with the hands, kept close to the body in lockets and stored in wallets, they are now vestiges of the past to be either thrown away or collected as rarities. AN

1. Adam Szymczyk, "Accidents among the Slow Things: Adam Szymczyk Interviews Moyra Davey," in *Moyra Davey: Speaker Receiver,* ed. Adam Szymczyk (Kunsthalle Basel, 2010), 142.
2. Jess T. Dugan, "A Conversation with Moyra Davey," *Big Red & Shiny* 1, no. 9, April 1, 2008, http://www.bigredandshiny.com/cgi-bin/BRS.cgi?section=article&issue=79&article=INTERVIEW_WITH_MOYRA_2552759.
3. The Northern Peace Democrats embraced their nickname by wearing copper coins as badges of honor highlighting their antiwar stance. Passionate defenders of civil liberties and states' rights, many were also virulent racists.
4. George Baker, "The Absent Photographer," in *Moyra Davey: Speaker Receiver,* 67–68.

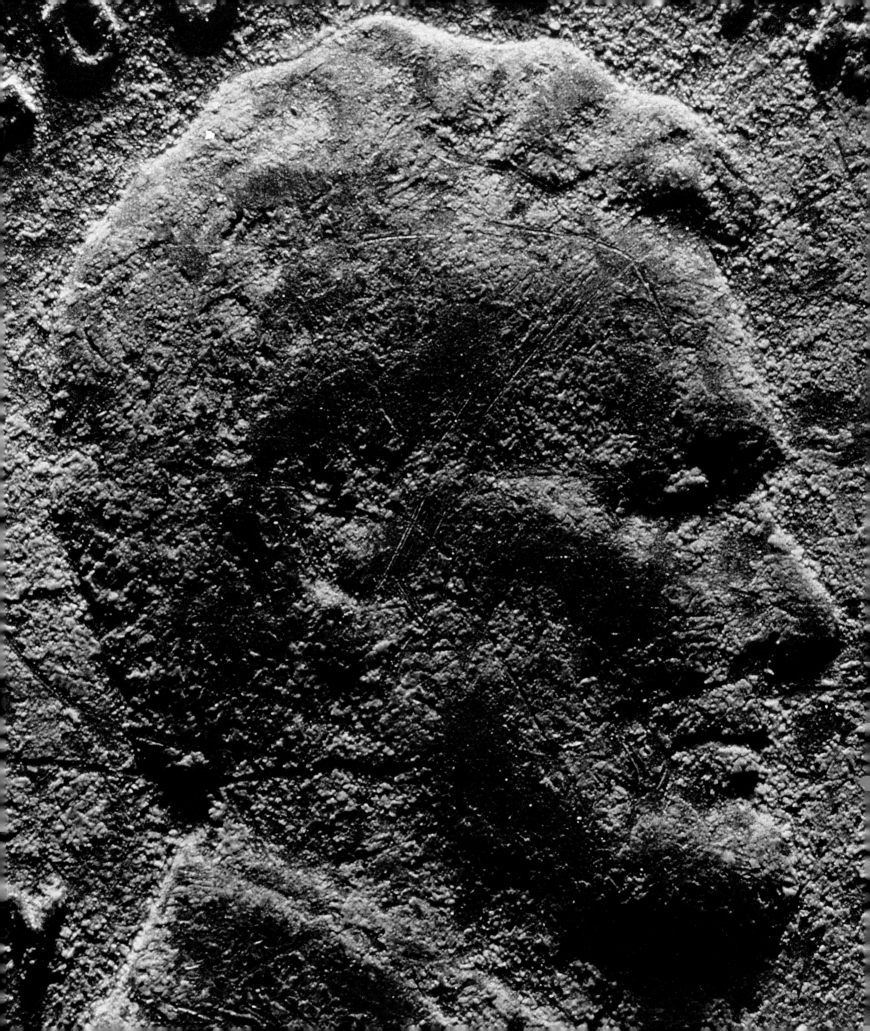

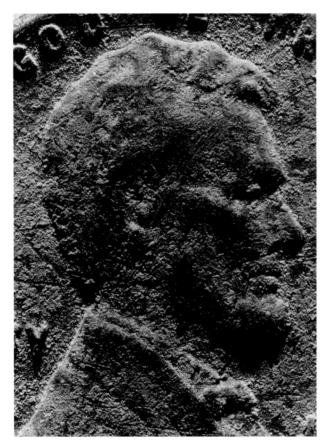

54

55

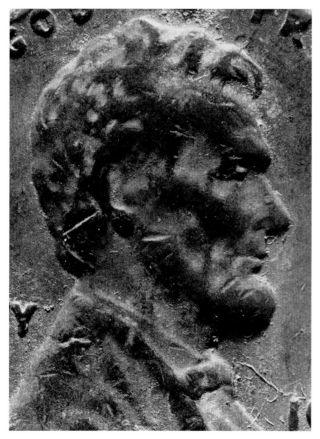

56

57

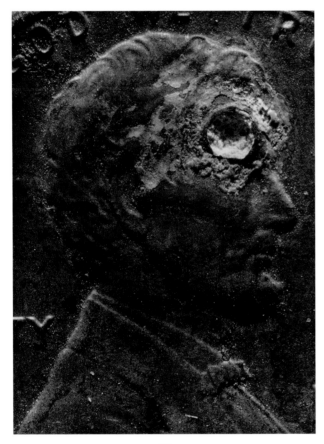

58

59

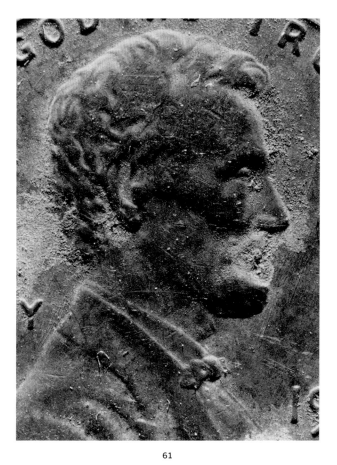

60

61

62
63

WITHO WORMS (Dutch, born 1959)

64 *Farciennes I (Chemin d'Aiseau), Belgium,* 2007, carbon print | **65** *Herzogenrath, Germany,* 2007, carbon print

66 *Rydułtowy II (Anna), Poland,* 2008, carbon print | **67** *Haillicourt, France,* 2007, carbon print

68 *Maerdy, Wales,* 2007, carbon print

Witho Worms' somber yet beautiful landscape photographs investigate the tenuous relationship between humans and the natural environment. The intriguing mountainous forms depicted in his works are actually slag heaps—mounds of waste material produced by coal mining—captured in various stages of use and reclamation. Visiting industrial sites across Belgium, France, Germany, Poland, and Wales, Worms collects coal from each slag heap and then grinds it into a pigment that he uses to produce luminous carbon prints. The atmospheric, almost sooty prints display varying tonalities due to the specific properties of the coal mined from each region: some tend toward brown, others black or gray. Each reveals a point of convergence between representation and reality, combining subject and object into one.

Worms is not only reviving the nineteenth-century technique of carbon printing, he is also engaging with a larger overarching concept. His works comment on how humans have zealously mined the earth for natural resources, and more specifically, on the history of coal production in northern Europe. Fundamental to the growth of the industrial revolution, coal was the means by which these regions amassed significant political and economic power during the nineteenth and twentieth centuries. It was the European Coal and Steel Community that became the forerunner to the European Union. Yet such ambitions come with a cost, and the safety of workers and the long-term effects on the environment have become an issue of intense debate. Coal mining creates energy and employment, but it is also dangerous work that devastates the landscape and contributes to climate change. Merging the natural and industrial landscape, the slag heaps are symbols of the historic and contemporary struggles of the mining industry, from deadly accidents to poverty, workers' strikes, and the eventual decline of iron and steel manufacturing economies across Europe.

Taking a panoramic viewpoint, Worms focuses on the heaps and their relationship with the surrounding landscape. In *Farciennes I (Chemin d'Aiseau), Belgium* (pl. 64), trees and foliage are just beginning to grow on the mound, creating an idyllic background to a marshy, picturesque landscape. Farciennes was once a major city in Belgium's "Black Country," or coal-mining basin, and coal was actively mined in the area until 1984. Infused with a sense of the passage of time, both this print and *Herzogenrath, Germany* (pl. 65), feature reclaimed slag heaps that reveal the astounding resilience of nature: a former wasteland transforms itself into a beautiful, natural setting that at first glance would mask the area's complicated mining history. Yet as remnants of coal production, the towering heaps can appear as pyramidal forms that jut oddly out of the earth, as seen in *Haillicourt, France* (pl. 67) or as barren, windswept pits as in *Maerdy, Wales* (pl. 68). In comparison, *Rydułtowy II (Anna), Poland* (pl. 66) depicts the still-operating Rydułtowy-Anna mine, founded more than two hundred years ago in the Upper Silesia area of Poland, where construction to deepen one of the shafts to over 1,200 meters is currently under way. In this work, an unpaved road winds up the still-young slag heap; the deep tire tracks embedded in the mud are evidence of the necessary trucks and heavy machinery strangely absent from the scene. Together, the five prints featured here reveal the cyclical process of ruination and reclamation of the land.

Worms gave the series and accompanying photography book the title *Cette montagne c'est moi* (This Mountain That's Me), in part as a reference to the miners—the "human origin of the landscape" whose labor and livelihood are so closely interconnected to the creation of the slag heaps. It also refers to the challenges Worms faced when learning the complicated and labor-intensive carbon printing process, having developed and mastered the technique "from the ground up." Worms has called the heaps "burial mounds of a nearly bankrupt capitalist system," yet his prints are more elegiac in their documentation of loss, the ruination of pristine nature and the death of certain industrial practices.[1] Shimmering with specks of coal, they also speak to restoration and the revitalization of the landscape. AN

1. Witho Worms, *Cette montagne c'est moi* (Amsterdam, 2012), 171.

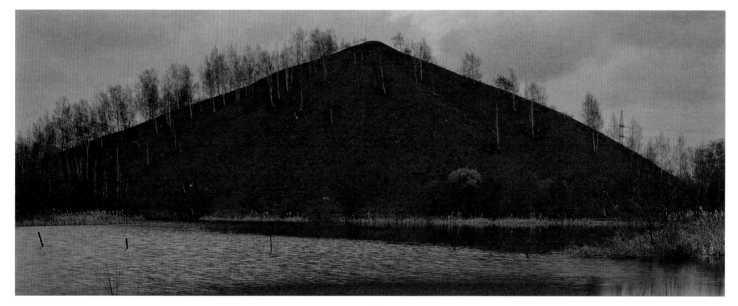

64

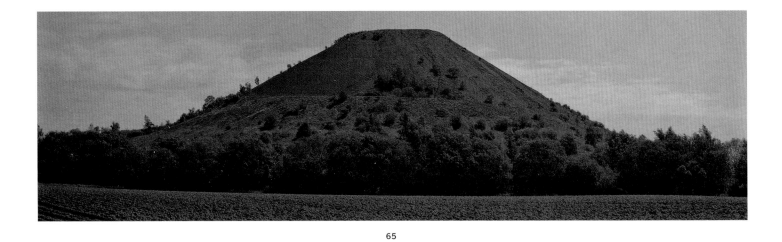

65

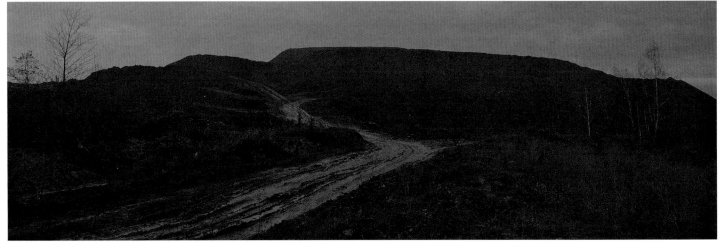

66

67

68

ALISON ROSSITER (American, born 1953)

69 *Eastman Kodak Azo Hard C Grade, expired November 1917, processed 2010 (#2)*, 2010, gelatin silver print

70 *Eastman Kodak Azo Hard C Grade, expired November 1917, processed 2010 (#6)*, 2010, gelatin silver print

Fascinated with the rapidly disappearing materiality of earlier photographic processes, Alison Rossiter has collected old, expired photographic printing paper since 2007, filling her studio with hundreds of packages, which she uses for her art. Made without a camera, her photographs are created solely by developing the lapsed papers. Rossiter's intuitive, organic processes of swirling and dipping sheets in the developing tray, or pouring developer onto them, draws on her extensive technical experience: she began working in the darkroom at the Banff School of Fine Arts at the age of seventeen, moved on to study photography at the Rochester Institute of Technology, and later volunteered in the photography conservation department of the Metropolitan Museum of Art. Through Rossiter's deft handling, each piece reveals its own happenstance: the reactions of the obsolete chemicals and the chance effects of fingerprints, mold, or light leaking into the packaging during the paper's dormant years mottle the surface and render it inky and tenebrous.

The descriptive title of each work identifies the kind of paper used, followed by the date of expiration and the year that Rossiter processed it, making explicit the passage of time that has indelibly marked the sheet. Noting the product's expiration date rather than its manufacture accords each photograph a peculiar but trenchant timeline, calling attention first to its initial instant of death, the subsequent long gap in years, and finally its momentous rebirth when Rossiter rescues it from the dark. By highlighting the distinctive trajectory of the paper, as well as her own later action upon it, Rossiter not only invokes the archival history of photography but also exposes the unsettling yet inevitable effect of time upon matter.

These two gelatin silver prints are made using sheets of a Kodak Azo paper that expired almost a hundred years ago. Azo was a contact printing paper (the negative was placed directly on the pre-sensitized paper and exposed to light, resulting in a print the same size as the negative) and versions of it were produced until 2005. Evoking an eerie,

murky landscape, the pictures' deep blacks conjure the elusive outlines of hills at twilight, topped by smoky, caliginous clouds massing above. This topography offers elliptical glimpses of past photographic imagery, such as Gustave Le Gray's ethereal seascapes and Roger Fenton's atmospheric cloud studies, which Rossiter knew well from her work at the Metropolitan Museum of Art. At the same time, the subtle textures of the sheets remain visible, reminding us of their physical journey through time. As elegies to the visual materiality of silver-based photography as it disappears in the digital age, Rossiter's images fuse past and present together, fashioning a rich yet melancholy afterlife for an outmoded and orphaned technology. DW

1. Robert Enright, "Paper Wait: The Darkroom Alchemy of Alison Rossiter." *Border Crossings* 30, no. 119 (September 2011), 78–79.

69

LAMENT WAS THE FIRST THING I COULD
COME UP WITH IN MY OWN VOCABULARY
FOR THIS LOSS OF MATERIALS,
FOR THE LOSS OF PHOTOGRAPHY.

ALISON ROSSITER[1]

70

THAT HISTORY IS TO BE READ IN ITS TRANSIENCE MEANS THAT ITS TRUTH COMES IN THE FORM OF RUINS. THERE IS NO PHOTOGRAPH THAT DOES NOT TURN ITS "SUBJECTS" TO RUINS.

EDUARDO CADAVA[1]

Taken just after the sun has set below the horizon, these five elegiac photographs from Mark Ruwedel's series *Dusk* depict newly constructed houses in Southern California's Antelope and Imperial Valleys. The homes—some briefly lived in, others never finished—are all now abandoned. Existing in various stages of decay, the neglected structures stand as contemporary ruins, the result of economic recession and ill-conceived suburban development.

During the period of the Enlightenment, ruins came to symbolize Western society's need to understand and reclaim its past and were elevated as a focus of academic contemplation. By the middle of the nineteenth century, a fervor to document ruins spread across Europe and the United States, popularized by the advent of photography. Ruins, like photographs, are traces of the past that embody temporal and historical paradoxes.

In Ruwedel's series, the generically designed houses sit uneasily in the barren landscape of the high desert. For example, in *Dusk #21* (pl. 71), we can look right through the shell of single-story home to see rugged mountains off in the distance.[2] Lacking its facade, this home appears to have been abandoned decades ago. In contrast, *Dusk #5* (pl. 72) reveals a yard littered with discarded mattresses, windblown detritus, and what appears to be a television—evidence that points to a more recent desertion. Both works act as portraits of these neglected homes that are now relics of an early twenty-first-century ghost town.

Known for examining the interaction between society and the landscape of the American West, Ruwedel creates photographs that are "about the interrogation of human values, not only about beauty or geology."[3] In this manner he is participating in a tradition of landscape photography that seeks not to uphold the pristine, awe-inspiring vistas made famous by Ansel Adams during the 1950s and 1960s, but rather calls attention to the delicate balance between human ambition and the environment. Ruwedel's approach is grounded in the "New Topographics" movement, a shift in landscape photography that began in the 1970s and is more conceptual, bridging aesthetic concerns with culturally relevant issues such as environmentalism, national identity, and documentary

modes of production.[4] Ruwedel's tonally rich, luminous prints convey the eerie glow of twilight and force us to come to terms with failure— with the effects of rampant foreclosures, rising unemployment, and severe water shortages that have significantly shaped the cultural identity of the American West over the last twenty years. These prints stand as memorials to a national desire for unlimited resources; their desolate landscapes reveal that unfettered consumption yields tangible consequences, resulting in waste and environmental destruction. AN

1. Eduardo Cadava, *Words of Light: Theses on the Photography of History* (Princeton, 1998), 49.
2. Antelope Valley is bordered by the Tehachapi and San Gabriel Mountains.
3. Edward Robinson, "Artists on New Topographics, Part I: Mark Ruwedel," October 29, 2009, http://unframed.lacma.org/2009/10/29/artists-on-new-topographics-part-i-mark-ruwedel.
4. "New Topographics" was named after the landmark exhibition *New Topographics: Photographs of a Man-Altered Landscape* originally mounted in 1975 at George Eastman House International Museum of Photography and Film and included the photographers Robert Adams, Lewis Baltz, Bernd and Hilla Becher, Joe Deal, Frank Gohlke, Nicholas Nixon, John Schott, Stephen Shore, and Henry Wessel Jr. It signaled a paradigm shift in the practice of landscape photography, as photographers began to focus on the often mundane-looking built environment and the uneasy relationship between humans and the landscape.

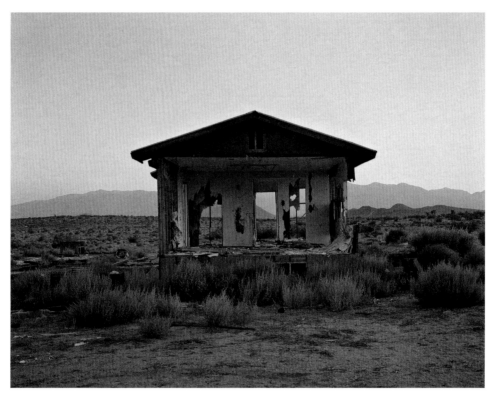

71

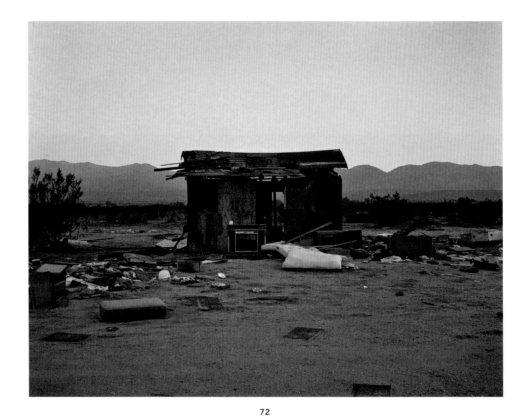

72

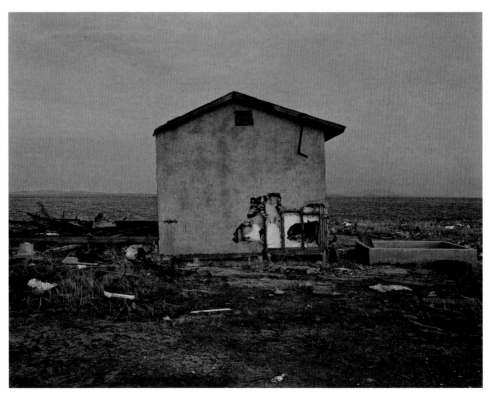

73

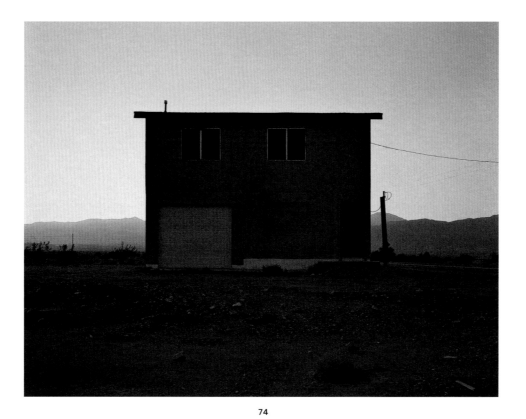

74

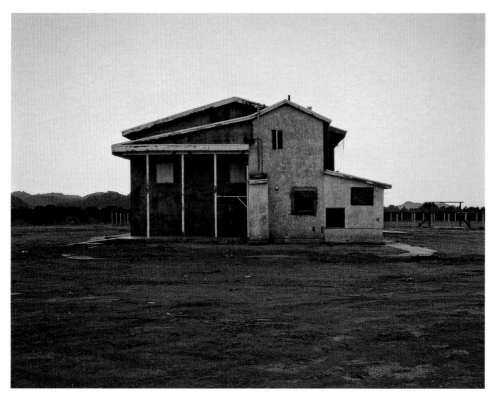

75

CHRISTIAN MARCLAY (American, born 1955)
76 *Allover (A Gospel Reunion),* 2009, cyanotype

WHAT IS DOCUMENTED IN THESE PHOTOGRAMS IS NOT MUSIC BUT THE SHADOW OF A RECORDING MEDIUM, IN THIS CASE MAGNETIC TAPE, AN ALMOST OBSOLETE MEDIUM.

CHRISTIAN MARCLAY[1]

Celebrated filmmaker and multimedia collage artist Christian Marclay has been exploring the connections between sound recording, photography, film, and video since the late 1970s. In early performances with phonograph records and turntables, Marclay—an experimental composer and avant-garde DJ—created a "theater of found sound."[2] Guided by a conceptual understanding of sound, he also turned to making works of art that explore the interplay between the audible and the visual. In 2007, Marclay began a series of cyanotypes in collaboration with the University of South Florida's Graphicstudio involving audiocassettes, some intact and some broken. He placed the obsolete and often ruined cassettes, along with reels of unspooled tape and bobbins, directly onto photosensitized paper, then exposed them to ultraviolet light.

Allover (A Gospel Reunion) is part of the *Allover* series—a group of large, horizontal cyanotypes that invoke the critical language used to describe the revolutionary 1950s paintings of Jackson Pollock and other abstract expressionist artists. To work "allover" the canvas is both a physical means of production and a metaphorical interpretation; it requires giving equal weight to all parts of the composition as there is no longer a clear determination between foreground and background, center and periphery.[3] It also requires that the material support be placed on the ground so that the artist can move around it. Instead of recreating Pollock's famous drips and pours with everyday house paint and sticks, Marclay drapes magnetic audiotape across the paper, creating dense, tangled skeins in some areas and, in others, delicate calligraphic lines that underscore the improvisational nature of the production process. Marclay then makes multiple exposures, spreading the audiotape over the paper several times and adding pieces of cassettes in order to create varying tones and allow chance and serendipity to assist him in the construction of his final compositions.

Named after one of the broken cassette tapes seen in reverse in the lower left, *Allover (A Gospel Reunion)* is dynamic: like both gospel music and Pollock's paintings, the exuberant composition leaps, soars, and swirls back on itself in a soulful refrain. The evocative photogram—a one-of-a-kind image made without a camera—is composed of rich blue hues due to the iron salts in the paper that constitute the cyanotype. First invented by Sir John Herschel in 1842, cyanotypes were quickly utilized by figures such as botanist and photographer Anna Atkins (1799–1871) to make studies of plants. However, the process was more commonly used by architects and engineers to make reproductions of plans known as blueprints; in the early 1950s, Robert Rauschenberg revitalized it for the fine arts.

Marclay has pushed the cyanotype far beyond these earlier sources by layering historical references and merging popular culture with fine art. By repurposing cast-off, cultural artifacts, Marclay intertwines Marcel Duchamp's conception of the readymade with Pollock's drip painting.[4] However, his use of audiocassette tapes speaks of both cultural loss and technological obsolescence: "We assume, because we're able to capture sounds or images, that they will exist forever—when, in fact, obsolescence makes you feel the limit of those assumptions."[5] Harking back to some of the earliest photographs ever made and some of the most celebrated art of the twentieth century, and merging two outmoded technologies—cyanotypes and audiocassette tapes—Marclay brilliantly explores the resonances between past and present, between aural and visual. AN

1. Lyle Rexer, "Blue Tape: Christian Marclay's Old Masters," *DAMn,* no. 33 (May/June 2012): 104.
2. "Christian Marclay," University of South Florida Graphicstudio, http://www.graphicstudio.usf.edu/GS/artists/marclay_christian/marclay.html.
3. Noam M. Elcott, "Untimely Detritus: Christian Marclay's Cyanotypes," in *Christian Marclay et al., Cyanotypes: Christian Marclay* (Tampa, 2011), viii. In regard to abstract expressionism, Harold Rosenberg describes the canvas as an arena for action, while Clement Greenberg advocates it as an optical space for contemplation.
4. A pioneer of the dada movement, Duchamp designated mass-produced, often utilitarian objects as art by simply giving them the title of "readymade."
5. Christian Marclay quoted in Frances Richard, "Music I've Seen: Christian Marclay in Conversation with Frances Richard," *Aperture,* no. 212 (Fall 2013): 30. Marclay also noted, "[T]here's always a sense of nostalgia in something that records the passing of time. But you can have a critical look at things that seem nostalgic."

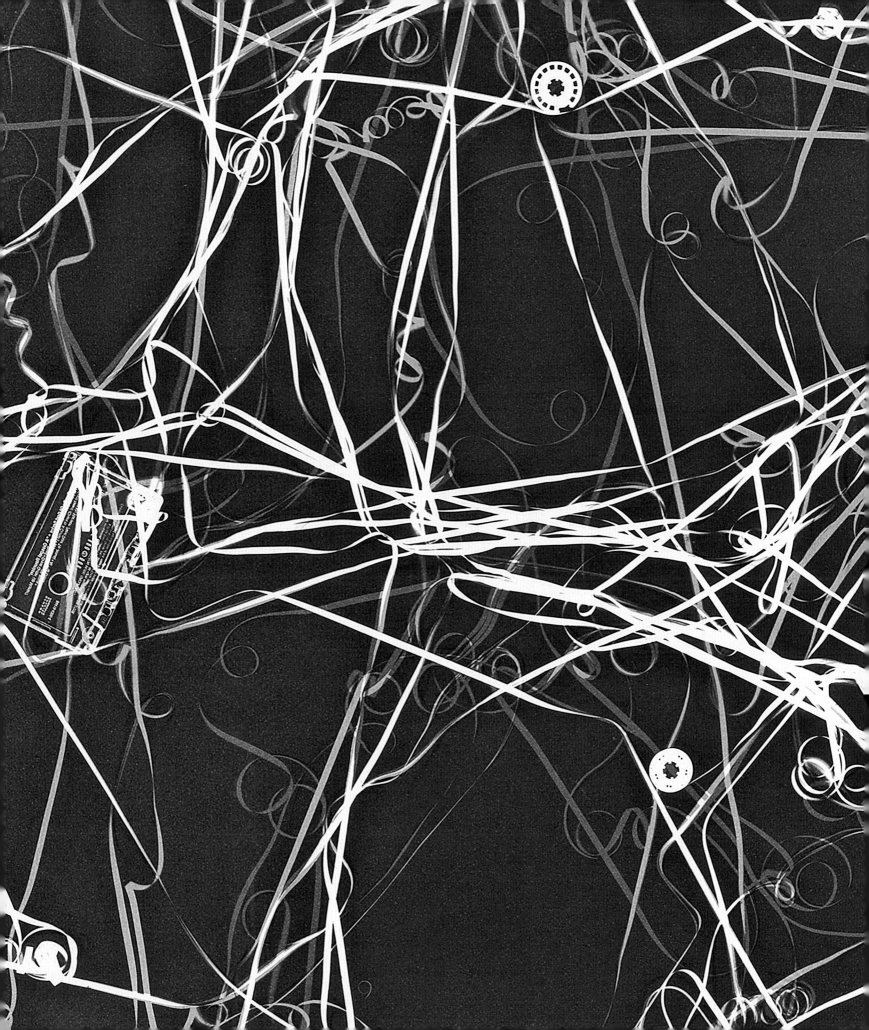

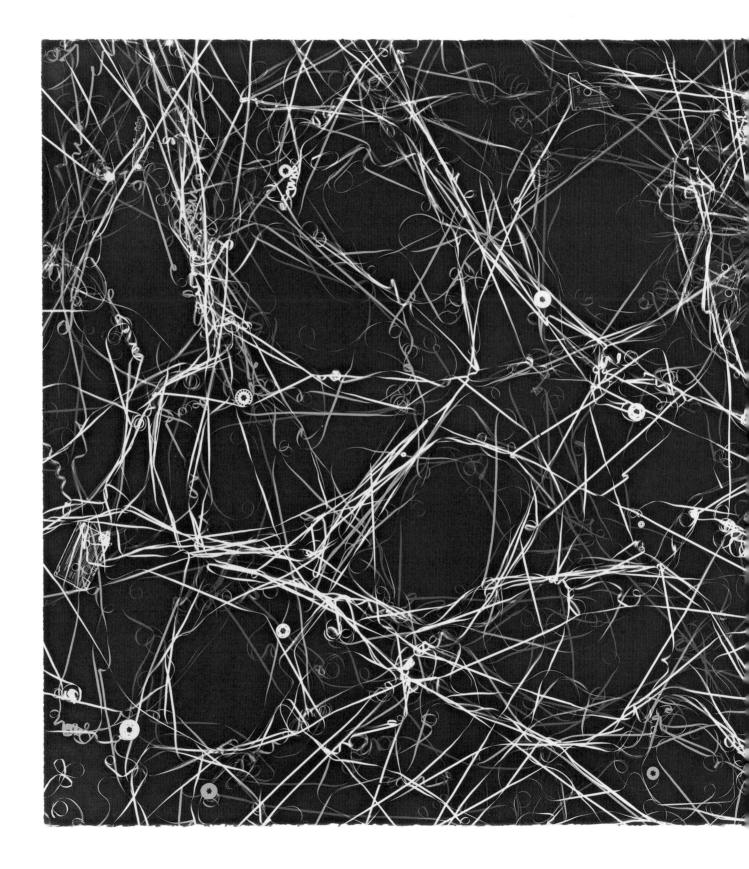

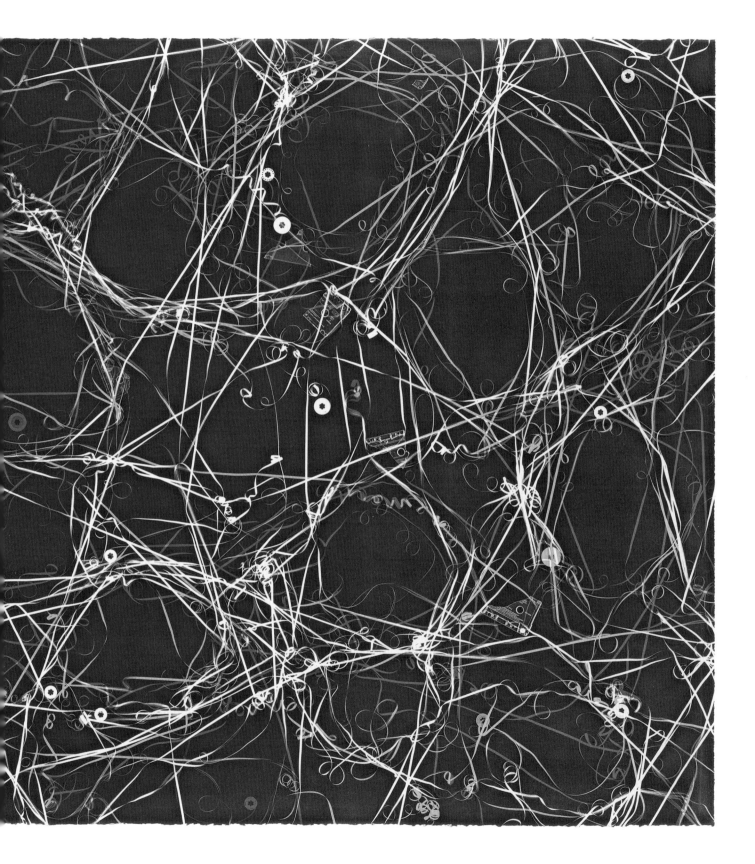

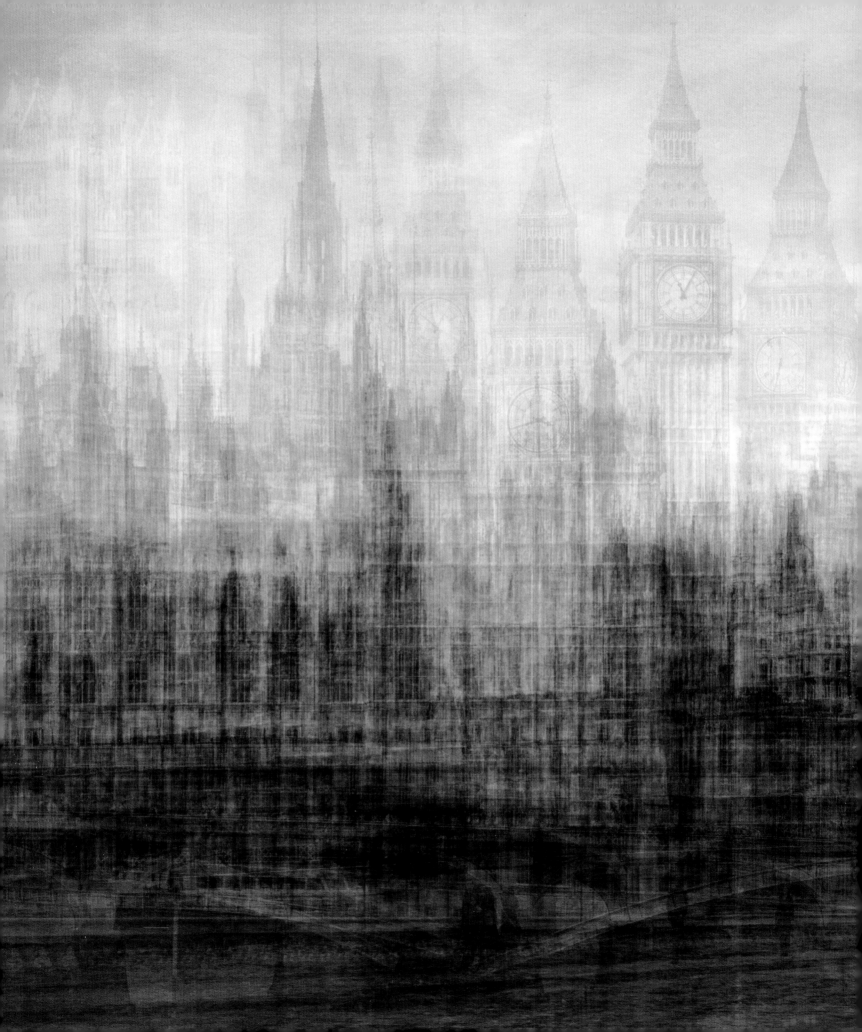

CHECKLIST OF THE EXHIBITION

1 CHUCK CLOSE
Kara, 2007, daguerreotype, 21.59 ×
16.51 cm (8 ½ × 6 ½ in.), Alfred H. Moses
and Fern M. Schad Fund

2 CARRIE MAE WEEMS
After Manet, 2002, chromogenic
print, printed 2015, 78.74 × 78.74 cm
(31 × 31 in.), Alfred H. Moses and
Fern M. Schad Fund

3 CARRIE MAE WEEMS
May Flowers, 2002, chromogenic
print, printed 2013, 78.74 × 78.74 cm
(31 × 31 in.), Alfred H. Moses and
Fern M. Schad Fund

4 SALLY MANN
Untitled (Self-Portraits), 2006–2012
nine ambrotypes, each: 38.1 × 34.29 cm
(15 × 13 ½ in.), Alfred H. Moses and Fern M.
Schad Fund

5 MYRA GREENE
*Untitled [Ref. #77] from Character
Recognition*, 2007, ambrotype,
9.9 × 7.5 cm (3 ⅞ × 2 ¹⁵⁄₁₆ in.), Alfred
H. Moses and Fern M. Schad Fund

6 MYRA GREENE
*Untitled [Ref. #60] from Character
Recognition*, 2006, ambrotype,
9.9 × 7.5 cm (3 ⅞ × 2 ¹⁵⁄₁₆ in.), Alfred
H. Moses and Fern M. Schad Fund

7 MYRA GREENE
*Untitled [Ref. #56] from Character
Recognition*, 2006, ambrotype,
10.2 × 7.7 cm (4 × 3 ¹⁄₁₆ in.), Alfred
H. Moses and Fern M. Schad Fund

8 MYRA GREENE
*Untitled [Ref. #72] from Character
Recognition*, 2007, ambrotype,
10 × 7.5 cm (3 ¹⁵⁄₁₆ × 2 ¹⁵⁄₁₆ in.), Alfred
H. Moses and Fern M. Schad Fund

9 MYRA GREENE
*Untitled [Ref. #63] from Character
Recognition*, 2006, ambrotype,
10.1 × 7.4 cm (4 × 2 ¹⁵⁄₁₆ in.), Alfred
H. Moses and Fern M. Schad Fund

10 MYRA GREENE
*Untitled [Ref. #20] from Character
Recognition*, 2006, ambrotype,
7.4 × 10.1 cm (2 ¹⁵⁄₁₆ × 4 in.), Alfred
H. Moses and Fern M. Schad Fund

11 MYRA GREENE
*Untitled [Ref. #75] from Character
Recognition*, 2007, ambrotype,
10.5 × 7.5 cm (4 ⅛ × 2 ¹⁵⁄₁₆ in.), Alfred
H. Moses and Fern M. Schad Fund

12 DAVID MAISEL
History's Shadow GM16, 2010, inkjet print,
74.93 × 100.97 cm (29 ½ × 39 ¾ in.),
Alfred H. Moses and Fern M. Schad Fund

13 DAVID MAISEL
History's Shadow GM12, 2010, inkjet print,
100.33 × 75.57 cm (39 ½ × 29 ¾ in.),
Alfred H. Moses and Fern M. Schad Fund

14 ADAM FUSS
For Allegra, from the series "My Ghost,"
2012, daguerreotype, 59.69 × 96.52 cm
(23 ½ × 38 in.), Alfred H. Moses and Fern M.
Schad Fund

15 BINH DANH
Sugar Pine Tree, Yosemite, CA, April 2, 2012,
2012, daguerreotype, 21.59 × 16.51 cm
(8 ½ × 6 ½ in.), Alfred H. Moses and Fern M.
Schad Fund

16 BINH DANH
*Lower Yosemite Falls, Yosemite, CA,
October 13, 2011*, 2011, daguerreotype,
21.59 × 16.51 cm (8 ½ × 6 ½ in.), Alfred H.
Moses and Fern M. Schad Fund

17 MATTHEW BRANDT
Salton Sea C1, 2007, salted paper print,
75.57 × 96.52 cm (29 ¾ × 38 in.), Alfred H.
Moses and Fern M. Schad Fund

18 CHRIS MCCAW
Sunburned GSP #475 (San Francisco Bay),
2011, two gelatin silver paper negatives,
top: 20.2 × 25 cm (7 ¹⁵⁄₁₆ × 9 ¹³⁄₁₆ in.),
bottom: 20.3 × 25 cm (8 × 9 ¹³⁄₁₆ in.),
Alfred H. Moses and Fern M. Schad Fund

19 CHRIS MCCAW
*Sunburned GSP #492 (North Slope
Alaska—24 Hours)*, 2011, thirteen gelatin
silver paper negatives, overall, framed:
60.01 × 274.32 cm (23 ⅝ × 108 in.),
Alfred H. Moses and Fern M. Schad Fund

20 CHRIS MCCAW
Sunburned GSP #541 (Galapagos), 2012,
gelatin silver paper negative, 25 × 20.3 cm
(9 ¹³⁄₁₆ × 8 in.), Alfred H. Moses and Fern M.
Schad Fund

21 HIROSHI SUGIMOTO
Tri City Drive-In, San Bernardino, 1993,
gelatin silver print, 42.4 × 54.3 cm
(16 ¹¹⁄₁₆ × 21 ⅜ in.), Alfred H. Moses and
Fern M. Schad Fund

22 HIROSHI SUGIMOTO
101 Drive-In, Ventura, 1993, gelatin silver print, 42.3 × 54.3 cm (16 ⅝ × 21 ⅜ in.), Alfred H. Moses and Fern M. Schad Fund

23 VERA LUTTER
Ca' del Duca Sforza, Venice II: January 13–14, 2008, 2008, three gelatin silver paper negatives, overall, framed: 265.43 × 430.53 cm (104 ½ × 169 ½ in.), Alfred H. Moses and Fern M. Schad Fund

24 UTA BARTH
…and to draw a bright white line with light (Untitled 11.5), 2011, three inkjet prints, overall, framed: 95.41 × 431.64 cm (37 ⁹⁄₁₆ × 169 ¹⁵⁄₁₆ in.), Alfred H. Moses and Fern M. Schad Fund

25 LINDA CONNOR
July 23, 1903, 2002, gelatin silver print, 25.3 × 20.3 cm (9 ¹⁵⁄₁₆ × 8 in.), Alfred H. Moses and Fern M. Schad Fund

26 LINDA CONNOR
September 3, 1895, 2002, gelatin silver print, 25.4 × 20.2 cm (10 × 7 ¹⁵⁄₁₆ in.), Alfred H. Moses and Fern M. Schad Fund

27 LINDA CONNOR
April 16, 1893, 1997, gelatin silver print, 24.5 × 20 cm (9 ⅝ × 7 ⅞ in.), Alfred H. Moses and Fern M. Schad Fund

28 LINDA CONNOR
August 10, 1955, 1996, gelatin silver print, 20.2 × 25 cm (7 ¹⁵⁄₁₆ × 9 ¹³⁄₁₆ in.), Alfred H. Moses and Fern M. Schad Fund

29 BINH DANH
Ghost of Tuol Sleng Genocide Museum #1, 2008, daguerreotype, 21.59 × 16.51 cm (8 ½ × 6 ½ in.), Alfred H. Moses and Fern M. Schad Fund

30 SOPHIE CALLE
Autobiographies (Wait for Me), 2010, inkjet print and text panel, photograph: 170.18 × 99.06 cm (67 × 39 in.), text panel: 49.53 × 49.53 cm (19 ½ × 19 ½ in.), Alfred H. Moses and Fern M. Schad Fund

31 ISHIUCHI MIYAKO
Mother's #24, 2001, gelatin silver print, printed 2014, 107.5 × 74 cm (42 ⁵⁄₁₆ × 29 ⅛ in.), Alfred H. Moses and Fern M. Schad Fund

32 ISHIUCHI MIYAKO
Mother's #49, 2002, gelatin silver print, printed 2014, 107.5 × 74 cm (42 ⁵⁄₁₆ × 29 ⅛ in.), Alfred H. Moses and Fern M. Schad Fund

33 CARRIE MAE WEEMS
Slow Fade to Black II, 2010, seventeen inkjet prints, each: 33.18 × 25.56 cm (13 ¹⁄₁₆ × 10 ¹⁄₁₆ in.), Alfred H. Moses and Fern M. Schad Fund
Artists' names, left to right and top to bottom: Dinah Washington, Mary Lou Williams, Marian Anderson, Mahalia Jackson, Koko Taylor, Abbey Lincoln, Billie Holiday, Betty Carter, Ella Fitzgerald, Dorothy Dandridge, Leontyne Price, Dorothy Dandridge, Pearl Bailey, Dinah Washington, Nina Simone, Shirley Bassey, Ethel Waters

34 SUSAN MEISELAS
The Life of an Image: "Molotov Man," 1979–2009, 2014, mixed-media installation, dimensions variable, Alfred H. Moses and Fern M. Schad Fund

34A Series of transparencies from the final assault on the National Guard Headquarters, Estelí, Nicaragua, July 16, 1979; **34B** Final assault on the National Guard Headquarters, Estelí, Nicaragua, July 16, 1979; **34C** The moment before, Estelí, Nicaragua, July 16, 1979; **34D** "Molotov Man" at the walls of the National Guard Headquarters, Estelí, Nicaragua, July 16, 1979; **34E** Tear sheet from Swedish magazine, c. 1981;

34F First anniversary matchboxes of the FSLN triumph over Somoza, Nicaragua, July 1980; **34G** Catholic church publication, Nicaragua, 1980; **34H** Sandinista poster to raise a popular militia, Nicaragua, 1982; **34I** Flyer soliciting funds for Contra revolution, United States, 1983; **34J** Mural featuring Nicaraguan folk legends including "Molotov Man," Masaya, Nicaragua, 1986; **34K** Wall previously painted with "Molotov Man," blackened before election campaign, Masaya, Nicaragua, 1991; **34L** Wall stencil based on "Molotov Man," Estelí, Nicaragua, 1982; **34M** Wall stencil mobilizing popular militia to fight against the Contra, based on "Molotov Man," and reads "They will not pass," Estelí, Nicaragua, 1982; **34N** Interview with "Molotov Man," Pablo Jesús Aráuz, in Somoto, Nicaragua, March 25, 1990, outtake from the film *Pictures from a Revolution* by Susan Meiselas, Alfred Guzzetti, and Richard P. Rogers; **34O** Excerpt from the film *Reframing History* by Susan Meiselas and Alfred Guzzetti, showing the mural installation for the twenty-fifth anniversary of the overthrow of Somoza by the FSLN, Estelí, Nicaragua, July 2004; **34P** Monument to Pablo Jesús Aráuz, known as "Molotov Man," Estelí, Nicaragua, July 2009; **34Q** T-shirts sold at the thirtieth anniversary celebration in the Plaza of the Revolution, Managua, Nicaragua, July 2009

35 DEBORAH LUSTER
Tooth for an Eye: A Chorography of Violence in Orleans Parish #06-16, 2008–2011, ledger panel and gelatin silver print, overall, framed: 68.58 × 159.39 cm (27 × 62 ¾ in.), Alfred H. Moses and Fern M. Schad Fund

36 DEBORAH LUSTER
Tooth for an Eye: A Chorography of Violence in Orleans Parish #06-22, 2008–2011, ledger panel and gelatin silver print, overall, framed: 68.58 × 159.39 cm (27 × 62 ¾ in.), Alfred H. Moses and Fern M. Schad Fund

37 IDRIS KHAN
Houses of Parliament, London, 2012, digital silver bromide print, 76.2 × 101.6 cm (30 × 40 in.), Alfred H. Moses and Fern M. Schad Fund

38 MARK RUWEDEL
Carson and Colorado #6 from *Westward the Course of Empire*, 1997, gelatin silver print, 19 × 24.1 cm (7 ½ × 9 ½ in.), Gift of Dan and Jeanne Fauci

39 MARK RUWEDEL
Utah Southern Extension #4 from *Westward the Course of Empire*, 2001, gelatin silver print, 18.8 × 24.4 cm (7 ⅜ × 9 ⅝ in.), Alfred H. Moses and Fern M. Schad Fund

40 MARK RUWEDEL
Tecopa #1 from *Westward the Course of Empire*, 1996, gelatin silver print, 18.8 × 24.2 cm (7 ⅜ × 9 ½ in.), Gift of Peter T. Barbur

41 MARK RUWEDEL
Death Valley #1 from *Westward the Course of Empire*, 1995, gelatin silver print, 19 × 24.4 cm (7 ½ × 9 ⅝ in.), Alfred H. Moses and Fern M. Schad Fund

42 MARK RUWEDEL
Union Pacific #20 from *Westward the Course of Empire*, 1996, gelatin silver print, 19.3 × 24.1 cm (7 ⅝ × 9 ½ in.), Gift of Gregory and Aline Gooding

43 MARK RUWEDEL
Canadian Pacific #3 from *Westward the Course of Empire*, 2000, gelatin silver print, 19.4 × 24.1 cm (7 ⅝ × 9 ½ in.), Alfred H. Moses and Fern M. Schad Fund

44 MARK RUWEDEL
Oregon California and Eastern #1 from *Westward the Course of Empire*, 1998, gelatin silver print, 18.8 × 24.1 cm (7 ⅜ × 9 ½ in.), Alfred H. Moses and Fern M. Schad Fund

45 MARK RUWEDEL
Central Pacific #18 from *Westward the Course of Empire*, 1999, gelatin silver print, 18.9 × 24.2 cm (7 ⁷⁄₁₆ × 9 ½ in.), Gift of Peter T. Barbur

46 MARK RUWEDEL
Nevada Central #4 from *Westward the Course of Empire*, 1999, gelatin silver print, 19 × 24.4 cm (7 ½ × 9 ⅝ in.), Alfred H. Moses and Fern M. Schad Fund

47 MARK RUWEDEL
Mohave and Milltown #3 from *Westward the Course of Empire*, 2004, gelatin silver print, 19 × 24.2 cm (7 ½ × 9 ½ in.), Alfred H. Moses and Fern M. Schad Fund

48 MARK RUWEDEL
Nevada Short Line #1 from *Westward the Course of Empire*, 1998, gelatin silver print, 19.1 × 24.3 cm (7 ½ × 9 ⁹⁄₁₆ in.), Gift of Dan and Jeanne Fauci

49 MARK RUWEDEL
Silver Peak #1 from *Westward the Course of Empire*, 1999, gelatin silver print, 18.8 × 24.1 cm (7 ⅜ × 9 ½ in.), Alfred H. Moses and Fern M. Schad Fund

50 ANDREW MOORE
Palace Theater, Gary, Indiana, 2008, inkjet print, 91.44 × 115.57 cm (36 × 45 ½ in.), Alfred H. Moses and Fern M. Schad Fund

51 ANDREW MOORE
Model T Headquarters, Highland Park, Michigan, 2009, inkjet print, 91.44 × 115.57 cm (36 × 45 ½ in.), Alfred H. Moses and Fern M. Schad Fund

52 MIKHAEL SUBOTZKY AND PATRICK WATERHOUSE
Doors, Ponte City, Johannesburg, 2008–2010, light box with color transparency, 388 × 128.4 × 17.15 cm (152 ¾ × 50 ½ × 6 ¾ in.), Alfred H. Moses and Fern M. Schad Fund

53 MIKHAEL SUBOTZKY AND PATRICK WATERHOUSE
Televisions, Ponte City, Johannesburg, 2008–2010, light box with color transparency, 388 × 128.4 × 17.15 cm (152 ¾ × 50 ½ × 6 ¾ in.), Alfred H. Moses and Fern M. Schad Fund

54 MOYRA DAVEY
Copperhead #95, 1990, chromogenic print, printed 2010–2011, 61 × 45.8 cm (24 × 18 ¹⁄₁₆ in.), Alfred H. Moses and Fern M. Schad Fund

55 MOYRA DAVEY
Copperhead #77, 1990, chromogenic print, printed 2010–2011, 61 × 45.8 cm (24 × 18 ¹⁄₁₆ in.), Alfred H. Moses and Fern M. Schad Fund

56 MOYRA DAVEY
Copperhead #4, 1990, chromogenic print, printed 2010–2011, 61 × 45.8 cm (24 × 18 ¹⁄₁₆ in.), Alfred H. Moses and Fern M. Schad Fund

57 MOYRA DAVEY
Copperhead #48, 1990, chromogenic print, printed 2010–2011, 61 × 45.8 cm (24 × 18 ¹⁄₁₆ in.), Alfred H. Moses and Fern M. Schad Fund

58 MOYRA DAVEY
Copperhead #36, 1990, chromogenic print, printed 2010–2011, 61 × 45.8 cm (24 × 18 ¹⁄₁₆ in.), Alfred H. Moses and Fern M. Schad Fund

59 MOYRA DAVEY
Copperhead #40, 1990, chromogenic print, printed 2010–2011, 61 × 45.8 cm (24 × 18 ¹⁄₁₆ in.), Alfred H. Moses and Fern M. Schad Fund

60 MOYRA DAVEY
Copperhead #50, 1990, chromogenic print, printed 2010–2011, 61 × 45.8 cm (24 × 18 ¹⁄₁₆ in.), Alfred H. Moses and Fern M. Schad Fund

61 MOYRA DAVEY
Copperhead #22, 1990, chromogenic
print, printed 2010–2011, 61 × 45.8 cm
(24 × 18 ¹⁄₁₆ in.), Alfred H. Moses and
Fern M. Schad Fund

62 MOYRA DAVEY
Copperhead #32, 1990, chromogenic
print, printed 2010–2011, 61 × 45.8 cm
(24 × 18 ¹⁄₁₆ in.), Alfred H. Moses and
Fern M. Schad Fund

63 MOYRA DAVEY
Copperhead #44, 1990, chromogenic
print, printed 2010–2011, 61 × 45.8 cm
(24 × 18 ¹⁄₁₆ in.), Alfred H. Moses and
Fern M. Schad Fund

64 WITHO WORMS
Farciennes I (Chemin d'Aiseau), Belgium,
2007, carbon print, 19.1 × 49 cm
(7 ½ × 19 ⁵⁄₁₆ in.), Alfred H. Moses and
Fern M. Schad Fund

65 WITHO WORMS
Herzogenrath, Germany, 2007, carbon
print, 14.3 × 49 cm (5 ⅝ × 19 ⁵⁄₁₆ in.), Alfred
H. Moses and Fern M. Schad Fund

66 WITHO WORMS
Ryduttowy II (Anna), Poland, 2008, carbon
print, 16.3 × 48.9 cm (6 ⁷⁄₁₆ × 19 ¼ in.),
Alfred H. Moses and Fern M. Schad Fund

67 WITHO WORMS
Haillicourt, France, 2007, carbon print,
11 × 48.7 cm (4 ⁵⁄₁₆ × 19 ³⁄₁₆ in.), Alfred H.
Moses and Fern M. Schad Fund

68 WITHO WORMS
Maerdy, Wales, 2007, carbon print,
17.3 × 48.8 cm (6 ¹³⁄₁₆ × 19 ³⁄₁₆ in.), Alfred H.
Moses and Fern M. Schad Fund

69 ALISON ROSSITER
*Eastman Kodak Azo Hard C Grade, expired
November 1917, processed 2010 (#2)*,
2010, gelatin silver print, 35.5 × 43 cm
(14 × 16 ¹⁵⁄₁₆ in.), Alfred H. Moses and
Fern M. Schad Fund

70 ALISON ROSSITER
*Eastman Kodak Azo Hard C Grade, expired
November 1917, processed 2010 (#6)*,
2010, gelatin silver print, 35.5 × 43 cm
(14 × 16 ¹⁵⁄₁₆ in.), Alfred H. Moses and
Fern M. Schad Fund

71 MARK RUWEDEL
Dusk #21 (Antelope Valley #230), 2008,
gelatin silver print, 25.9 × 33.6 cm
(10 ³⁄₁₆ × 13 ¼ in.), Alfred H. Moses and
Fern M. Schad Fund

72 MARK RUWEDEL
Dusk #5 (Antelope Valley #63B), 2007,
gelatin silver print, 26.3 × 34 cm
(10 ⅜ × 13 ⅜ in.), Alfred H. Moses and
Fern M. Schad Fund

73 MARK RUWEDEL
Dusk #46 (Antelope Valley), 2010,
gelatin silver print, 26.1 × 34 cm
(10 ¼ × 13 ⅜ in.), Alfred H. Moses
and Fern M. Schad Fund

74 MARK RUWEDEL
Dusk #51 (Salton City), 2010, gelatin
silver print, 26.3 × 34 cm (10 ⅜ ×
13 ⅜ in.), Alfred H. Moses and Fern M.
Schad Fund

75 MARK RUWEDEL
Dusk #6 (Antelope Valley #65), 2007,
gelatin silver print, 26.2 × 34.2 cm
(10 ⁵⁄₁₆ × 13 ⁷⁄₁₆ in.), Alfred H. Moses
and Fern M. Schad Fund

76 CHRISTIAN MARCLAY
Allover (A Gospel Reunion), 2009,
cyanotype, 130.81 × 254 cm (51 ½ ×
100 in.), Alfred H. Moses and Fern M.
Schad Fund

ACKNOWLEDGMENTS

In 2007, when Alfred H. Moses and Fern M. Schad announced their intention to give the National Gallery of Art an endowed acquisition fund for photography, it was, quite simply, a dream come true. Since we began collecting photographs in 1990, one of our primary objectives has been to establish such a fund because we knew it would ensure the long-term growth of not only the Gallery's collection, but also the photography program more broadly. As any director or curator knows, very few donors understand the importance of such a gift, and even fewer actually make one. It requires the donors to put their faith in the future and the museum itself that the money will be spent wisely. Alfred Moses and Fern Schad are among that very rare breed of philanthropists. No one who knows Alfred and Fern, however, would be surprised by their gift. Deeply committed to justice, Alfred, an attorney and diplomat who was special advisor and special counsel to President Jimmy Carter, special presidential emissary for the Cyprus Conflict, and US ambassador to Romania, has been active in the cultural life of Washington for many years. Fern and her first husband, Tennyson Schad, were the founders of Light Gallery, a pioneering New York City gallery devoted to photography, in the early 1970s. Part of a new wave of interest in photography, the Schads helped introduce to the world at large the importance of photography through their many exhibitions and critical support of photographers themselves. Together, Alfred and Fern have made a gift to the National Gallery of Art that will ensure we are able to expand on that mission and educate generations to come, both in Washington and around the world, about the profound ways photography has influenced art and culture.

As Fern and Light Gallery were so deeply involved with living photographers, and as Alfred has always been engaged with the key issues of our time, their suggestion that we focus our first acquisitions from their fund on contemporary photography made perfect sense. It also helped us acquire major works of art for the collection in an area that we have long wanted to expand. Over the last few years, as we have conceived and formed this exhibition, we have been delighted to work with them. Their suggestions and insights have significantly enriched both the exhibition and the collection, and we thank them immensely for the time they have been willing to devote to this project.

We are also extremely fortunate that this exhibition has enabled us to work with so many gifted artists. We are indebted to all of them for the assistance both they and their representatives have given us. We wish to thank Uta Barth and Ethan Sklar and Annie Rochfort from Tanya Bonakdar Gallery; Matthew Brandt, Chris McCaw, and Alison Rossiter, as well as Yossi Milo and Alissa Schoenfeld from Yossi Milo Gallery; Sophie Calle and Anthony Allen and Cat Kron from Paula Cooper Gallery; Chuck Close and Hiroshi Sugimoto, along with Peter MacGill and Lauren Panzo, from Pace/MacGill Gallery; Binh Danh, Linda Connor, and David Maisel, as well as Cheryl Haines, Sasha Tierney, and Monique Deschaines from Haines Gallery; Moyra Davey and Margaret Murray, Janice Guy, and Fabiana Viso from Murray Guy Gallery; Adam Fuss, Idris Khan, and Christian Marclay, along with Jeffrey Fraenkel, Ola Dlugosz, and Amy Whiteside from Fraenkel Gallery; Myra Greene and Catherine Edelman from Catherine Edelman Gallery; Ishiuchi Miyako and Michael Hoppen from

Michael Hoppen Gallery; Vera Lutter and Leeza Chebotarev from Gagosian Gallery, and Claire Lachow and Casey Baden from the Vera Lutter studio; Sally Mann and Edwynn Houk and Alexis Dean from Edwynn Houk Gallery; Susan Meiselas and Mary Sabbatino from Galerie Lelong, and Alex Nelson from the Susan Meiselas Studio; Andrew Moore and Yancey Richardson and Maggie Waterhouse from the Yancey Richardson Gallery; Mark Ruwedel and Theresa Luisotti, Natasha Berokoff, and Michael Peña from Gallery Luisotti; Mikhael Subotzky and Patrick Waterhouse, along with Liza Essers, Damon Garstang, and Wendy McDonald from The Goodman Gallery; Deborah Luster and Carrie Mae Weems, along with Elisabeth Sann, Brian McCamley, and Daniel Tsai from the Jack Shainman Gallery; and Witho Worms and Johan Deumens from Johan Deumens Gallery.

In addition, we wish to thank Anna Schwartz from Anna Schwartz Gallery; Nowell Karten from Angles Gallery; Carla Chammas from CRG Gallery; Cristin Tierney and Valerie Altahawi from Cristin Tierney Gallery; Kristin DuFrain and Sarah Howard from Graphicstudio-Institute for Research in Art at the University of South Florida; Leslie Nolan and Jesse Washburne-Harris from Marian Goodman Gallery; Alicia Colen from Howard Greenberg Gallery; Mark Klett; Alissa Friedman from Salon 94; the Sean Kelly Gallery; Annalisa Palmieri Briscoe from Sicardi Gallery; Meg Malloy from Sikkema Jenkins & Co.; elin o'Hara slivick; Elli Resvanis at Thomas Dane Gallery; and Ben McMillan and Kristine Bell from David Zwirner Gallery.

We also wish to extend our deep thanks to Peter Barbur, Greg and Aline Gooding, and Dan and Jeanne Fauci, who augmented our acquisition of photographs by Mark

Ruwedel with gifts of additional works by him. And we wish to thank Paula Brenneman in Alfred Moses' office for all the kind assistance she has given us over the years.

From the outset, this project has been an unusual one for the National Gallery of Art, not only because of its focus on contemporary art but also because we had to identify the artists and works we wished to exhibit, and then acquire the pieces. It has demanded both a belief in the endeavor, as well as flexibility, patience, and creativity—attributes that have been repeatedly demonstrated by all our colleagues at the Gallery. We would especially like to thank Earl A. Powell, director, and Franklin Kelly, deputy director, for their steadfast support of the project and their confidence in our vision. Thanks are also due to D. Dodge Thompson, chief of exhibitions, and Mark Leithauser, senior curator and chief of design, whose insights and assistance have helped guide us in our work on this endeavor. And we are especially indebted to Chris Myers, chief development and corporate relations officer, and Cathryn Dickert Scoville, senior development officer for major gifts, in the development office for the astute guidance they have given us with this endeavor since 2007. In the department of design and installation, we wish particularly to thank Gordon Anson, Jame Anderson, Jon Frederick, Drew Watt, and Stefan Wood for their exceptional work on the design and installation of the exhibition—along with Jenny Ritchie and Stephen Muscarella in the department of paper conservation and Alisha Chipman and Sarah Wagner in the department of photograph conservation, whose careful oversight and attention to detail enabled us to display these many disparate works with great sensitivity and elegance. We thank Susan Arensberg and Lynn Matheny in the department of exhibition programs; Wendy Battaglino in the department of exhibitions; and Faya Causey, Ali Peil, and Sarah Battle in the department of academic programs for their assistance with coordinating the show and preparing its exciting educational programming. And we thank William McClure, treasurer, along with Myles Burgess, Nancy Hoffmann, and Tykie Tobin for their assistance throughout all aspects of this project.

We are, as always, especially indebted to the superb team in the publishing office organized by Judy Metro, editor in chief, and especially wish to thank Chris Vogel, deputy publisher, and Wendy Schleicher, design manager, whose devoted attention to this book has made it the elegant and thoughtful volume you hold in your hands. Caroline Weaver deftly edited the text, giving clarity and grace to our words. We also wish to thank John Long, assistant production manager, and Sara Sanders-Buell, who secured images and permissions for works in the exhibition.

In order to accommodate photographs as large and complex as many in this exhibition, the Gallery's division of imaging and visual services was faced with particularly complex challenges, yet, as always, their work has been exceptional. We wish particularly to thank Alan Newman, chief of imaging and visual services, along with Peter Dueker, Lorene Emerson, Lee Ewing, Tricia Zigmund, and Greg Williams for their attention and devotion to this project. In the office of the registrar, headed by the able Michelle Fondas, chief registrar and head of the division of registration and loans, we would like to acknowledge the excellent assistance given to us by Lehua Fisher, who skillfully arranged for the shipment of all the works to the Gallery. Further thanks are due to Melissa Stegeman and the Gallery's talented art services staff for their safe handling and adept installation of the works in the exhibition. In the department of press and public information Deborah Ziska, chief press and public information officer, Anabeth Guthrie, deputy press officer, and Emily Bond, senior publicist, skillfully oversaw all publicity and responded to press inquiries, while Carol Kelley, chief of protocol and special events, expertly arranged all special events related to the exhibition. We also thank the exceptional staff in the department of reader services of the National Gallery of Art Library, especially Jacqueline Protka for her skilled handling of interlibrary loans, as well as John Hagood, Yuri Long, Roderick McElveen, and Charlotte DonVito.

Our colleagues in the department of photographs deserve special acknowledgment. They have been involved every step of the way as we conceived this exhibition, selected the artists we hoped to include, and vetted and acquired each photograph. We would especially like to thank Sarah Kennel, associate curator, Diane Waggoner, associate curator, and Leslie Ureña, curatorial research associate, for their thoughtful catalog entries. Maryanna Ramirez, curatorial assistant, also deserves special recognition for her superb organizational skills and her adept assistance with all aspects of our acquisition of these photographs, as does intern Grace Kuipers for her work on the bibliography, and exhibition research assistant Chloe Downe and intern Bethany Wratislaw for graciously lending a hand whenever asked.

SARAH GREENOUGH | senior curator and head, department of photographs

ANDREA NELSON | assistant curator, department of photographs

SELECTED BIBLIOGRAPHY

GENERAL SOURCES

Baetens, Jan, Alexander Streitberger, and Hilde Van Gelder, eds. *Time and Photography*. Leuven, 2010.

Barthes, Roland. *Camera Lucida: Reflections on Photography*. Translated by Richard Howard. New York, 1981.

Batchen, Geoffrey. *Burning with Desire: The Conception of Photography*. Cambridge, MA, 1997.

Benjamin, Walter. *The Arcades Project*. Edited by Rolf Tiedemann. Translated by Howard Eiland and Kevin McLaughlin. Cambridge, MA, and London, 1999.

Blessing, Jennifer, and Nat Trotman, eds. *Haunted: Contemporary Photography/ Video/Performance*. Guggenheim Museum, New York, 2010.

Cadava, Eduardo. *Words of Light: Theses on the Photography of History*. Princeton, 1998.

Dillon, Brian, ed. *Ruins: Documents of Contemporary Art*. London and Cambridge, MA, 2011.

Dougherty, Linda Johnson, ed. *0 to 60: The Experience of Time through Contemporary Art*. North Carolina Museum of Art, Raleigh, 2013.

Emerling, Jae. *Photography: History and Theory*. London and New York, 2012.

Enwezor, Okwui. *Archive Fever: Uses of the Document in Contemporary Art*. International Center of Photography, New York, 2008.

Farr, Ian, ed. *Memory: Documents of Contemporary Art*. London and Cambridge, MA, 2012.

Foster, Hal. "An Archival Impulse." *October* 110 (Autumn 2004): 3–22.

Green, David, and Joanna Lowry, eds. *Stillness and Time: Photography and the Moving Image*. Brighton, 2006.

Huyssen, Andreas. *Twilight Memories: Marking Time in a Culture of Amnesia*. New York and London, 1995.

Langford, Martha. *Scissors, Paper, Stone: Expressions of Memory in Contemporary Art*. Montreal and Kingston, 2007.

Macaulay, Rose. *Pleasure of Ruins*. New York, 1966.

Merewether, Charles. *Archive: Documents of Contemporary Art*. London and Cambridge, MA, 2006.

Phillips, Sandra S., and Simon Baker. *Exposed: Voyeurism, Surveillance, and the Camera Since 1870*. San Francisco Museum of Modern Art, 2010.

Rexer, Lyle. *Photography's Antiquarian Avant-Garde: The New Wave in Old Processes*. New York, 2002.

BARTH, UTA

Barth, Uta. *Uta Barth. "to draw with light."* Annandale, NY, 2012.

Conkelton, Sheryl, Russell Ferguson, and Timothy Martin. *Uta Barth: In Between Places*. Henry Art Gallery, University of Washington, 2000.

Crary, Jonathan, Russell Ferguson, and Holly Myers. *Uta Barth: The Long Now*. New York, 2010.

Lee, Pamela M., Matthew Higgs, and Jeremy Gilbert-Rolfe. *Uta Barth*. London, 2004.

Soto, Paul. "Literal Photography: Q+A with Uta Barth." *Art in America*, October 18, 2011. http://www.artinamericamagazine. com/news-features/interviews/uta-barth/.

BRANDT, MATTHEW

Bierend, Doug. "Photos of Lakes Turn Psychedelic after Soaking in Their Waters." *Wired*, September 10, 2014. http://www. wired.com/2014/09/matthew-brandt-lakes-and-reservoirs/.

Brandt, Matthew. *Lakes and Reservoirs*. Bologna and New York, 2014.

Cunningham, Mark K. "Surface Tension: Matthew Brandt's Lakes and Reservoirs 2." *Octopus: A Visual Studies Journal* 4 (Fall 2008): 143–145, 147, 149, 151.

Evans, Catherine. *Matthew Brandt: sticky/ dusty/wet*. Columbus Museum of Art, 2013.

Kuriyama, Emily Anne, and Matthew Brandt. *Dust Rising: Public Library*. Los Angeles, 2013.

Rothman, Lily. "'Lakes, Trees, and Honeybees': Matthew Brandt at Yossi Milo Gallery." *Time Lightbox*, May 22, 2012. http:// lightbox.time.com/2012/05/22/matthew-brandt/.

CALLE, SOPHIE

Barbieri, Claudia. "Sophie Calle: Tapes, Diaries, and Burial Plots." *New York Times*, June 12, 2012. http://www.nytimes.com/ 2012/06/13/arts/13iht-rartcalle13.html.

Baudrillard, Jean et al. *Sophie Calle: The Reader*. Whitechapel Gallery, London, 2009.

Calle, Sophie. *Exquisite Pain*. New York, 2005.

Calle, Sophie. *True Stories: Hasselblad Award 2010*. Göttingen, 2010.

Calle, Sophie. *Sophie Calle: True Stories*. Arles and Paris, 2013.

Guralnik, Nehama, ed. *Sophie Calle: True Stories*. Tel Aviv Museum of Art, 1996.

Macel, Christine, ed. *Sophie Calle: Did You See Me?*. Munich, 2003.

Schube, Inka, ed. *Sophie Calle*. Cologne, 2003.

CLOSE, CHUCK

Close, Chuck. "Why I Make Daguerreotypes." In *Photography's Antiquarian Avant-Garde: The New Wave in Old Processes*, by Lyle Rexer, 36–39. New York, 2002.

Kesten, Joanne, ed. *The Portraits Speak: Chuck Close in Conversation with 27 of His Subjects*. New York, 1997.

Paparoni, Demetrio, ed. *Chuck Close: Daguerreotypes*. Milan, 2002.

Peyton, Elizabeth. "About Face: Chuck Close in Conversation with Elizabeth Peyton October 3, 2000, New York City." *Parkett*, no. 60 (2000): 28–43.

Prose, Francine. "Chuck Close: Distances and Faces of the Moon." *Parkett*, no. 60 (2000): 16–27.

Rexer, Lyle. "Chuck Close Daguerreotypes." *Aperture*, no. 160 (Summer 2000): 40–49.

Westerbeck, Colin. *Chuck Close: Photographer*. Munich, 2014.

CONNOR, LINDA

Connor, Linda. *Spiral Journey: Photographs 1967–1990*. Museum of Contemporary Photography, Columbia College, Chicago, 1990.

Connor, Linda. *Luminance*. With an essay by Rebecca Solnit. Carmel Valley, CA, 1994.

Connor, Linda, Robert Adams, Emmet Gowin, and William L. Fox. *Odyssey: The Photographs of Linda Connor*. San Francisco, 2008.

Kelly, Anne. "Linda Connor's Prints from the Archive of the Lick Observatory." *Photo-eye* (blog), November 7, 2012. http://blog.photoeye.com/2012/11/linda-connors-prints-from-archive-of.html.

Shostak, Anthony, ed. *Starstruck: The Fine Art of Astrophotography*. Bates College Museum of Art, Lewiston, ME, 2012.

DANH, BINH

Copeland, Colette. "Madness and Mayhem: The Aesthetics of Dark Tourism." *Afterimage* 39, no. 1/2 (July 2011): 43–46.

Đông, Hoài, Lori Chinn, and Moira Roth. *Binh Danh: Collecting Memories*. Mills College Art Museum, Oakland, 2010.

Ly, Boreth. "Devastated Vision(s): The Khmer Rouge Scopic Regime in Cambodia." *Art Journal* 62, no. 1 (Spring 2003): 66–81.

Ly, Boreth. *Binh Danh: Yosemite*. Haines Gallery, San Francisco, 2012.

Schulz, Robert, Amy G. Moorefield, and Joanna Ruth Epstein. *In the Eclipse of Angkor*. Eleanor D. Wilson Museum, Hollins University, Roanoke, VA, 2009.

Sischy, Jacqueline. "The Ethics of Remembrance: The S-21 Photographs." Master's thesis, Concordia University, 2009.

Wasserman, Abby. "Binh Danh: First Person." *The Museum of California* 28, no. 3 (Summer 2004): 18–19.

Weintraub, Max. "Mirrors with Memories: The Photographs of Binh Danh." *Art21 Magazine* (blog), December 7, 2010. http://blog.art21.org/2010/12/07/on-view-now-mirrors-with-memories-the-photographs-of-binh-danh/.

DAVEY, MOYRA

Baker, George. "Some Things Moyra Taught Me." *Frieze*, no. 130 (April 2010): 19–20.

Davey, Moyra. *The Problem of Reading*. Montpelier, VT, 2003.

Davey, Moyra. *Copperheads*. Toronto, 2010.

Davey, Moyra, and Helen Anne Molesworth. *Long Life Cool White: Photographs and Essays*. Harvard University Art Museums, Cambridge, MA, 2008.

Szymczyk, Adam, ed. *Moyra Davey: Speaker Receiver*. Kunsthalle Basel, Switzerland, 2010.

Verhagen, Marcus. "Moyra Davey: Slack Time." *Afterall: A Journal of Art, Context and Enquiry* 29 (Spring 2012): 19–25.

Walsh, Meeka. "A Certain Kind of Distance. Picturing the Art of Moyra Davey." *Border Crossings* 27, no. 4 (November 2008): 48–56.

Witkovsky, Matthew. "Another History." *Artforum* 48, no. 7 (March 2010): 212–221, 274.

FUSS, ADAM

Barnes, Martin, ed. *Shadow Catchers: Camera-Less Photography*. Victoria and Albert Museum, London, 2010.

"Behind the Scenes with Adam Fuss." *Art on Paper* 7, no. 1 (September/October 2002): 68–73.

Bleckner, Ross. "Adam Fuss." *BOMB*, no. 39 (Spring 1992): 24–29.

Brutvan, Cheryl A., and Christopher Bucklow. *Adam Fuss*. Madrid, 2010.

Fuss, Adam, Andrew Roth, and Jerry Kelly. *My Ghost, Daguerreotypes from the Series*. Santa Fe, 2002.

Kellein, Thomas. *Adam Fuss*. New York, 2003.

Parry, Eugenia. *Adam Fuss*. Santa Fe, 1997.

Sand, Michael. "Adam Fuss." *Aperture*, no. 133 (Fall 1993): 44–53.

Tannenbaum, Barbara. *Adam Fuss: Photograms*. Akron Art Museum, 1992.

GREENE, MYRA

Gonzalez, David. "Some of Her Best Friends are White." *Lens* (blog), *New York Times*, May 22, 2012. http://lens.blogs.nytimes.com/2012/05/22/some-of-her-best-friends-are-white.

Greene, Myra. *Character Recognition.* Self-published, 2009.

Greene, Myra, and Tate Shaw. *My White Friends: Myra Greene.* Heidelberg, 2012.

Mestrich, Qiana. "Photographer Interview: Myra Greene." *Dodge & Burn* (blog), April 29, 2009. http://dodgeburn.blogspot.com/2009/04/photographer-interview-myra-greene.html.

Smith, Shawn Michelle. *Taking Another Look at Race: Myra Greene and Carla Williams.* Rochester, 2009.

ISHIUCHI MIYAKO

Botman, Machiel, ed. *Miyako Ishiuchi Yokosuka Story Apartment Endless Night 1.9.4.7 1906 to the Skin Mothers.* Langhans Gallery, Prague, 2008.

Ishiuchi Miyako. *Mother's.* Translated by Ito Haruna. Tokyo, 2002.

Kasahara Michiko and Sandra Phillips. *Ishiuchi Miyako: Mother's 2000–2005: Traces of the Future.* The Japan Foundation, Tokyo, 2005.

KHAN, IDRIS

Casley-Hayford, Gus. *Idris Khan.* Victoria Miro Gallery, London, 2010.

Dyer, Geoff. "Between the Lines." *The Guardian*, September 2, 2006. http://www.theguardian.com/artanddesign/2006/sep/02/art.

Fuss, Adam. "Portfolio: Idris Khan." *BOMB Magazine Literary Supplement* (Fall 2007): 105.

MacDonald, Kerri. "Postcard from a New London." *Lens* (blog), *New York Times*, March 1, 2012. http://lens.blogs.nytimes.com/2012/03/01/postcard-from-london/.

"Pretty as a Thousand Postcards." *New York Times Magazine*, March 1, 2012. http://www.nytimes.com/interactive/2012/03/01/magazine/idris-khan-london.html.

Risch, Conor. "Idris Khan on Exploring the Creative Process through Imagery." *PDN*, May 1, 2013. http://www.pdnonline.com/features/Idris-Khan-on-Explor-8042.shtml.

Smith, Trevor, ed. *Idris Khan.* Yvon Lambert, New York, 2007.

LUSTER, DEBORAH

Díaz, Eva. "Absent Populations: Deborah Luster's *Tooth for an Eye.*" *Pelican Bomb*, May 12, 2011. http://pelicanbomb.com/art-review/2011/absent-populations-deborah-lusters-tooth-for-an-eye.

Luster, Deborah. *One Big Self: Prisoners of Louisiana.* With a poem by C. D. Wright. Santa Fe, 2003.

Luster, Deborah. *Tooth for an Eye: A Chorography of Violence in Orleans Parish.* Santa Fe, 2011.

Nelson, Davia, and Nikki Silva. "Tooth for an Eye: A Gallery Walk with Photographer Deborah Luster, Jack Shainman Gallery, New York." February 1, 2011. http://www.kitchensisters.org/girlstories/tooth_for_an_eye/.

Patterson, Tom. "Deborah Luster's Tooth for an Eye: A Chorography of Violence in Orleans Parish." *Aperture*, no. 205 (Winter 2011): 177.

Simmons, Lizbet. "Deborah Luster on the Photographic Performance: An Interview with Lizbet Simmons December 21, 2008." In *Prison Culture*, edited by Sharon Bliss, 36–39. San Francisco, 2009.

LUTTER, VERA

Cohen, Françoise, Douglas Crimp, Steven Jacobs, and Gertrud Koch. *Vera Lutter.* Ostfildern, 2012.

Dillon, Brian. "Ruined: How the Camera Sees Architecture." *Modern Painters* (June 2005): 41–43.

Jobey, Liz, and Miriam Wiesel, eds. *Vera Lutter: Light in Transit.* Berlin, 2002.

Lutter, Vera, David Sylvester, Jonathan Crary, and Will Self. *Vera Lutter: Battersea.* Gagosian Gallery, London, 2004.

Newhall, Edith. "Turning Rooms into Cameras." *ARTnews* 9, no. 3 (March 2009): 101–105.

Newman, Michael. *Vera Lutter: Venice, Rheinbraun, New York, London, Philadelphia.* Gagosian Gallery, New York, 2007.

Pakesch, Peter, and Adam Budak, eds. *Inside In.* Cologne, 2004.

Wollen, Peter. "Vera Lutter." *BOMB*, no. 85 (Fall 2003): 46–53.

MAISEL, DAVID

Maisel, David, Natasha Egan, Geoff Manaugh, Alan Rapp, Kirsten Rian, Mark Strand, Joseph Thompson, and Kazys Varnelis. *Black Maps: American Landscape and the Apocalyptic Sublime.* Göttingen, 2013.

Maisel, David, and Jonathan Lethem. *History's Shadow.* Portland, 2011.

Maisel, David, Geoff Manaugh, Terry Toedtemeier, and Michael Roth. *Library of Dust.* San Francisco, 2008.

Robertson, Rebecca. "Seeing Inside Buddha." *ARTnews* 109, no. 9 (December 2010): 31.

MANN, SALLY

Parsons, Sarah. "Public/Private Tensions in the Photography of Sally Mann." *History of Photography* 32, no. 2 (Summer 2008): 123–136.

Ravenal, John B., David Levi Strauss, and Anne Tucker. *Sally Mann: The Flesh and the Spirit*. Virginia Museum of Fine Arts, Richmond, 2010.

Roberts, John D. "Facing It: Sally Mann, Upon Reflection." *The New York Photo Review* 3, no. 35 (October 31–November 6, 2012). http://www.nyphotoreview.com/NYPR_REVS/NYPR_REV2506.html.

MARCLAY, CHRISTIAN

Ferguson, Russell, ed. *Christian Marclay*. Hammer Museum, Los Angeles, 2003.

Gordon, Kim, Jennifer A. González, and Matthew Higgs. *Christian Marclay*. London, 2005.

Marclay, Christian. *Christian Marclay: Stereo*. Fraenkel Gallery, San Francisco, 2008.

Marclay, Christian, David Norr, Noam M. Elcott, and Margaret Miller. *Cyanotypes: Christian Marclay*. Graphicstudio, University of South Florida, Tampa, 2011.

Rexer, Lyle. "Blue Tape: Christian Marclay's Old Masters." *DAMn*, no. 33 (May/June 2012): 98–104.

Richard, Frances. "Music I've Seen: Christian Marclay in Conversation with Frances Richard." *Aperture*, no. 212 (Fall 2013): 26–33.

MCCAW, CHRIS

Johnson, Ken. "Chris McCaw, 'Marking Time.'" *New York Times*, December 29, 2012, C29.

Kelly, Anne. "Chris McCaw on His Sunburn Series." *Photoeye* (blog), October 12, 2010. http://blog.photoeye.com/2010/10/chris-mccaw-on-his-sunburned-series.html.

McCaw, Chris, Katherine Ware, and Allie Haeusslein. *Chris McCaw: Sunburn*. Richmond, 2012.

Ollman, Leah. "Black Hole Sun: Chris McCaw Burns a Photograph." *Art on Paper* 13, no. 5 (May/June 2009): 24–27.

MEISELAS, SUSAN

Garnett, Joy, and Susan Meiselas. "On the Rights of the Molotov Man: Appropriation and the Art of Context." *Harper's Magazine* 314, no. 1881 (February 2007): 53–58.

Lubben, Kristen, ed. *Susan Meiselas: In History*. International Center of Photography, New York, 2008.

Meiselas, Susan, and Claire Rosenberg. *Nicaragua, June 1978–July 1979*. New York, 1981.

MOORE, ANDREW

Colberg, Joerg. "A Conversation with Andrew Moore." *Conscientious*, March 5, 2007. http://jmcolberg.com/weblog/extended/archives/a_conversation_with_andrew_moore/.

Hering, Deirdre. "Andrew Moore's Beautiful Ruins." *The L Magazine*, November 22, 2009. http://www.thelmagazine.com/newyork/andrew-moores-beautiful-ruins/.

Kozloff, Max. "A Planet of Relics." *Art in America* 99, no. 1 (January 2011): 53–60.

Leary, John Patrick. "Detroitism." *Guernica: A Magazine of Art and Politics*, January 15, 2011. https://www.guernicamag.com/features/leary_1_15_11/.

Moore, Andrew. "Urban Archaeology: Photographs and Commentary by Andrew Moore." *Aperture*, no. 197 (Winter 2009): 46-51.

Moore, Andrew, and Philip Levine. *Detroit Disassembled*. Akron Art Museum, 2010.

Rubin, Mike. "Capturing the Idling of the Motor City." *New York Times*, August 18, 2011. http://www.nytimes.com/2011/08/21/arts/design/andrew-moores-photographic-take-on-detroit-decay.html.

ROSSITER, ALISON

Enright, Robert. "Paper Wait: The Darkroom Alchemy of Alison Rossiter." *Border Crossings* 30, no. 119 (September 2011): 68–79.

Robertson, Rebecca. "A Developing Love Affair with Film." *ARTnews* 113, no. 2 (February 2014): 54–61.

Rossiter, Alison. "Artist's Statement." *Southern Review* 49, no. 1 (Winter 2013): 86–94.

Tousley, Nancy. "Darkroom Legacy: Alison Rossiter Brings Heirloom Papers to the New World of Photography." *Canadian Art* (Spring 2011): 96–100.

RUWEDEL, MARK

Mallinson, Constance. "Now It Is Dark." *The Times Quotidian* (blog), July 30, 2010. www.timesquotidian.com/2010/07.

Robinson, Edward. "Artists on New Topographics, Part I: Mark Ruwedel." October 29, 2009. http://unframed.lacma.org/2009/10/29/artists-on-new-topographics-part-i-mark-ruwedel.

Round, Phillip. *The Impossible Land: Story and Place in California's Imperial Valley*. Albuquerque, 2008.

Ruwedel, Mark. "The Land as Historical Archive." *American Art* 10, no. 1 (Spring 1996): 36–41.

Ruwedel, Mark. *Westward the Course of Empire*. With an essay by Jock Reynolds. Yale University Art Gallery, New Haven, 2008.

Ruwedel, Mark, Barry Holstun Lopez, Karen Love, and Ann Thomas. *Mark Ruwedel: Written on the Land*. Presentation House Gallery, North Vancouver, BC, 2002.

Sholis, Brian. "Mark Ruwedel." *Artforum* 47, no. 8 (April 2009): 189.

SUBOTZKY, MIKHAEL, AND PATRICK
WATERHOUSE

Lehan, Joanna, Kristen Lubben,
Christopher Phillips, and Carol Squiers.
A Different Kind of Order: The ICP Triennial.
New York, 2013.

Vladislavić, Ivan, ed. *Ponte City.* Göttingen,
2014.

SUGIMOTO, HIROSHI

Adams, Parveen. "Out of Sight, Out of
Body: The Sugimoto/Demand Effect."
Grey Room, no. 22 (Winter 2006): 86–104.

Belting, Hans, and Hiroshi Sugimoto. *The-
aters: Hiroshi Sugimoto.* New York, 2000.

Brougher, Kerry, David Elliott, and Hiroshi
Sugimoto. *Hiroshi Sugimoto.* Ostfildern,
2005.

Brougher, Kerry, Peter Hay Halpert,
Jacinto Lageira, Hiroshi Sugimoto, and
John Yau, *Sugimoto.* Fundación "la Caixa,"
Madrid and Centro Cultural de Belém,
1998.

Halpert, Peter Hay. "The Blank Screens of
Hiroshi Sugimoto." *Art Press*, no. 196
(November 1994): 51–53.

Kellein, Thomas. *Hiroshi Sugimoto: Time
Exposed.* New York, 1995.

Morgan, Robert C. "Moving Images." *Per-
forming Arts Journal* 18, no. 2 (1996):
53–63.

Rousmaniere, Nicole Coolidge, William
Jeffett, and Hiroshi Sugimoto. *Hiroshi
Sugimoto.* Sainsbury Centre for Visual
Arts, University of East Anglia, Norwich,
England, 1997.

Yau, John. "Hiroshi Sugimoto: No Such
Thing as Time." *Artforum* 22, no. 8 (April
1984): 48–52.

WEEMS, CARRIE MAE

Berger, Maurice. "Black Performers, Fad-
ing from Frame, and Memory." *Lens* (blog),
New York Times, January 22, 2014. http://
lens.blogs.nytimes.com/2014/01/22/
black-performers-fading-from-frame-
and-memory.

Bey, Dawoud. "Carrie Mae Weems."
BOMB, no. 108 (July 2009): 60–67.

Carr, C. "More Than Meets the Eye: The
Quiet Revolution of Carrie Mae Weems."
The Village Voice, March 4, 2003. http://
www.villagevoice.com/2003-03-04/art/
more-than-meets-the-eye/full/.

Delmez, Kathryn E., ed. *Carrie Mae Weems:
Three Decades of Photography and Video.*
Frist Center for the Visual Arts, Nashville,
2012.

Kirsh, Andrea, and Susan Fisher Sterling.
Carrie Mae Weems. National Museum of
Women in the Arts, Washington, DC, 1993.

Olds, Kirsten. "Recent Museum of Art
Acquisition: Historically Resonant Portrait
by Photographer Carrie Mae Weems." *Bul-
letin: The University of Michigan Museums
of Art and Archaeology* 16 (2005). http://
hdl.handle.net/2027/spo.0054307.0016.110.

Ose, Elvira Dyangani, ed. *Carrie Mae
Weems: Social Studies.* Centro Andaluz de
Arte Contemporáneo, Seville, 2010.

Weems, Carrie Mae. *Ritual and Revolution.*
Künstlerhaus Bethanien, Berlin, 1998.

WORMS, WITHO

Tallman, Susan. "Witho Worms: Slagheap
Beauty." *Art in Print.* http://artinprint.org/
index.php/edition-reviews/article/witho_
worms.

Worms, Witho. *Cette montagne c'est moi.*
With an essay by Xavier Canonne. Amster-
dam, 2012.

INDEX

Note: Illustrations are indicated by page numbers in italic type.

PHOTOGRAPHY CREDITS